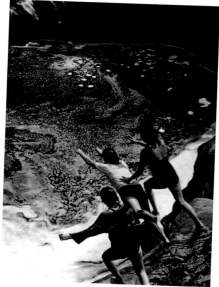

Looking Back

Memoirs and Photographs
Todd Webb

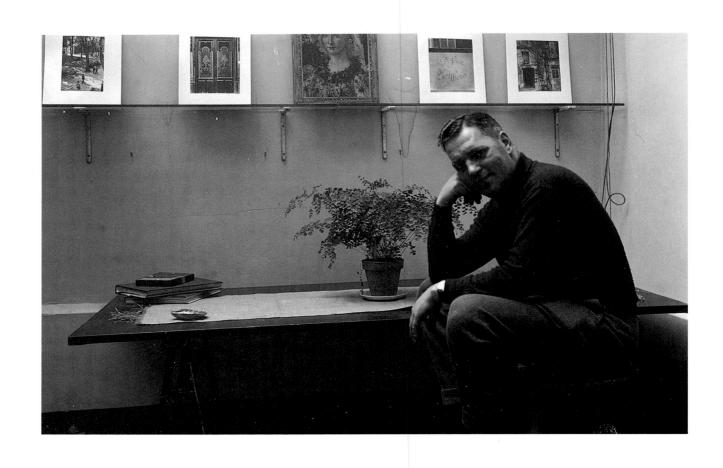

Todd Webb in his studio, Paris, 1949. Photo by Lucille Webb.

Looking Back

Memoirs and Photographs

Todd Webb

Foreword by Michael Rowell

University of New Mexico Press
Albuquerque

Library of Congress Cataloging-in-Publication Data

Webb, Todd
Looking back: memoirs and photographs/Todd Webb:
foreword by Michael Rowell.—1st ed.
 p. cm.
ISBN 0-8263-1294-2
1. Webb, Todd.
2. Photographers—United States—Biography.
I. Title.
TR140.W38A3 1991
770' .92—dc20
[B]
91-3894

Contents

Foreword

One of the most revealing anecdotes about Todd Webb
concerns a time that he was on extended assignment in
Africa for the UN. He and his interpreter found themselves
in a distant livestock market, where Todd made friends with
a bedouin chief. Despite the lack of a common language,
Todd realized that the man was inviting him to visit his
camp. Soon Todd and his cameras were on a camel racing
across the desert—about seven miles it turned out—leaving
the stunned interpreter far behind. Todd visited the camp,
photographed the people extensively, and rejoined his
thoroughly disconcerted interpreter the next day.

It was a typical thing for Todd to do. First of all, he is very
interested in people. He is fascinated with them, the way they
live and where they live; and always he tries to communicate
with them. He has learned Spanish, French, some Italian,
and bits and pieces of dozens of other languages.

Second, he has an irresistible urge to photograph anyone or
anyplace that beckons to his fancy. This has led him not only
to ride off into the desert, but to leave New York City in the
late forties for Europe, when fame and success could have
been his by just staying in New York and doing the
commercial and publishing assignments being pressed on
him. It has caused him to reject prestigious teaching
opportunities to remain a simple photographer.

As a result, Todd Webb's fame is slight. He has founded no
photographic movements. He has no hordes of adoring
students. And he has expressed no esoteric theories on the
meaning of photography as an art form.

That is beginning to change. Throughout his photographic
career, other photographers have recognized his extraordinary
talent and his enormous output of beautiful and insightful
photographs. Now the word is beginning to slip out. There are
major shows, print sales in London and Tokyo, and growing
media attention.

Todd Webb first picked up a camera in the late 1930s. He had
thoughts of becoming a travel writer and lecturer like Lowell
Thomas or Richard Halliburton, and a camera was necessary

to record his adventures. Todd was and is an adventurer, but in the purest sense. He is not a man who brags about the places he has been and the things he has done, but rather one whose chief delight is in seeing new places and things.

Though his joy in photography soon crowded out any writing ambitions, he never lost that spirit of adventure and exploration, although it often appeared in strange forms. In 1946, Todd went to New York with the same sense of discovery that others would take to Timbuktu and Samarkand. New York had more aggressive, ambitious, and talented photographers than any place on earth, but it took Todd Webb to show them that the elevated trains were more exotic than the Great Wall of China, and that the Fulton fish market was livelier and more diverse than the bazaars of Baghdad. No one has ever depicted the energy, bustle, and strength of New York when that city was the center of the world as Todd Webb has.

Then Todd discovered Paris and Lucille. The photographs of Paris are warm and loving. It is a complete change of style. Undoubtedly Lucille, the love of his life, had much to do with it. However, Todd always photographs a new place in its own unique style. Ibiza, the trails and ghost towns of the American West, Mexico, Spain all have their own special look. Perhaps most startling are the photographs of the area around his friend Georgia O'Keeffe's home in New Mexico, which seem to be through her eyes and which provide a fascinating bridge between the barren landscape and the excitement and tension of her paintings.

Todd's photographs are much like the man himself. At first they seem very simple, without obvious tricks or manipulation. On closer examination, they are increasingly complex and marvelously subtle. It is not surprising that everywhere he has attracted the friendship and respect of talented and interesting people. This is all the more true because Todd has submerged his small but vital ego in a sea of Quaker serenity and because he is totally devoid of envy and jealousy. Thus he has avoided the quarrels and anger that disrupt the lives of so many artists.

A remarkable number of celebrities, artists, and photographers troop through Todd's life and through the

pages of his journal. A journal is not a diary. That is to say it is not an exercise in vanity and narcissism. It is rather a tool that the artist uses. In the thirties, experts recommended that would-be writers keep journals of experiences that they could draw on for inspiration. This may have been how Todd was moved to begin his. But we know that Todd was fully aware of an earlier American tradition of keeping a journal for spiritual discipline. Todd used many of these journals in researching his books about the West. By writing down each day's activities, the writer must face the achievements, failures, and purpose of those activities. It encourages goals and discourages idleness. Often in his journal, we find Todd chiding himself for too much partying or setting himself tasks to stir a reluctant muse. Of course Todd took great pleasure in his photography, and you will find little note that those conversations at An American Place with Steiglitz followed long, exhausting days trudging around New York with heavy cameras, wooden tripods, and bulky film holders.

The frequency of the journal entries falls off after Todd married Lucille. This bright, aggressive, and highly partisan fan and advocate of Todd and his work replaced the necessity of confiding regularly to a journal. Lucille eagerly wishes all the rewards of fame and recognition for her beloved husband, but Todd himself at eighty-five is less excited about being a famous photographer than about photographing. He doesn't shoot a lot of film these days, but he never did. It is a legacy of sheet film days, when ten film holders would fill your camera bag. But each shot that he takes is done with the same care and the same joy he found all those years ago in Detroit.

In 1978, when Todd received a grant from the National Endowment for the Arts, another photographer commented that the grants were given for new work by emerging artists. Todd used the money to print a huge volume of new work. In a sense, that is the truth about Todd Webb. For as long as he lives that is what he will be, an emerging artist doing new work.

—Michael E. Rowell
Portland, Maine
1991

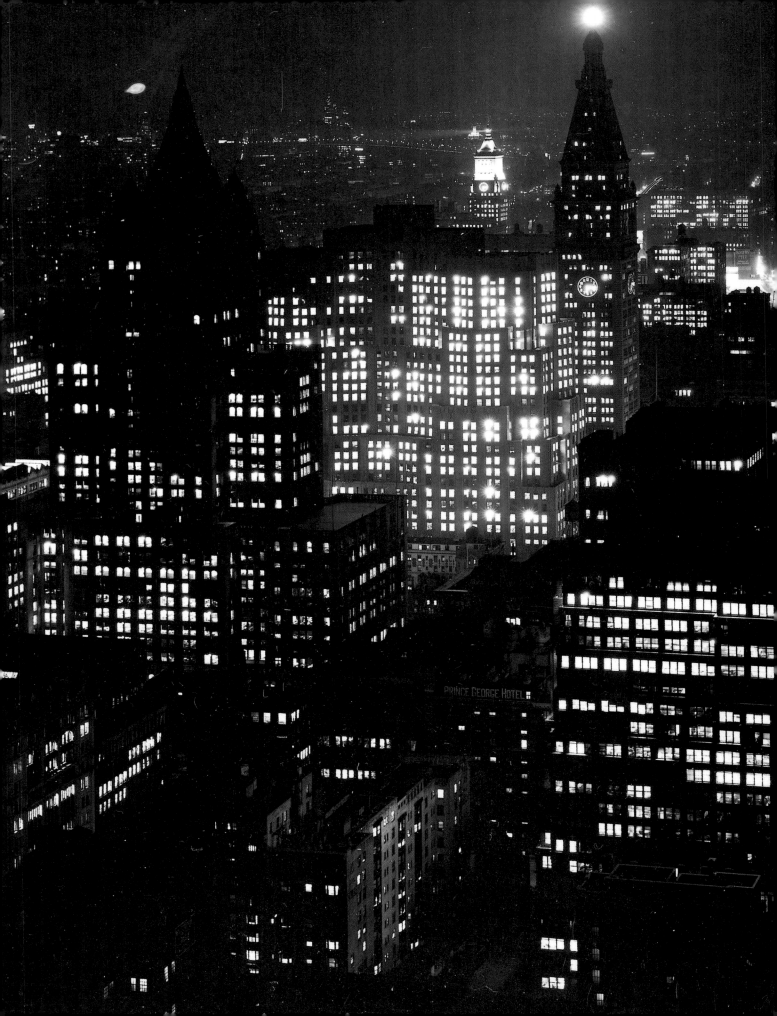

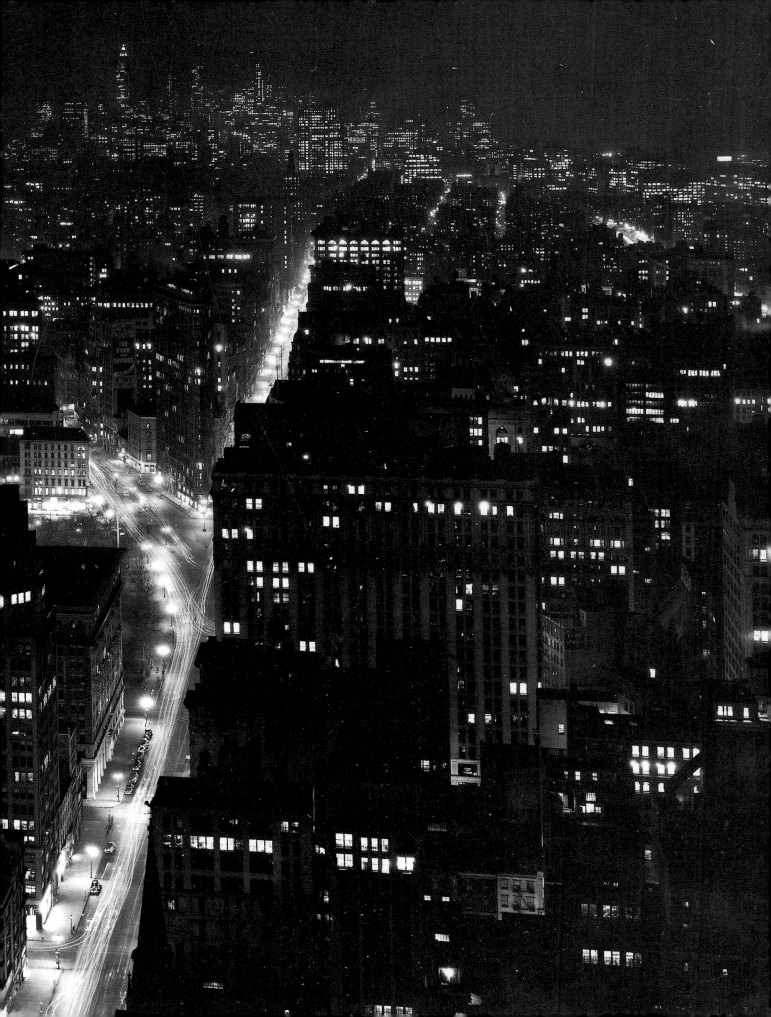

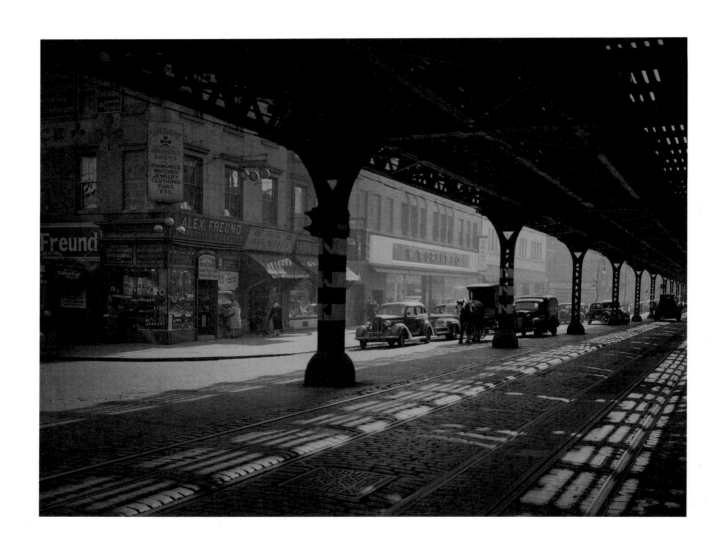

Under the El on Third Avenue, New York, 1946.

Mott Street, New York, 1948.

(Preceding pages) From the Empire State Building, New York, 1946.

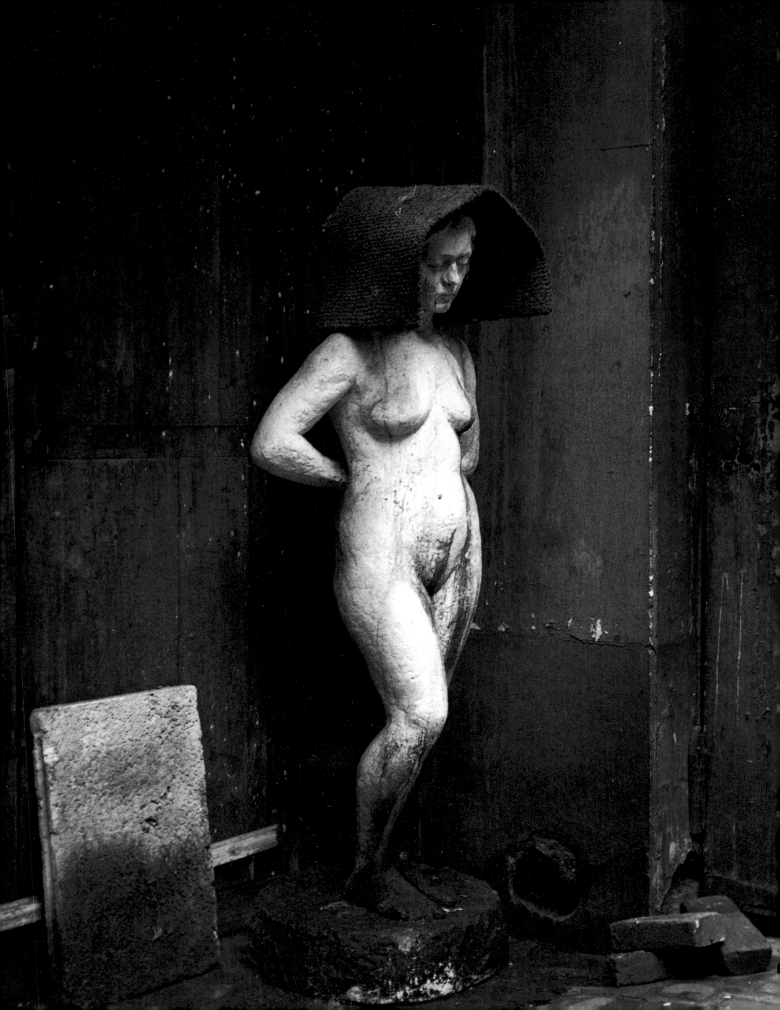

Luxembourg Gardens, Paris, 1949.

Abandoned statue, rue Jacob, Paris, September 1948.

Cafe game, Jumiege, Normandy, 1949.

Place du Forum, Arles, France, 1949.

Abiquiu, New Mexico, 1977.

Oaxaca, Mexico, 1963.

Nazaré, Portugal, 1980 (following page).

Looking Back

Memoirs and Photographs
Todd Webb

Looking Back:
The Memoirs of Todd Webb

My birth certificate, issued by the Detroit Department of Health, reads: Born to Joseph Franklin Webb and Bertha Hollingshead Webb, a son, Charles Clayton Webb III on September 15, 1905.

I should explain the discrepancy between Todd Webb and Charles Clayton Webb III. When my mother was pregnant with me she was reading a very popular book called *Helen's Babies*. It was about a family with two small boys, the youngest of whom was named Toddy. My mother must later have seen some resemblance, because she began to call me Toddy, a name that stuck from my childhood to the present. My grandparents always called me Charles, as did my mother when she was annoyed.

Fifty-six years later I discovered that I was not the only son affected by a mother reading a book. In 1961, when my wife Lucille and I first moved to Santa Fe, we attended the opening of the Santa Fe Opera season in the handsome outdoor theater. As is usual, opening night was celebrated by the beginning of the rainy season. The audience left their seats and crowded into the sheltered area. Lucille was talking to someone in the crowd and called to me. Another woman asked, "Did you call my husband?" Lucille said she was calling her husband. We introduced ourselves and subsequently became friends, the Charles (Todd) Finckes and the Charles (Todd) Webbs. One day the other Todd asked me, "Is Todd really your name?" I told him it was a nickname I'd had from childhood. He asked when I was born and I told him 1905. He said, "No kidding, what month?" And he wanted to know what day and I told him the fifteenth. He was born on the eighteenth. The next question was, "By any chance, do you know if your mother was reading a book called *Helen's Babies* at about that time?"

The early part of my life is written from memory. My family were Quakers and did not keep much in the way of memorabilia. The few family pictures we had have been lost in my travels. All the data about my parents' childhoods are from memories of stories told. I do know that the Webbs and

the Hollingsheads were in a group of Quaker families who, for religious reasons, left their homes in Yorkshire, England, in 1670 and moved to the Colonies. They settled in Pennsylvania and farmed near what is now the town of Reading. They prospered until 1776 when the great revolution began. Being Quakers, they refused to join the fighting and were therefore very unpopular and cruelly persecuted both during and after the war. In 1806, after a series of barn burnings, thirty families decided to move to Canada where they would be free from prejudice. They made the trip by oxen train, driving their stock, and the men built barges to ferry the wagons across Lake Ontario, while the women and children walked around the lake. Most of the families settled in York County about thirty miles north of Toronto. A few of the families pushed on and settled in Ravenswood, near Sarnia, Ontario.

The Webbs prospered and eventually owned four hundred acres of fine farmland. My father was raised on that farm, and my grandparents lived there until about 1910, when they moved into the nearby town of Newmarket. As children, my brother and I spent most of our summers with our grandparents in Newmarket.

My parents were second cousins, my mother's mother having married one of the Hollingshead boys from one of the families that had moved to Ravenswood. He was a cousin of my Grandmother Webb. I am not sure of how my father and mother met. After graduating from medical school and then from the University of Toronto Pharmacy School, my father went to Detroit and opened a drugstore on the corner of Third Avenue and Canfield. My mother had gone to normal school in Sarnia and planned to be a teacher. In 1898 she went to Detroit and found a job as governess, tutor, and nanny with a wealthy family that had two young boys. During this period she met my father and they became engaged. They were married in 1901 and lived in a house my father bought at 1051 Third Avenue. My brother, Joseph Franklin Webb, Jr., was born on July 1, 1903, and I came along on September 15, 1905.

We were a reasonably happy family, and I remember my childhood with pleasure. Some of the events are still prominent in my memory. I remember when my father became an American citizen in 1919, and when my mother

was eligible to cast her first vote in 1920. Detroit at that time was a nice, gentle city. Most of the traffic on the streets was horse-drawn vehicles. Even the fire engines were pulled by horses. Our house was lighted with quite elegant chandeliers. I think it was in 1919 that we had the house wired for electricity but continued to use the old chandeliers, now sprouting electric bulbs. Because my father had a drugstore, it was necessary that we have a telephone. The telephone book had only a few pages. For some reason I remember the number: North 2480 J. I was allowed to call my father and remind him to bring home a pitcher of Vernor's Ginger Ale on hot days.

When I was five or six I began attending the Tilden School, an old school even then. I liked school and got along well. I learned to read when quite young, and by the time I was ten I was reading all types of books. It was one of my great pleasures and still is. I was about ten when I began to deliver morning papers. I had a route of about twenty-five customers and after that was finished I sold papers on the corner of Third and Kirby. That must have been around 1915–18, during World War I. I was an avid reader of the headlines. I had one customer I remember well. He lived on Third right near Kirby, an elegant man with a neat goatee who always wore a handsome gray fedora. He would discuss the war headlines with me while waiting for his streetcar. He seemed as great a war student as I. The Detroit News, the evening paper, was running a serialized book, *Over the Top*, and since we both followed it, that became a topic of conversation. My father told me that this gentleman was a photographer with a studio downtown. But it was not until 1956, when I visited the William Henry Jackson Museum in Nebraska and saw a portrait made in 1918 of this famous pioneer photographer of the American West wearing his fine gray fedora, that one of my claims to fame became, "I knew William Henry Jackson, not as a photographer but as a war buff."

I graduated from the Tilden School when I was thirteen and went on to Central High School. I was interested in athletics, played all the games, and was on some of the teams. When I was fifteen, our family moved to another school district and I transferred to Northwestern High School. It was a new school and more sophisticated than Central. Just before school closing in June there was a tea dance in the school gym. One

of the girls invited me to attend, and I accepted without talking to my parents about it. When I was late getting home, the fact that I had gone to the dance didn't sit well with my Quaker parents. After some discussion they decided that, when the fall term came, I would go to school in Newmarket, Ontario, where my father and grandfather had gone to the Quaker school, Pickering College. I was pretty upset about being sent off to Ontario to live in a little town of four thousand people. Also, going to a Quaker school didn't sound very good to me. Luckily, my grandfather didn't think much of the idea either and let me go to the public high school. The boys at the Quaker school were from many different parts of the British Empire; I would have been one of only three "townies"—as the boys who lived at home were called—and townies were rather looked down on. The high school was fine, and I made the adjustment of leaving Detroit without any problems. I seemed to adapt quickly to the small-town life. My grandfather didn't seem to object to dancing and allowed me to go to the bimonthly dances at the Odd Fellows Hall. One of the highlights was the Moon Waltz, during which the lights were turned very low to reveal a great yellow moon at the end of the hall. That was at the beginning of "The Terrible, Terrible Jazz Age," and dancing as close as possible was the vogue.

I took part in sports here also, some of which were quite different from the ones played in Detroit. I played baseball, soccer, and hockey as well as competing in track and field events. I was lucky to be a baseball player; otherwise, I would have played lacrosse, a fierce Indian game that often changed the facial features of the players.

Radio first became available while I was in Newmarket. Because one had to listen with earphones, early radio was a quite solitary amusement. One of my friends had a superior crystal set with six sets of rubber tubes and attached earpieces, allowing as many as six people to listen at one time. One still could not hear very much because of the squealing and squeaking of the static, but with perfect weather conditions it was possible to make some sense of the program. I was at his home the night Jack Dempsey fought Luis Firpo in 1923. The weather was just right, with better reception than usual. As I recall, Firpo knocked Dempsey out of the ring in the first round. After that, Dempsey was his old

self and knocked Firpo down for the count. That was my first big sports thrill over the air. When I was selling papers in Detroit in 1915, it took about three days before we knew the results of the Willard-Johnson fight in Havana.

My grandfather was a worldly man in spite of being a Quaker. He raised trotting horses that were raced at county fairs around Newmarket. He didn't drive the sulkies but often went to see the races, and I went with him. It was a good excuse for me to drive the Studebaker. I never was quite sure what was going on, but I often saw him giving money to a man who looked to me like a bookmaker. I didn't ask him about it but I did notice that whenever his horse lost, he looked as if he had just lost five dollars.

I liked school in Canada. It seemed more serious and I had very good teachers. I was a good student though I did take it easy on the homework. I listened carefully in class and always had a good memory. Another thing I liked was the long summer vacation. Most of the kids were from farm families so the vacations began in early June and lasted until almost October. I always had a job in the summer with the Department of Lands and Forest in the Northern Development branch, working in the forests of northern Ontario, usually as a surveyor's assistant.

In Canada a student nearing graduation has an option. If he wants to go to college, he can take a fifth year in high school and receive credit for his first year in college toward an arts or science degree. It is a hard grind and one must be a reasonably good student. Though I was good at mathematics and was advised to take an engineering course, I had no idea of what I wanted to be. I took my fifth year and wrote my honor matriculation, which consisted of twelve subjects. By some miracle I passed. Just before the year started I discovered that I must have two languages and I had only taken Latin during my high school years. Miss Cole, the French teacher, could also teach German, and she offered to tutor me. My good memory served me well enough to squeak by. In 1924, I began my studies at the School of Practical Science at the University of Toronto, with the intention of becoming a mining engineer. But I found that I was not interested in it. When my grandfather died at age ninety-one in early 1925, I gave up college to return to Detroit. My grandmother had died a month earlier at age eighty-nine.

I liked the idea of living in a big city again, and got a job at the Dime Savings Bank. By 1927 I had become a teller. I knew a number of people downtown and in 1927 or early 1928 I was offered a job in a brokerage office, with a quite prestigious company specializing in writing new issues. The market was very bullish, and everything Keane, Higbie underwrote seemed to go up. Everybody was making money, even I who knew nothing about finances. I made more money than was good for a twenty-three year old. I had a fancy apartment and two cars. I was drinking and smoking too much and if the October crash had not come, I think I was headed for an early demise. The crash wiped me out, including $5,000 more than I had. I hate to admit it, but I was relieved. I sold my cars and other luxury items to pay my debts. The Depression began soon after, and jobs were no longer available.

Remembering some of what I had learned in geology, I decided to go to California to prospect for gold. It was easy to get there from Detroit. Car dealers from California would come to Detroit and buy used cars, then advertise for people to drive them to Los Angeles. The biggest part of your pay was getting to California. At the library I had researched where I might look for gold. The newspaper ran articles on how to cope with the lack of jobs, including several stories on prospecting for gold. Saugus, California, was often mentioned, so that is where I headed after I turned the car over to the dealer. Others must have heard about Saugus, for there were about twenty men scratching out a few flakes of gold for a day's work when I arrived. In desert country, Saugus had been a mining camp in the 1820s, almost thirty years before the discoveries at Sutter's Mill in 1848. The placer gold that was available, very fine gold mixed with sand and gravel, had to be worked with a dry washer due to the lack of water. The dry washer worked on the principle of the threshing machine. In that dry country, getting water for the final washing of the concentrates was the biggest problem. The great conduit that carried water from the Owens Valley to Los Angeles passed near the place we were working, and somehow it had developed a small leak. There was always a line of men with five-gallon cans waiting their turn to get water for drinking, washing, and separating the gold in the final wash.

I was lucky to meet George Neumeyer, a German man in his

sixties who was a great mechanic. He had built one of the best dry washers in the area and needed a young, strong back to shovel the gravel into the machine. My new friend considered himself a visionary. He had come to this country around 1900, first working in Oregon as a mechanic and general handyman. Now he had been prospecting for several years, moving from one place to another in an old Apperson Jack Rabbit, a car that was an antique even in the early 1930s. We built a shelter with boards and sheet metal collected from nearby towns and made ourselves quite comfortable. George was a vegetarian and a health nut, and I realize now that he did know about nutrition. He often woke me up in the middle of the night to say, "Chucky, I just had a vision," and then would tell me some wild tale.

One night he had a vision about where we were digging and saw a spot where we would find a pocket of gold. After earning about fifty cents a day, a pocket sounded pretty good. He insisted we get up and go to our diggings. Nothing happened that night, but a few days later as we worked in that same area, we did find a pocket containing more than two ounces of gold. When we took the gold to the dentist in Saugus, who was our best buyer, we had almost sixty dollars. With our bonanza we bought a gasoline-powered washing machine motor. It did not increase our production very much, but it made a nice noise and seemed to impress our neighboring prospectors.

In another vision George saw a great herd of mules, and he wanted me to help him decipher it. A couple of nights later he woke me to say that he had realized the meaning of the vision: it meant "go to Jackass Hill," the site of a big gold strike in 1849 or 1850. He wanted me to come with him, but I was getting tired of all the advice about what to eat and being wakened in the night to listen to his visions.

About the same time a man came along with several burros, which he was selling for five dollars each. We would see wild burros from time to time, but they were too wary to be caught. This man had been a cowboy though, and they were no problem for him, so I bought one. When George left for Jackass Hill in his Apperson Jack Rabbit, we had an almost tearful parting. I packed my things on the burro and went off to look for better pickings.

I really enjoyed traveling by myself, and soon the burro and I had become good friends. I always made a sourdough pancake for my breakfast, so when I saw Herman—the burro—longingly watch me eat my pancake, I made one for him. He became very attached to me. We took almost three weeks to hike the seventy-five miles from Saugus to Piru Canyon in Santa Barbara County, a mining area said to have water. The Piru River ran through the canyon and it was a very beautiful place.

Five or six miles up the canyon from the town of Piru we came upon a busy-looking mining operation run by five men from Los Angeles who were trying to cope with the Depression. One had been a mining engineer so he was the boss. I camped nearby, and in the evening we traded stories. They could use another hand and hired me for a share of the take. I turned Herman loose, but he refused to leave and became the pet of the camp. A ranger working on new trails for the Forest Service told us we would be allowed to shoot a deer now and then as long as the meat was eaten in camp. One of the men had a .22 high-power rifle and it was decided that part of my job would be to keep the camp supplied with meat. The next day I went out with the rifle, followed by Herman. When I returned with Herman carrying the dressed carcass of a young buck, I got a big welcome. After taking out all of the edible innards, we hung the carcass in a white cotton bag to allow the meat to age without being at the mercy of the flies. The next morning we had a treat with our pancakes, deer liver, and gravy. I remember it being a tasty addition to our rather plain fare. I worked with the miners for about three months. They were just about making expenses and had no profits to share. Even so, we all enjoyed the outdoor life.

I became acquainted with the forest rangers who were building a trail up to Cobblestone Mountain. After they found that I had been a surveyor the district ranger offered me a job surveying the route of the new trail. I was in heaven, having a wonderful time and earning real money for a change—$125 a month with my food and a place to sleep. They were a fine bunch of men, some younger and some older than I. *One of them, Danny Tudor, became a good friend, and we have stayed in contact ever since. His family lived in a big house in Santa Barbara, and Danny often took me home with him.*

I kept this job for a year and a half. Roosevelt was elected president in 1932 and recruiting for the Civilian Conservation Corps began soon after he took office in January 1933. A trainload of kids from New York arrived in Santa Barbara and were sent out into the hills under supervision of the Forest Service to build roads and trails and make land improvements. They were paid board and thirty dollars a month for their work. As a nonregular ranger, I was offered the chance to be a group leader at sixty dollars a month. During my year and a half with the Forest Service I had saved more than a thousand dollars, so instead of going with the CCC camp, I decided to go to Mexico and try prospecting for gold again.

One of the men I had worked with at the mine on Piru River had been talking about trying to find a good digging in the Sierra Madre, so we got together and made a trip by boat from Los Angeles to Mazatlan, Mexico. The timing was very bad. We arrived at the beginning of a mini-revolution in Mexico in which all of the American oil people were expelled. When the oil companies retaliated by putting sand in refinery machinery and otherwise making the plants unusable, the Mexican government and people felt little goodwill toward Americans. As we were restricted to the dock area, I left as soon as I found a boat, *The Celila*, going north with a load of Mexican beer to San Francisco. Prohibition had just been repealed, and there was a demand for good beer in San Francisco.

After stormy weather for almost the entire trip, it was a relief when *The Celila* passed into San Francisco Bay. I was happy to find myself in the big city I had dreamed of seeing, and I still had more than a thousand dollars, which I carried in my boot. I found a room at the Dunloe Hotel on Eddy Street for four dollars a week. At about this time, the Golden Gate Bridge was being planned. Men were coming from all over the country hoping to find jobs. I too tried to get a job on the bridge but didn't seem to have the skills that were needed.

I worked at all kinds of jobs the year I was in San Francisco. I mowed lawns, washed windows, and from time to time hoed beets or some other crop. The pay was by the row, usually fifty cents a row, and when the rows were three hundred yards long you were lucky to earn a dollar fifty a day. By 1934

the Depression seemed to be lifting and I decided to go back to Detroit. I still had some of my Forest Service money left, and I was not about to spend any of it on train fares. In getting around California looking for jobs, I learned about riding the rods on freight trains. Around the railroad yards there were always men traveling, so it was easy to get information about where to catch trains. I met a great variety of men on the freight trains, from all walks of life—men who had been lawyers, doctors, actors, artists, even a couple of stock brokers. By the time I made my journey home, many of the Hoovervilles—the hobo camps on the edges of the big cities—had begun to be abandoned. It took me only about ten days to get back to Detroit and I still had a couple hundred dollars.

While I was away, my family had somewhat dispersed. My father had gone to Europe—I never heard from him again—and my mother had moved to Grand Rapids. I was on my own. I felt lucky to find a job at Chrysler Corporation as a laborer in the parts department at forty-three cents an hour. I was soon made a billing clerk and from then on my progress was rapid. By 1936 I was working for the Chrysler Export Corporation and would soon be training for one of the agencies in South America. In my spare time I was trying to be a writer. I wrote all kinds of things but none seemed to be in demand.

In 1937 I received a letter from my Forest Service friend Danny Tudor. He was in Panama to prospect for gold and wanted me to join him. It didn't take much urging for me to ask my boss for a year's leave of absence to try my luck in Panama. He thought it might be good for me and would improve my command of Spanish. When I left Detroit my boss at Chrysler gave me an Argus camera, and a man from the Chrysler Camera Club made out a list of instructions for me which I tried to follow.

My girl friend at that time, Dorothy Miller, offered to combine her vacation with my departure so we could drive to San Francisco, where I was booked on one of the intercoastal liners plying between San Francisco and New York. It was a great experience—my first real sea voyage. The trip to Panama City, with an overnight stop in Acapulco, Mexico, took nine days. It was a luxury cruise and seemed like an

almost continuous party, with many young people on board and lots to do. I almost hated to arrive in Panama. Danny met me at the landing and I said my fond farewells to my shipboard friends. We stayed at a modest hotel right downtown.

Danny had a car and soon we were taking trips to the interior, looking for a site to prospect. We talked to people with mining interests and finally found an area on the Atlantic side of the isthmus, but it was not accessible by car. We were able to get passage on a small boat trading up the coast as far as the Costa Rica border. There we bought a dugout canoe which gave us mobility to explore a few rivers as we worked our way back to Colon. This was tropical jungle with all the problems that go with such conditions—mosquitoes, snakes, and never an English-speaking person from whom we could ask directions. Although we both knew a smattering of Spanish, we set aside a couple of hours each day for study.

Samples of placer soil from the banks of several rivers did yield a small amount of gold. Of course we were looking for a bonanza where we could set up sluice boxes and make a fortune. At that time, an American could make a mineral claim on twenty acres of land. Eventually we filed claims on six or seven sites we thought might be productive. I saved all my pannings and later found I had almost five ounces of pure gold. At that time gold was fixed at thirty-five dollars an ounce. I made a half-dozen rolls of 35mm film with my new camera depicting some of our adventures. But, after about six weeks and visits to half a dozen villages to restore our food supply, Danny came down with a high fever which we were sure was malaria. Our supply of quinine, the standard medication at that time, seemed to help him, but we decided to make our way back to Colon and on to Panama City where we knew a good American doctor.

That trip down the coast in a dugout was an adventure. We stepped-in a small mast and, using our ground sheet for a sail, made some headway south. We were making good time as night came on, so we decided to sail all night. With a big moon, the night was quite bright. Toward morning we hit heavy seas and our canoe began to take on water. We headed in toward the coastline. As we edged along we saw a narrow

opening between two big rocks giving into a lagoon about one hundred yards in diameter where the water appeared calm. Carefully working our way between the rocks as we entered the lagoon, the water came alive with sharks disturbed by our entry. They began circling and trying to get through the narrow opening to the sea. We made for the shore and safety. Danny shot one of the sharks with his .22 rifle, starting another uproar. In a few minutes the lagoon was empty of sharks and we had the place to ourselves.

We stayed there overnight and continued our journey early the next day. That afternoon the seas began to build up again, at about the time we saw a village on shore. As we neared it, we noticed the heavy surf but decided to try to come in on a breaker. In the strong cross-current our canoe capsized and all our gear was dumped into the sea, including my Argus camera and all of my exposed film. We got ashore and retrieved most of our equipment, but our canoe was so badly damaged in the wreck that we had to abandon it. Just then Danny had another malarial attack. The villagers told us that the weekly trading boat would be stopping in a few hours. When it came we were able to book a passage to Colon.

We arrived in Colon late in the afternoon and took the night train to Panama City. The next day Danny checked into the hospital. After a week of rest and treatment he appeared to be on the road to recovery. We then made a trip in the car to David where we had heard there was a possible site for prospecting. After a month we had to return to Panama City for further treatment for Danny. This time the doctor insisted that it was imperative to get Danny back to the States for treatment. We booked passage on the next intercoastal liner to New York. Once we were started home Danny seemed fine and had a good time aboard ship. A day's stopover in Havana was welcome. As we were coming into New York harbor Danny got the shakes and was really sick. Off the ship, I got him to a quiet spot to rest while I took our things through customs. After that I came back to find my friend gone. I was frantic, but with the help of people in the steamship office we finally located him at the French hospital on 23rd Street. Seeing that he was ill, a taxi driver had taken him there. He stayed in the hospital for a week to get in shape for his train ride home to Santa Barbara. I have never understood why I didn't have malaria too, as we were always in the same place.

When I returned to Detroit I was given a big welcome at the Chrysler Export Corporation. One disappointment was that I had no photographs to show of my trip. I did write an article about it, which my boss thought was a good piece. He told me that everything I wrote was a visual experience and suggested that I accompany the article with pictures. At that point, in 1938, I decided to try photography instead of writing.

I bought a fancy and expensive camera, a Kodak Special with an f/2 lens. It used 828 film—eight negatives on a roll—which was not very practical, but the lens was good and it did make very sharp pictures. I went to meetings of the Chrysler Camera Club where one member looked at my drugstore prints and offered to print three or four of the negatives for me. I entered the prints in the next competition, and although I didn't win any prizes, my prints were well received. At the same time, the club attracted another new member, Harry Callahan, who was at about the same stage I was. It seems that Harry's efforts to paint were as unsatisfactory as mine to write. We became good friends, and have remained so these fifty-plus years. As there was not enough talent or challenge at the Chrysler Camera Club, Harry and I joined the more stimulating Photographic Guild of Detroit. We met Art Siegel who was younger than we but quite advanced in photography. He had a complete set of *Camera Work* and a large collection of books on photography, and was knowledgeable about the history and the early personalities. He was interested in what we were doing and became our mentor. I think it was because of Art that I gave up my experiments with small cameras and bought a 5x7 Deardorff view camera. Harry did me one better by getting an 8x10 Deardorff. My interest in becoming an expert in a foreign country for the Export Corporation began to wane.

In 1941, when Art Siegel got Ansel Adams to come to Detroit to give a ten-day seminar, both Harry and I were ecstatic. Thirty guild members signed up for the course at a fee of thirty dollars each. Ansel had not grown his beard yet so he was still fairly inexpensive. He was wonderful for us. We had become quite unpopular in the guild because we insisted on doing straight photography without any of the pictorial overtones that were in vogue at the time. Ansel reaffirmed what we felt about photography and was equally unpopular

Ansel Adams in Detroit, September 1941.

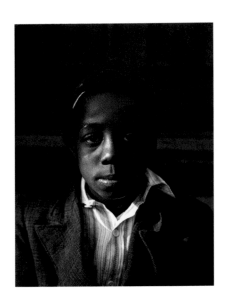

Black boy, Detroit, 1942.

with the guild members who took his workshop. Many dropped out before half the term was finished. Ansel understood this and gave most of his attention to the few who were obviously interested in and moved by his teaching. He stayed up late at night talking, often to just Harry and me. He came to our darkrooms to give us tips on negative developing and print making. He gave us his formulas for A, B, C Pyro developer for negatives and the Amidol paper developer he used in making contact prints from his 8x10 negatives. He showed us how to develop large negatives in a tray by inspection using a Wratten 3 safelight. Before putting the film in the developer, it was soaked in a solution of Pinokryptol Green for two minutes. This would partially desensitize the film so that it could be looked at briefly under a dark green safelight. I used this method for many years, as well as the developers he recommended. I feel his influence to this day. We were, of course, impressed with the great prints he made from his 8x10 negatives. At that time Ansel made only contact prints.

When the workshop was finished we had a party for Ansel attended by only five or six of the original group. He hoped we would stay in contact with him and send him our prints for review. At last Harry and I could get some sleep. We had been staying up after Ansel's evening sessions to discuss everything we had heard. After ten days of staying up until three or four in the morning, we were tired. The enthusiasm generated by Ansel's visit made photography something we had to do, not just wanted to do. We went out photographing every weekend. Often five or six of us, including Art Siegel, went out into the country with all types of cameras, used up our film, and then dashed home to develop our negatives.

Three months after Ansel left, the Japanese attacked Pearl Harbor and life in Detroit began to change. Many of the automobile factories had already begun to build military equipment for the British who were in their third year of battle with Germany. With the Japanese incursion, war was imminent; both real and imagined security problems existed.

One Sunday, five of the photographers affected by Adams's visit were out in the country making pictures of the snow-covered landscape. We were packing up our equipment when two Pontiac police cars came roaring up with sirens

screaming. They allowed us to finish packing before they herded us into the cruisers and drove us to the Pontiac police station. They would not talk to us during the trip. In Pontiac we learned we had been arrested on the complaint of some residents near where we had been working, who said that several men appearing to be Japanese were trying to set fire to haystacks using the lenses of cameras. They had read that this was one of the means the Japanese used to sabotage the war effort. I didn't understand how the police could think we were Japanese since none of us had Asian features. After they finally allowed us to call the lawyer who represented the Photographic Guild, he got us released. That incident, along with others, made us resolve to work closer to home.

The day after Pearl Harbor, I went to the navy recruiting center to volunteer. The recruiting officer looked up from reading his paper and said, "Too old." As I was leaving, three young men came in and the officer just waved at them and said, "Nothing for colored boys today." But by the end of January volunteers were in great demand, and the draft was in full swing. I was too old for an early draft so I went again to volunteer as a photographer. The navy asked for recommendations, so Ansel wrote a letter for me. I wasn't called up until the following November.

During a vacation in July, Harry, his wife Eleanor, and I took a motor trip to Rocky Mountain National Park in Colorado to see if we could make mountain photographs like Ansel. I think that Harry was not as anxious to emulate Ansel as I was. Knowing that gasoline was soon to be rationed, we wanted to travel while we could. We found Rocky Mountain Park spectacular and proceeded to knock ourselves out climbing around with our heavy cameras. After about a week Harry and Eleanor decided they had had enough of mountains and would take the last half of their vacation on a trip to New York. I stayed on, making about two hundred 5x7 negatives of beautiful mountain scenes. I was eager to get home to develop my negatives. After driving almost 1,500 miles, I arrived home about eleven o'clock on a hot July night. Despite my fatigue, I had to develop just a few of my precious negatives. I developed twelve at a time in a tray. It was so hot that the emulsion ran on a couple of them. As soon as I could, I turned on the yellow safelight to get a glimpse of them. A

beautiful snowcapped mountain! Another beautiful snowcapped mountain! Another and another. After looking at twelve BSCMs, I was pretty sick of them. I did another twelve and was another twelve sicker. I hung them up to dry and threw the rest of my undeveloped negatives in the trash barrel. Realizing I was never going to be an Ansel Adams, I was free to do something on my own.

I promised myself I would photograph only in my house or yard for three months. I understood that I must find things that moved me wherever I was and not rely on some spectacular location for photographs. I made pictures of the ceiling of my house using one floodlight. They looked like abstract optical illusions, something I didn't understand. When Art saw them he was quite excited. After a month or so—I would be called soon for my navy service—I took my camera and ventured out into the streets again.

I was still under the influence of Ansel, and my next adventure had to do with exposure when making portraits. Before Ansel had invented the Zone System, he was using the Weston Meter System—basically a simpler version of the Zone System. Ansel had told us to take a reading from the face and increase the exposure by a half-stop when making a portrait. I wondered how to expose to get a good skin tone for a black person—reduce the exposure by a half-stop? A black family living near me would provide good subjects for an experiment. I walked by their house on a Sunday afternoon and saw two of the boys on the porch. We said hello to each other as usual, and they agreed to let me make a picture of them. I promised to bring a print for each of them the following week. The negatives were about the best I had made up to that time. The whole family was delighted the next Sunday when I gave the boys their prints, and I learned a lot about them. There were twenty-five children with the same father and mother, ranging in age from four to thirty-two. Nine of the boys were already in the army. I made pictures of the family and we were all pleased. Ansel was delighted with the set I sent him and told me to take the pictures to show Dorothy Norman, Alfred Stieglitz's assistant at An American Place in New York when I went east to boot camp. When I received my orders I went a week early to have some time in New York, having written to Dorothy Norman and being told when I could find her in.

I quit my job at Chrysler, sold my car, gave away things I thought I would never want again, and left for New York. When I first went to An American Place it was empty. A little old man came out of a back room and asked me what I wanted. I told him I had an appointment to see Dorothy Norman. He said she would be in shortly and I could look at the pictures on the walls. It was a show of paintings by John Marin I had never seen before. The little man walked along behind me. When I had made the rounds he said, "Well, what do you think of them?" I told him I had just come from the Cézanne show at Rosenberg's and that if Marin kept on he would be as good as Cézanne. By then I was pretty sure that the little man was Alfred Stieglitz. "Exactly," he said, obviously pleased with my response. Quite by accident I had gotten off to a good start with Stieglitz. He asked me what was in my package, and I told him I had some photographs to show Dorothy Norman. He asked to take a look while we waited for her, and seemed delighted with them. When Dorothy Norman came in and saw them she said she would like to use one in the next issue of *Twice A Year*, an avant-garde book on the arts she published every year. Stieglitz wanted to keep the prints for a few days. When I came back for them later, he took me into the darkroom where Georgia O'Keeffe was supervising the framing of some of her paintings. She had my photographs lined up on a shelf to look at while she was working. It was a big time for me, one I will always remember with pleasure. Before I left, Stieglitz asked me to be sure to write him from my war zone and tell him what it was like.

The War Years

In October 1942 I had my physical examinations and was ordered to report for boot camp training on November 15. I reported to the Detroit recruiting office and went by train to Rhode Island with a couple of hundred others for preliminary training. I found out that I was enlisted as a seaman first class with a note that I was to be assigned to a photographic unit, and to train with the 84th Seabee Battalion at Camp Davis, Rhode Island. I didn't mind boot camp although it was quite rigorous, and I enjoyed the New England country as it was new to me. There was no photography training during boot camp and I missed that. I was pleased when I finished second in the battalion rifle competition and was assigned to train on the 20mm anti-aircraft weapons. I later learned that was a mistake when my commander in New Guinea told me that I was to go to officer's school in the States to become a gunnery officer. I managed to escape that quandary.

In March 1943 the 84th Battalion was sent to Camp Pendleton in California for three weeks of additional training. In April we were sent to Port Hueneme where we boarded the cargo ship *Christopher Lykes,* a C-3 outfitted to carry troops. Eighteen days later we docked in Brisbane, Australia. We had a week ashore and then set out again on the same ship for Milne Bay on the southeast tip of New Guinea. The 84th Battalion built a huge supply base on the shore of the bay. The photographic supplies were unpacked just before the landing, with Bill McCuddy and me assigned to document the unloading of the ship and building of the camp. Unloaded first were the materials to build a darkroom and photo office so that photographs could be made of all the activities. The Seabees set up an eight-man tent, making half into a darkroom and the other half into office space and quarters for two men. After some exploration a better site for the main camp was found about a half-mile down the beach, but our darkroom and living quarters were left alone, giving Bill and me the luxury of privacy for the eleven months we were there. By the time we arrived at Gamadaudau on Milne Bay, the war had drifted north. The camp and work projects were put on a five-day-a-week schedule, and life was quite normal.

Native people were not allowed to enter the main camp, but because we were a half-mile away, Bill and I had a chance to

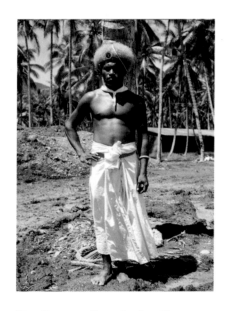

Standing man, Gamadaudau, New Guinea, 1943.

become acquainted with a number of them. I made a phonetical dictionary and learned enough of the language to have some communication, and I photographed many of them when they came to our tent. I still feel a little guilty when I hear veterans telling about their harrowing experiences during the war. At this time I learned that I was to be sent to officer's school in Arizona. I put aside the papers I was given to fill out. The last thing I wanted to be was an officer living four men to a tent. It took some arguing to avoid being sent back to the States, but I succeeded.

In May 1944 the whole unit was sent to Australia for rehabilitation leave. One could put his name in for any one of several rest camps. The camp at Toowoomba in the Blue Mountains appealed to me after our long stay on the beach in New Guinea. It was a great three weeks. The Australians were good to us and many invited us into their homes. I got to know one family who had a sheep station at Charleville, four hundred miles west of Toowoomba in the outback. They invited me to spend a week on the station, which the commanding officer gave me permission to do. That fine experience made me an Aussie fan for life.

Shortly after our rest leave, the battalion was broken up and units were assigned to new battalions just coming out from the States. I was attached to 7th Fleet headquarters in Brisbane and ran the darkroom for a month. Commodore Angus, an ardent amateur photographer, was then personnel officer for the 7th Fleet. Whenever he came to the camp he always stopped at the darkroom to talk. He was appalled when he found that I had no rating and was running the photographic department with the rating of seaman first class. I soon had a photographer's mate rating. When later I was assigned to the 103rd Seebee Battalion in Hollandia, New Guinea, I was put in charge of the lab and continued to have the unheard-of privacy I had become accustomed to.

Hollandia was a huge base where the invasion of the Philippines was spawned. Several hundred thousand troops were there as well as many assault vessels and crews to man them. When the newly formed 113th Battalion landed, a young officer asked me to help him bring ashore a small sailboat that he had brought for his personal use. He was disillusioned about being in the war zone, and when within

two weeks he was sent back home asked me to take care of his sailboat. Hollandia was so huge that I was able to use the boat as transport around to the areas that needed photographing. So, for several months I was a real sailor. The young officer never returned, and I don't know what happened to the sailboat when in October 1944 we sailed on two LST landing craft for the invasion of Leyte. We sat out in Leyte Gulf for almost a week, waiting for the beach to be secured so we could land our supplies. We had front row seats for the first Kamikaze attacks by the Japanese flyers. I was never in danger, but the other LST took a Kamikaze right on the bridge, with eight men killed and several wounded. The ship I was on then sailed to Mindoro Island where the unit was soon at work building an air strip for a navy search group. After a couple of early scares, Mindoro Island turned out to be another blissful place for war duty. Again we were on a five-day-a-week schedule, and I had another opportunity to get to know the native people. I made another phonetical dictionary, this time for Tagalog, the language of the Philippines, and had some facility for communication.

In May 1945 I was given rehabilitation leave to go home with a number-four travel priority and turned loose to find my own way back to the States. I knew quite a few of the flyers at the navy base so I had no trouble getting a ride to Manila, but it took me several days to get a ride from Manila to Guam, the first leg on any air trip home. My number-four priority was useless in Guam as there were a lot of officers trying to get home too. So I returned to Manila, reported to the navy, and was assigned to a camp where one just waited for transportation. I was also assigned to the kitchen and wound up washing pots and pans for a week. I finally left on a luxurious ship that was taking home the civilians from the Japanese prison camp near Manila. All of us, civilians and sailors, sat in the ship's dining room and ate the fine food. I remember how wonderful the ice cream tasted. We landed in San Francisco in late June, and I was soon on my way home by train to Detroit for a month's leave. The Callahans welcomed me to stay with them. They were both working, Harry in the photo lab at General Motors and Eleanor still at Chrysler. My month passed much too quickly; on August 6 I was on the train going back to the camp in Rhode Island to prepare for my return overseas. While on the train to New York, I heard a report that a strange bomb had been dropped

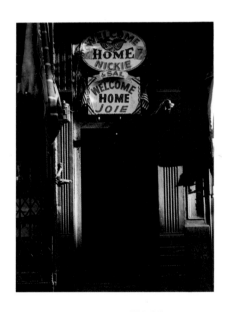

Welcome home series: Third Avenue, New York, 1945.

on Japan, causing tremendous damage and taking many lives.

I stayed in New York a few days and had several good visits with Stieglitz. I had written to him from New Guinea, and his replies had been warm and encouraging. He was delighted to see me. When the second atom bomb was dropped on Japan, it was clear that the war would soon be over. Two weeks after my return to Rhode Island, my orders to return overseas were cancelled and I joined the hundreds of thousands of men waiting to be discharged from the services. Being single and without dependents, I had to wait until November 11, 1945. I was sent from Rhode Island to the naval station in Chicago to receive my honorable discharge and resume my life as a civilian. While I waited, the Callahans had moved to New York into a small apartment on 123rd Street between Broadway and Amsterdam. During several weekend visits, we discussed my staying with them after my discharge. Harry had brought my 5x7 Deardorff with him, along with most of the other belongings I had left in Detroit, so I was soon established.

That was really the beginning of my career as a photographer. I spent considerable time trying to find some 5x7 film. All photographic materials were scarce in those days shortly after the end of the war. Most equipment was not available. Of course, there were no new German or Japanese cameras. In Rhode Island I had found a Plaubel Makina camera, used but in good condition. I paid an outrageous price for it ($325, when a new Rollei, if available, would have cost $125), but after I got my Deardorff back, I sold it for an equally outrageous price. It was a fine camera but not what I wanted at that time. Early in December I was able to buy a few boxes of 5x7 cut film, some of brands I didn't know, and I was ready to begin my postwar civilian career as a photographer in New York.

The Early Years in New York

This half of my life is written with the help of the journal I began in February 1946 and continue to this day. When the holidays were over, I was ready to face the streets of New York with those boxes of 5x7 film. Every day, except when the weather was impossible, I was out photographing with as much pleasure and excitement as I had ever enjoyed. The Callahans and I had arranged our accommodation so that we all had some privacy. I had a rollaway cot that I set up in the kitchen for sleeping. We had a kitty for our kitchen supplies and other household expenses. We made a darkroom in a closet. We may have been a bit crowded but we were all young enough to put up with that.

At first I thought I would stay in New York for three months. This was a happy, productive time for me. The endless walking every day was good for my physical condition. Early in February Harry was offered a teaching job at the Chicago School of Design, working with Moholy-Nagy and Art Siegel. It sounded great to all of us. Realizing that I would inherit the apartment, I rethought things and planned to stay in New York for a year. When the Callahans left and I had no one to talk to, I began to keep my journal.

[journal begins here]

2/19/46: This journal should have been started three months ago when I first came to New York. At that time I had no idea that living and photographing here would be such an exciting experience.

Some of the sessions with Stieglitz have been the highlights of my days. He told me that when the weather was foul I should come to the Place and talk to him. We discussed everything. One day when I went in Weston had just been there with Nancy Newhall. Stieglitz didn't seem enthusiastic about Weston's work, which surprised me. He did say that it demonstrated a high degree of technical excellence but that some feeling was missing. While I was there Dorothy Norman called and Stieglitz had me talk to her. She is buying some of my prints to use in *Twice A Year*. I am gratified that she likes them, but it is not nearly as exciting as it was in 1942 when she used the one photograph of the black boy from Detroit.

I am glad the weather has given me an excuse for some rest from the photographing. I feel that I am a little stale and I know that it is futile to try to push myself. I do it because I am fighting for time but I know that it is a waste of film when the results have a shallowness that is depressing. Stieglitz told me about the clock at his home that gains fifty-eight minutes a day. O'Keeffe and the girl who works for her always forget to reset it and depend completely on him to keep things going. He noted that O'Keeffe, in typical American fashion, always gambles on things coming out right.

I met Helen Levitt when I first came to New York and I see her once in a while. She and her friend Janice Loeb made a movie on the streets a couple of years ago, which she showed me one day. I was very impressed, and I hope she will do more.

I have gotten to know Nancy and Beaumont Newhall quite well. I met Nancy first at An American Place. Beaumont had just been discharged from the army and was getting back to work at the Museum of Modern Art.

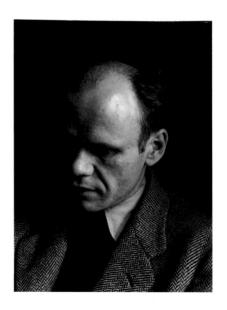

Beaumont Newhall, New York City, 1946.

I should explain my current financial position. While I was overseas I had most of my pay (thirty dollars a month at first, later one hundred) sent home and deposited in my bank in Detroit. By the time I was discharged I had a little more than fifteen hundred dollars. I planned to use most of it to expand my equipment. I wanted an 8x10 view camera and a Speed Graphic so that I could do some commercial work to earn money and continue my New York project. The apartment rent is thirty-eight dollars a month. Once I was settled in New York, I applied to the Fifty-Two-Twenty Club. The government allows veterans to draw twenty dollars every week for fifty-two weeks to help us adjust to civilian life. I've been "accepted." In April 1946 I was offered a one-day-a-week job at the Museum of the City of New York making photographs of their collection for another twenty dollars. I have enough income to pay my rent and feed myself. I live frugally and I am so happy to be out photographing every day that I don't require much outside entertainment. I meet people and squire a few girls, but I am not interested in anything serious. When I was about fifteen years old I had vowed not to marry until I was forty. Then I turned forty but being in such sketchy financial shape I thought I had best postpone matrimony for a few more years.

Most of my social life centers around Stieglitz and the Newhalls. At least twice a week I spend a few hours with Stieglitz. When I first met him he told me that he didn't look at photographs anymore because too many people came to him with portfolios. He was so often saddened by what he saw that he just would not look at any more photographs. Of course I didn't bring any of my work to show him. He always appeared interested in what I was photographing and finally said one day, "Webb, is it not time you let me see some of the work that you are doing?" From then on I've had an audience that I still treasure. It is something for a beginning photographer to have Stieglitz ask to see your work. He really looks at the photographs. Many of the pictures he will pass by without comment, and I have the feeling that he doesn't think much of them. But often he will stop at one photograph and talk about it with interest.

I have met dozens of people at An American Place, including William Carlos Williams, William Saroyan, Mary Callery *who later became a dear friend*, Beauford Delaney, and Richard Wright. One day Gary Cooper came with his wife who wanted to buy an O'Keeffe. Gary had a bad cough and Stieglitz said, "Young man, you are going to have to wait in the hall. I can't risk getting your cold." His wife looked at several O'Keeffes, found one she liked, and bought it for $12,000. Andrew, who worked at the gallery, wrapped the painting, and Mrs. Cooper said her good-bye and went out to join her husband. After she had gone, Stieglitz turned to me and said, "Who was that young man who could afford to let his wife write a check for twelve thousand dollars?" He didn't seem impressed when I told him it was Gary Cooper.

Just before the Callahans left New York, they joined me and Elinor (my current flame) for a terrific lobster dinner at The King of the Sea on Third Avenue. The bill was staggering, $17.76 including the tip, but Jesus, what a meal! That was New York in the 1940s.

Berenice Abbott has also become a friend during these first days in New York. I met her at the Newhalls' and she invited us to her studio on Commerce Street in the Village.

2/24/46: Bad light and snow flurries so no photographs. Went

Photograph of Todd Webb by Ferd Reyher, 1946.

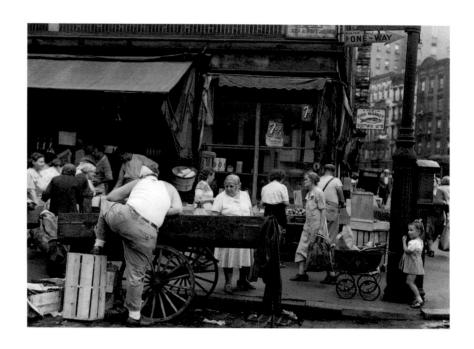

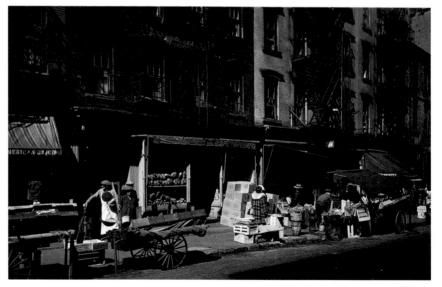

Lower East Side, New York, 1946.

**Suffolk and Hester streets, New York,
1946.**

to see Berenice with the Callahans and she told us about her experiences in Paris in the 1920s. She was a member of a small group similar to Art Siegel's in Detroit. They called themselves *L'Avant Garde*. In Detroit we called ours *Les Morons*. I recognized only Man Ray and André Kertesz, who is now living in New York, from her group. Berenice was generous with her time and treated us to a view of about a dozen Atget prints that were a revelation to us. I had never even heard of Atget, but when Berenice told us about him it seemed to me that I was doing about the same in New York as Atget had done in Paris a half-century earlier.

2/25/46: In spite of the cold and windy weather, I had to go out today. The light was beautiful. I took the subway down to Houston Street, walked east to Mulberry Street, and made a few negatives en route. I had never worked down there and I was excited by a new view of New York. On Mott and Mulberry, north of Chinatown, the streets are teeming with markets, pushcarts parked end to end in front of the endless rows of small stores. Both the stores and the pushcarts sell fruit, vegetables, neckties, fish, clothing, and everything else under the sun. The smells, the noise, and the whole feel of the place are just not describable and I couldn't photograph it. But I want to go back and try.

2/27/46: A rainy day so I went to An American Place and found Stieglitz in a talkative mood. I told him about being down on Mulberry Street, and he compared the feeling I had to what he had felt when he made his steerage photograph. I asked him what he thought of Atget. He was sorry that he didn't know about Atget when he was doing *Camera Work*. Atget was dead before he knew about him, and Stieglitz has a long-standing rule of showing only live artists. So Atget never was shown at An American Place, and Berenice Abbott never forgave Stieglitz for not showing him.

Just before the Callahans went back to Detroit, we had quite a few good times with Berenice and also with Minor White. I think Minor was working with Beaumont at the museum in some capacity. These were exciting days for me as March began with the usual bad weather.

3/1/46: Went to see Berenice with the Callahans and Minor White. Had a super dinner at Sweets on Fulton Street near

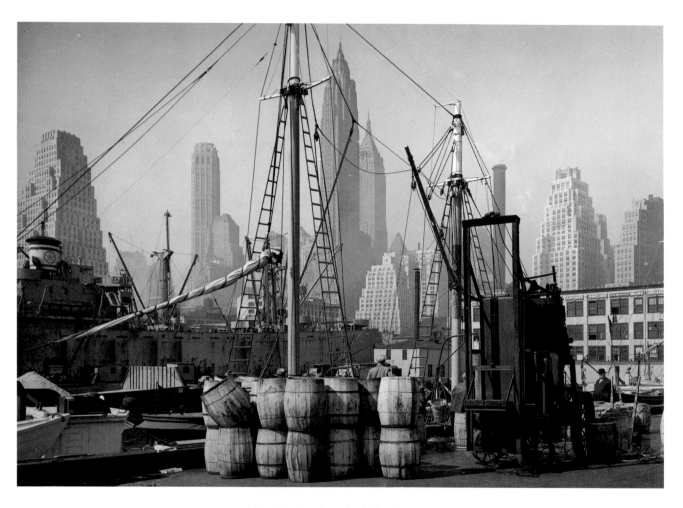

Fulton Fish Market wharf, New York, 1946.

the waterfront and the Fulton Fish Market. Went back to Berenice's house and looked at some more Atgets.

3/2/46: The Callahans are packing and will be leaving tomorrow. We are all a little sad. Harry and I went down to McSorley's Old Ale House on 7th Street in the afternoon. It is a colorful and very old place. Berenice told us about it last night. No women are allowed, but Berenice had been there.

3/4/46: Harry and Eleanor have gone back to Detroit and will soon be on their way to Chicago and some new experiences. We had some super times here, but it really was not right for them. Harry felt he could not photograph in New York and Eleanor was homesick. My being with them in such close quarters probably had something to do with the problems. I will remember the good times.

I photographed the O'Keeffe show at the Place again today and my negatives look fine this time. Both Stieglitz and O'Keeffe are pleased with the four prints I took to them today. The Place has meant so much to me since I came to New York that making photographs of it is a moving experience. The light is so delicate and to hold that feeling in a print is a bitch. Georgia wants an estimate on the price and I have no idea what to charge. I would be happy to do it for nothing, but both Georgia and Stieglitz insist that I should be paid for the job. I went downtown tonight and photographed the fantastic windows at Bonwit Teller. It was the first time I have tried anything like that and probably the last. It was quite easy but I don't care for the results. My bed is out of the kitchen now and the house looks so deserted. In the living room just my bed, my light stand, the little bureau, and the pictures on the wall, Helen Levitt's and mine. They look nice together. Today I bought the darkroom stuff, dishes, pots, and pans. Now I can eat, sleep, develop negatives, and make prints. Maybe next week I will buy a chair and a table.

3/6/46: Have my darkroom quite complete, even to a mounting iron and a trimmer. Made another set of O'Keeffe prints tonight for myself. I took the others to the Place today, and they were pleased. O'Keeffe wants me to photograph some more of her paintings. She talked a long time about her place in New Mexico. She told about the primroses that bloom just as it gets dark. She told it beautifully—I could

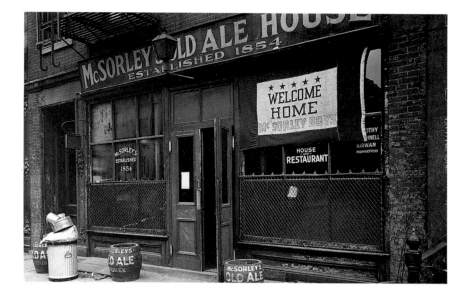

Welcome home McSorley boys, East Seventh Street, New York, February 1946.

almost see the blossoms opening. *U.S. Camera* is using some of my photographs in the annual. I had to go there so they could extract all the info from me that they felt was necessary to make the pictures mean something to their readers. How can I tell them why I have made all those photographs when I don't even know myself? The article will make me blush with shame, but I can use the money.

3/8/46: Photographed downtown. Film is almost impossible to get so I am limiting myself to six pieces when I go out— maybe that is a good thing. I am forced to take more time and care and I think I will have fewer failures due to anxiety and carelessness. I made a negative of McSorley's Welcome Home sign because I had just returned from the war and was touched by it. I was on 8th Street between 2nd and 3rd. It is a Polish district, quite potent, and maybe a little rugged. The poor people seem to live so hard here. The kids play interesting and exciting games in the street, and the people watch out of the windows, applauding and booing as if they were in a stadium. These people have big families and in spite of the poverty seem to get a lot out of life. They have an enthusiasm, in their sports at least, that appears lacking among those in better circumstances. I was talking to a man who told me that on Sunday mornings quite a bit of money is wagered on some of the street games.

3/9/46: I poured three nickels into the telephone while I was talking to Berenice today. She had been to the Weston show and had a lot of uncomplimentary things to say about him.

She even questioned his sex life. Minor White came by last night and we had a good talk. He was trying to explain his system for evaluating photographs. Seems very cold-blooded for my money.

3/10/46: I have discovered the Brooklyn Bridge. I took the subway to Brooklyn and then walked back to Manhattan on the bridge. As usual, I had only six pieces of film with me so I limited myself to a couple of photographs. I went back a few days later with a better supply of film and found a huge sign at the Manhattan end saying anyone caught photographing on the bridge would be prosecuted. So my days of photographing the bridge came to an end.

Brooklyn Bridge, New York, 1946.

3/13/46: Stieglitz told me the story of Arthur Dove today. He is to have a small show at the Place following the O'Keeffe show. He is sixty-five or a little more and suffers from a heart condition. He has no money. Stieglitz says Phillips has kept him alive for years. When Dove was young, he was a successful illustrator for *Collier's Magazine,* a very good periodical in those days. His father was a very wealthy lumberman from Geneva, New York. After a visit to Paris, Dove quit his job at *Collier's.* He wanted to devote himself to creative painting. He asked his father to give him an allowance of one hundred dollars a month so he could buy a small farm, raise chickens, have a cow, and grow enough food to feed his family and use his spare time for painting. His father refused and came to see Stieglitz, who showed him some Cézannes and Picassos. The father said that if his son was going to give up a five-thousand-dollar-a-year job to paint that kind of trash he could get along without him. Dove's mother and younger brother, who frittered away the fortune after the father died, also refused to help. When Dove's wife left him, taking their child, a judge awarded her one hundred dollars a month. Dove and a woman friend lived for years hidden on the Harlem River in a sailboat, Stieglitz said, to escape the police. He fished and traveled about in his boat, once even to Europe—he was a great sailor—and he painted. Because of the damage salt water does to canvas, he painted on zinc plates. He must have been a great guy. Dorothy Norman came in just at this point, and as she does not care for Dove, the story ended there. I hope to hear more sometime.

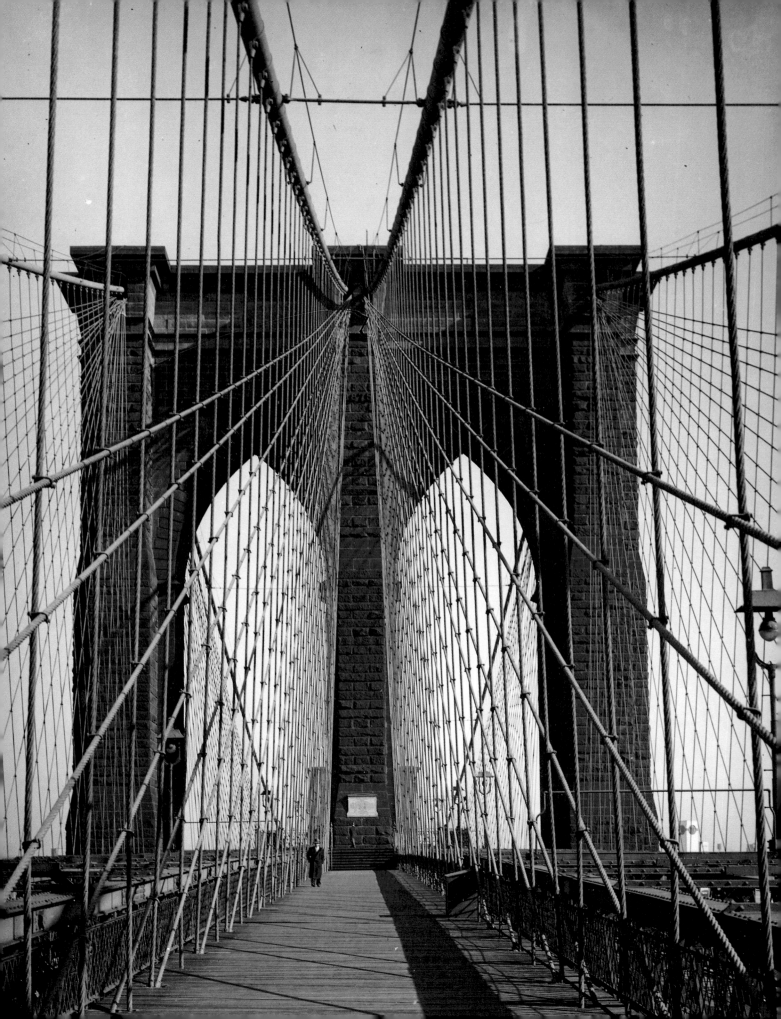

3/14/46: Had lunch with Berenice and Minor at a weird place in Chinatown. The food was good but very strange. Minor told us that Steichen is definitely in at the Museum of Modern Art and that Beaumont has handed in his resignation effective a month after Steichen takes over. I hate to see it happen as I am fond of Nancy and Beau, and I know they have worked very hard to promote photography.

I tried to make a photograph of the Third Avenue El from the Fulton Street station. The platform seems to be constantly shaking from the passage of the trains. It was just luck to get a sharp photograph with a camera on a tripod. It is one of the more obvious I have done with the exception, maybe, of the Brooklyn Bridge.

Alfred Stieglitz, 1946.

The Fulton Street El station, New York, 1946.

3/17/46: I can't tell if the stuff I am doing is any good or not. I will have to let Stieglitz see it. I feel the need to make these, so what the hell, maybe none of the stuff I have done is any good. Once in a while I have some doubts. Is all this sacrifice I am making worthwhile? I have hundreds of new photographs but what does it mean? On the other hand, if I were working on a job I would probably only have a few hundred dollars to show for my time and what the hell would that mean? I would rather have the pictures. The dollars would be spent and forgotten. The photographs will represent the rich and wonderful living I am experiencing for many years. I want to stay in New York and do some photographs in the summer. Then I will be satisfied to get a job and live like a good citizen.

3/19/46: Made a portrait of Stieglitz today. Jeez, was I scared! I didn't even get the camera set up straight and consequently the background is all cockeyed. I had just finished photographing some O'Keeffe paintings and I had one sheet of film left. A month or so ago I had mentioned that I would like to make a photograph of him. Today he suggested that while I had my camera set up I should make the picture. What could I do with one negative? I made the exposure and began to take my camera off the tripod. He said, "Is that all you are going to take?" I said that it was and he said, "Good, I thought it felt pretty good." He showed me a letter from Ansel that had just come in. He said I had something that Ansel didn't have in his photographs. I didn't have the nerve to ask him what but he told me anyway: "Your photographs have tenderness." I am not sure that is good or bad. Waldo Frank

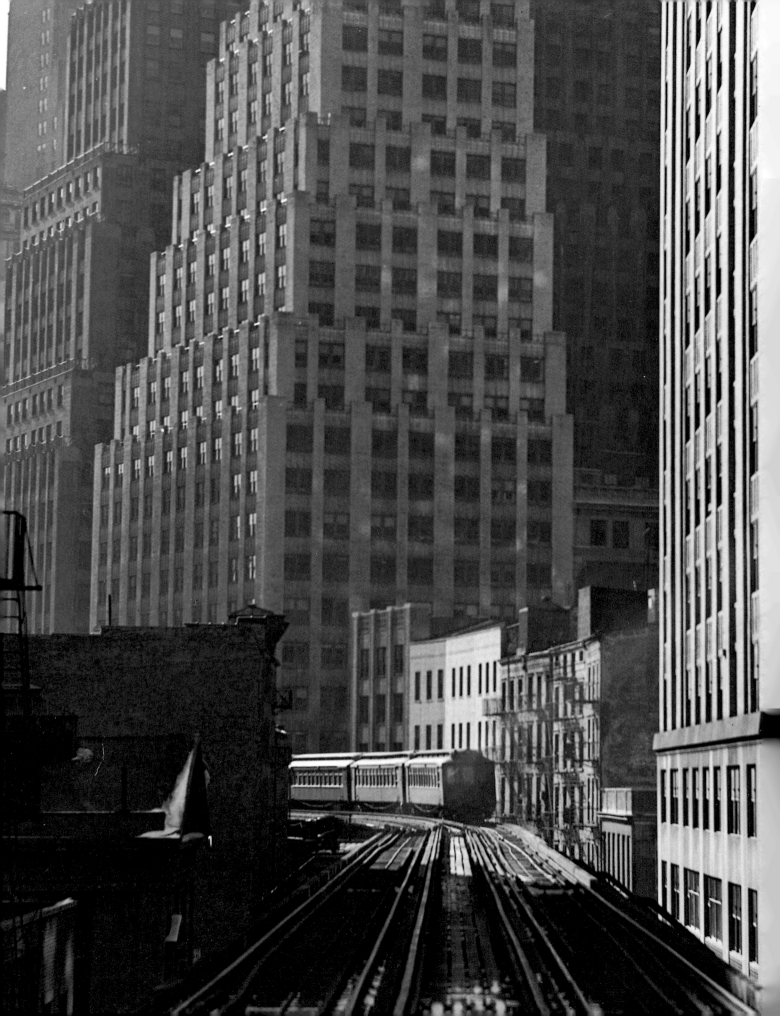

came in just then. His book had just gone to the publisher, and he was feeling very good.

3/20/46: Gave Stieglitz his picture today and he is pleased with it. I didn't tell him about the agony I went through last night when I got ready to develop the negative. He showed me some of his very old photographs. For the first time I felt that I would really like to have one of his photographs for my own.

3/21/46: Meeting of the Thursday Luncheon Club today. Berenice and Minor and I. We went to the Dutchman's on 13th Street between 4th and 5th. Berenice was full of stories about Paris. I wonder if I would like it. I doubt it. After lunch I walked down and photographed on the Lower East Side, a very potent section of the city for me. The buildings are old and they wear the years with an air. The layers of paint on the store fronts give a good feeling to the eye. It is a section with a great lived-in feeling. The people are mostly poor, I think, but somehow they have a dignity that you do not expect to find. Even the kids seem to be proud. It seems to be an area of different ethnic groups. I saw Spanish stores, Greek coffee houses, Italian and Polish shopping centers. You see more American flags displayed down there than anyplace else I know.

3/25/46: Photographed on Third Avenue today for the first time in a while. It was like visiting an old friend. I saw lots of new things but dammit I photographed in the same way I did before. One nice thing happened. While I was looking at a Welcome Home sign under the black cloth, a woman stopped to watch. When I came out from under the cloth she asked me what I was making a picture of. She was very nice and I tried to tell her. I asked her if she would like to see how it looked in the camera. She said she would like to very much, so I put the cloth over her head. At first the upside-down image puzzled her, but when she got the idea she was pleased and said it does look very nice. She is about sixty, I think. She asked where I am from and I said Detroit. She told me she had never been off Manhattan Island, never west of Fifth Avenue for that matter. I asked her if she had ever been to Coney Island or taken the Staten Island Ferry. At that time the fare on the subway was a nickel and so was the fare to the ferry. She had never been to either of them but said she would go and tell me about it the next time she sees me. I hope she

goes. I realized then how much New York is like a series of small towns. I think there are probably more hicks in New York than anyplace else.

3/27/46: Went to see Stieglitz. Not because it was raining but because when I got downtown I found I had forgotten to pack any film in my bag. He showed me a bunch of Marin's drawings, mostly of New York and on the East Side where I have been working. Stieglitz is going to show them at the Place. I went to see Beaumont yesterday, I had to show my pictures to someone. Beaumont said the ones of the Brooklyn Bridge are clichés. I know what he meant, but they weren't for me. I walked along Third Avenue to the Bowery and saw an amazing woman. She was a bleached blonde, loaded with makeup, really pretty awful. A guy, on the bum, insisted I take his picture with her, and when she agreed I set up my camera. I don't get many chances to photograph people with my big 5x7 camera. It turned out that she was Masie, Queen of the Bowery, and the gag was that the bum wanted me to take her picture giving him a dime. She walks along the Bowery every day giving out dimes to the down-and-outers.

3/29/46: I had to go on a film hunt today. It is almost impossible to find any. I finally found a couple of packages of Arrow Pan, which I have never used. Had a good letter from Harry. He is having a hell of a time. He is a misfit like me, only he worries about it. Having a wife makes a difference. When we became obsessed with photography we lost our competitiveness and that is what makes America tick. I am sure that the market for fine photography is limited, whereas there is a great demand for so-called popular photography, and for it to be popular, it must be corny. In America, "box office" is the criterion of what is good or bad. I feel like the man I met on the Brooklyn Bridge the other day. He has worked on it for the past twenty-two years. He speaks of it as a son. He knows its weaknesses and strong points. He told me of its history with great pride. The people he hates above all are those who want the bridge torn down. He called them low-down, conniving, know-nothing politicians.

3/31/46: I made some photographs of Mary Callery's sculpture today. I met her at An American Place a while ago. The pieces are in white plaster and she wants simple backgrounds. I tried them against dark gray, and I think that will work. I enjoyed

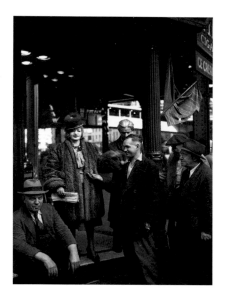

Masie, queen of the Bowery. She gave dimes to the men on the street, 1946.

doing it. While I am working on my New York project, it would be good to have several clients, sculptors and painters who need photographs of their work. That would not upset the seeing for the creative things I want to do on New York.

I see a lot of Helen Levitt, Elinor Schaffle, Berenice, Minor White, and of course the Newhalls and Stieglitz. Stieglitz has begun to invite me to come to dinner with O'Keeffe and him on Friday nights.

4/5/46: In the evening I went with Beaumont to a meeting of the Manhattan Photo League. I thought I would never go to one of those things again. I went because of Beaumont. Also Berenice had recommended it. It seems a little more mature than the old Detroit Photographic Guild. Morris Engel and Aaron Siskind seemed to be the best of the people I met.

4/10/46: Last night Elinor surprised me by coming up to the house breathless. Mary Callery had given her an invitation to the opening of the Chagall show at MOMA. We went, and it was so crowded it was hard to see the paintings. It seemed to be a social event where people came to be seen. Chagall looked nice, surprisingly like some of the people in his paintings. I like the feel of his work. I feel that at one time he might have been a farmer.

I went to see Stieglitz this afternoon. The Marin drawings were up. He has the things I feel about New York down on paper. He has the crowded, chaotic feeling I can't get with my big view camera. I might be able to get it with a hand camera and, if I could, it might be even clearer and more understandable than Marin's paintings. I took some of my March photographs to Stieglitz. He looked at them and some he liked, a lot he passed up in a hurry. He told me that Minor White had shown him some of his photographs, that they lacked the feeling mine had. O'Keeffe was there and she was swell. She told me she was trying some sculpture but that I shouldn't ask to see it for a while. Stieglitz gave me a check for twenty-five dollars for photographing O'Keeffe's paintings. I don't know what to do with it. Try to buy some film, I guess.

4/12/46: The weather is bad and I seem a bit dead photographically, so in the afternoon I went on a sightseeing trip sans camera. I took the 125th Street ferry and then

walked down the Jersey shore to the 42nd Street ferry. Seeing Manhattan from across the river was really something. I couldn't help thinking of "The Fabled City." From midtown north on Riverside Drive, the apartment houses stretch endlessly. They must house a million people. The tugs and big ships in the river give you some understanding of how a big city lives. I want to photograph what I saw yesterday. It has been done a thousand times, but I have a strong feeling for it and if I can get some of that in a couple of photographs they won't have to be corny. Right now it is just as well that I am not on a hot streak because film is almost impossible to find. I went to at least ten camera stores and could find only one box, Ortho film, which I have never used but will be happy to try.

4/17/46: Down to see Stieglitz today. He was in a fine, talkative mood. He told me about Lake George, how it had changed in the seventy-five years he had been going. He told how seventeen years ago he had made a trip from Lake George to New York in a plane. His first and only plane ride. It is still an exciting adventure for him. He described what it looked like flying over the Hudson River and what New York looked like from the air. It was the first year that O'Keeffe had gone to New Mexico and he was desolate. The year before he had had his first heart attack, and he knew it would be dangerous for him to go to a high altitude. He said that when he was flying along he thought what a wonderful way it would be to die if the pilot, not knowing Stieglitz had a bad heart, went up to a very high altitude.

I went over to see Beaumont. He invited me to a party on May 1 to celebrate their release from the museum. He is going to show some of my photographs to the director of the Museum of the City of New York. I printed some of the things I made from the Jersey shore. Not very good.

4/19/46: Beautiful day. Photographed on the Lower East Side. I had a nice feeling for texture and I did some simple things. Had a letter from Keith Wright offering me my old job at Chrysler. I would have to be back there by the end of the month, which would be almost impossible. I had a hell of a time making up my mind. To turn down that security and stay in something as indefinite as my present situation was difficult. If I went back to Detroit to work for Chrysler again,

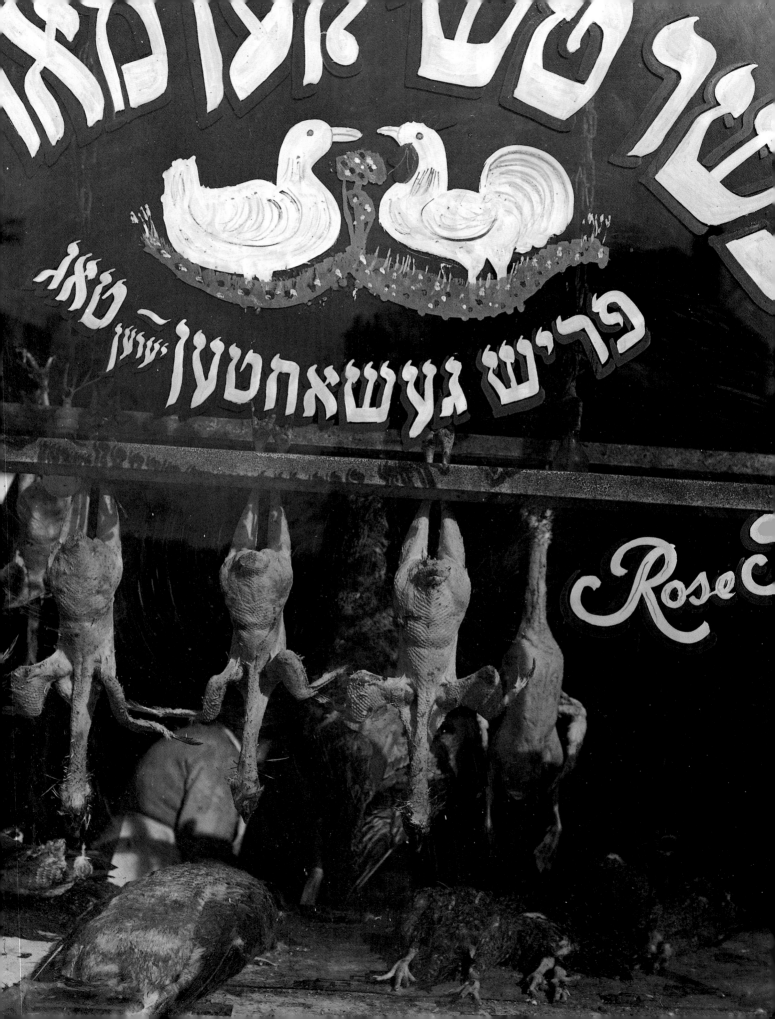

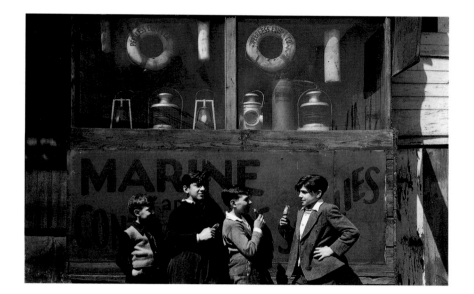

The four boys near Fulton Fish Market,
New York, 1946.

Hester Street, New York, 1946.

I felt I would be stuck there for good. I would never have the
guts to quit. I had made up my mind when I was overseas
that I did not want to go back to the motor industry. I didn't
like their whole premise—to build the economy on waste.
They change the models every year just to make last year's
car obsolescent.

4/20/46: I enjoyed photographing today, but I had the
misfortune to use some out-of-date film, and the negs are
almost too flat to print. Dealers are really bastards. When the
film goes out of date they should discard it. But they sell it at
a 25 percent discount to suckers like me who buy it because it
is the only film available. I applied to the VA for a veteran's
priority to buy film. I hope to get it. The Ortho film I used the
other day worked fine after I learned how to use it. It is
sensitive only to blue light. One of the photographs I made
yesterday had a fine quality that I think comes with Ortho
film. I was setting up my camera to do a storefront on South
Street near the Fulton Market when four young East Side
kids asked me to take their picture. They were nice and I
thought they might fit in well with what I was doing. I asked
them to stand in front of the store window. They stood in a
row and I asked them to just stand as though they were
talking. The boy who seemed to be the leader said with an
East Side accent, "Oh, you mean nonchalant. Okay, guys, get
nonchalant." It sounded funnier than it reads.

4/22/46: I have been going through hell the past few days. I
received a telegram from someone in Grand Rapids, who

signed herself Olive Branch, saying that my mother is critically ill and they want my approval for an operation. My finances are at such a low level that I feel helpless, but I called and gave my approval. *I had been separated from my family since before the war. My father disappeared during the Depression when I was in California, and my mother had a nervous breakdown. She gave up being a Quaker to become a born-again Christian, joining some kind of sect. She had some money which she gave to the group. They had what is now called a nursing home in Grand Rapids, and were taking care of her. The operation turned out to be something quite minor, and my mother lived for another twenty years.*

4/23/46: While I was in the midst of my crisis, Minor White came by. He is a level-headed guy, and I needed someone to talk to. I didn't mention my present problem, but he did give me assurance that what I was doing in New York was worthwhile. We talked about Stieglitz—he is crazy about him too. I feel a lot better. I guess I'll stick it out in New York.

4/24/46: Dull day. Had a fine chat with Stieglitz. He had some photographic magazines dating back to 1896. They were much better than the rags of today. O'Keeffe getting her show ready for MOMA is driving him nuts. And Andrew too. I never knew Andrew's last name. He was one of the only people Stieglitz called by his first name; he did all the framing, packing, and general errands around the gallery. He was pretty happy about Minor turning Steichen down for the curator's assistant job at the museum. I give Minor a lot of credit for turning down that $4,000-a-year job just because he didn't believe in it. Went to Maria's opening last night and then to the party at Mary Callery's house. Maria Martinez was a Brazilian sculptor, the wife of a diplomat. She had a third name that I don't remember, but she was known as Martinez. She made mostly jewelry in gold but it was called sculpture. What a bunch of odd people. I felt out of place speaking English with no accent. Later I had dinner with John Spring, who runs the foundry that casts for all of the sculptors, including Maria. He is down to earth.

4/25/46: The trees in New York have been beautiful the last few days. My pictures are printed and mounted, and I am tired. *U.S. Camera* is out with a spread of my pictures made on Third Avenue. The reproductions are poor. They should

look at the 1896 magazine that Stieglitz showed me
yesterday, the writing and pictures are superior.

4/29/46: Had a letter from Mr. Scholle, the director of the
Museum of the City of New York. He wants to see me about
having a one-man show of my New York photographs.
Beaumont Newhall is the person I have to thank for that
contact. I feel much indebted to the Newhalls. I spoke to Ann
Armstrong who works for Beaumont at the museum; she is
nice as ever and is happy about my having a show.

4/30/46: Saw Mr. Scholle at the museum about the show. Also
met Miss Mayer who is in charge of the print department.
They were both very enthusiastic about the work I have done.
Miss Mayer showed me the gallery where the show will hang.
Have I enough work and is it ripe for showing? They talked
about one hundred prints, but that seems a lot to me. Went to
see Stieglitz to ask what he thought of it, but I hardly had a
chance to talk to him. Georgia grabbed me as I came in the
door and put me to work helping her get her paintings ready
for the show at MOMA. Nancy was there too. It was fun until
she picked up one of the paintings wrong and Georgia blew
up. O'Keeffe is a pretty good slave driver, and you had better
be careful how you handle her work. She invited me to go
home and have supper with them, but both she and Stieglitz
were so tired that I begged off. Jerome Mellquist came in and
helped wrap the last two paintings. Georgia asked if I would
make photographs of her show after it is up at the museum.

I want to make the pictures of her paintings, but she wants them on 8x10 film and I don't have an 8x10 camera. Stieglitz suggested I use his old camera. He has recently given his old lens to Ansel, but I think I can have my twelve-inch Dagor mounted to a lens board that will fit his old camera. So, I am able to tell O'Keeffe I will make the photographs of her show.

5/2/46: An exciting day. Mary Callery wanted some photographs of her work to take to Paris with her on Friday. I tried a few of the things and made prints. She was pleased and gave me a check for thirty-three dollars. I am to do a couple more and mail them to Paris. She is excited about her trip. Went to Nancy and Beaumont's party last night. Quite an affair with 1929 champagne. Lots of people there: Willard and Barbara Morgan, Lisette Model and her husband, Charles Sheeler and Mosha, Berenice, Helen Levitt, Dorothy Norman (O'Keeffe was at the door but when she saw Dorothy she turned around, got on the elevator, and went home), Minor, Paul Strand, André Kertesz, and a number of other people.

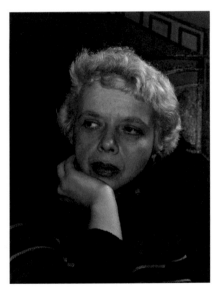

Lisette Model, New York, 1946.

5/6/46: Seems that I am in a seeing slump. I was out all day and made only one negative. I have had more of a social life than usual and it may be distracting me. Mr. Scholle wrote to ask if I would do some photography for the museum—copies of paintings and different exhibits. I am going to try but I am not certain that my equipment will suffice. Went to see Stieglitz. He was feeling miserable—had two teeth extracted yesterday. He was talkative though, and after giving me the bloody details of his extractions, he told me the story of a man who wanted a Marin but didn't have the money to buy a big one. Stieglitz showed him a very small one with a price tag of four hundred dollars, but the man wanted a big one. He left but came back the next morning and said he would take the small one. Stieglitz insisted he take the picture home and live with it for a few days. Weeks went by. Stieglitz, who didn't even know the man's name, wondered if he had died or the painting had been lost in the mail. This morning he received a check for four hundred dollars from the man and a letter saying that he would not trade the little painting for anything.

5/9/46: I am in a hell of a slump now photographically. I am not seeing well, and I can't even get a good negative. It is

depressing but I believe it is something we have to put up with once in a while. I feel that the show has something to do with it. I am human enough that it has sort of impressed me with my own importance. I have started seeing myself as Webb (Stieglitz always calls me Webb), the great documentarian. I start looking for things that fall into that category and I am lost. When I think about it I know I have not done anything very startling. The opportunity to have the show is a stroke of luck. Because I don't feel that I have done enough, I asked Stieglitz about it. He said to go ahead, my photographs will make a nice show; nothing sensational, but all right.

5/11/46: My journal is not at all what I want it to be. It has deteriorated into a personal gripe sheet. When I am out walking I hear so many things I would like to remember, little snatches of conversation. Like two ultra-refined ladies I noticed walking toward me on Park Avenue. They seemed to be having a high-level cultural conversation. Just as they were passing, the more elegant-looking woman said, "When I get home I am sure going to bend his ass."

Georgia sent me an invitation to her opening this Tuesday and that made me happy.

5/15/46: The opening of the O'Keeffe show was quite an exciting event, doubly so for me because I met John Marin. It was crowded, so he and Stieglitz were sitting on a stairway. Stieglitz introduced me with quite a fanfare. I wish I could have made a photograph of them sitting there. Georgia was really queenly last night, I thought quite beautiful. And she was nice to everybody. She wants me to call her in a couple of days to make arrangements to photograph the show. It looks hard.

Elinor's father, who is a doctor in Virginia, took us to dinner at Davey Jones's and then to see *The Glass Menagerie,* which was a treat.

5/18/46: I went to the ball game at Ebbetts Field yesterday and what a game—eleven errors! The Dodgers beat the Pirates 16 to 6. It looked like a high school game.

5/20/46: I am having a hell of a time getting started. It is probably my own fault, but I like to think there are

extenuating circumstances. The 8x10 camera I ordered from Eddie Wurst in Detroit last August hasn't been delivered, and I need it badly to do the O'Keeffe show at the museum. The Speed Graphic I ordered and paid for last December also has not come. The last straw is the film situation. There is nothing to be had but junk.

Marcella Moss and Katy Richardson, old Chrysler friends, looked me up while they were in town. It was fun hearing about the people back in Detroit. From what I heard I am glad I did not go back there to work.

5/21/46: Went to see Stieglitz about using his old Century 8x10 camera to do the O'Keeffe show. The camera is in good shape, even though it has not been used for ten years. I have to get a lens board and have my lens mounted. Poor Stieglitz had to have another tooth extracted. He was pretty good about it, more cheerful than usual as a matter of fact. He told me a story about a girl who was a stenographer next door to 291. She was about eighteen and, from his description, ravishing. He asked her one day how she managed to avoid being raped. He knew that she went out a lot with young fellows around town. She said she had a system that worked very well: she wore three pairs of pants. When one of the fellows got real frantic he would get one of the pairs off but would then give up. Once in a while, a very zesty one would get the second pair off; but the third pair always stopped them.

Went over to the museum to see Beaumont. Ann Armstrong was sitting in for him. She is a stunning girl, and I thought of asking her how she manages. Then I realized I am not Stieglitz. She has a good education, speaks French, German, Italian, and Spanish. She took a three-year premed course at McGill in Montreal and then three years of art history at Harvard. We went down and looked at the O'Keeffes. She is as crazy about them as I am.

5/23/46: I am going to use Stieglitz's camera to do the O'Keeffes; it was a lot of trouble, getting a lens board, having it bored, and fitting my lens. Tomorrow I am going to try it out on the Doves hanging at An American Place. On Monday I will take a crack at the O'Keeffes. Of course the only film I could get was some out-of-date Panatonic X. A wonderful alibi in case I muff the job.

5/27/46: Tried the camera on the Doves. It worked fine and the photographs are excellent. I hope to give Dove some prints. So yesterday I tried doing the O'Keeffes at the museum. The negatives look good. I stopped in to see Stieglitz when I had finished. He wants to photograph. He said that if there were any envy in him he would envy me. He talked at length about Paul Strand. I understand better now why I've always thought Strand's photographs show a strong Stieglitz influence.

Had a letter from my brother Joe today. He was married May 13 to a nurse he met in England a couple of years ago. He is flying back to Germany today.

5/28/46: Finished the O'Keeffe paintings and I am happy about the job. I made sixteen negatives, have sixteen prints, none of which I would call bad. I took the Doves to Stieglitz when I went to get his camera, and he was delighted with them. He said that Adams had made a hundred photographs of the Place, but mine had something Adams had not been able to get. He gave me the "What Is 291" issue of *Camera Work*. He talked a lot about the old days. About the Photo Secession, when the trains ran on Fourth Avenue—which is now Park Avenue—about the horse cars that ran on Madison Avenue, and about his father's house on Madison near 59th Street. A fine house with steam heat, hot and cold water, and even ice water. He talked of his life in Berlin, the wonderful freedom. He was there seven years and had to make only one social call. I feel very close to him when we sit in his office talking about anything and everything. He has no "isms," no politics, no formula for living.

5/29/46: Delivered the prints for O'Keeffe today. Stieglitz is delighted with them and now, if O'Keeffe likes them, I will feel even better. Took my photographs to the Museum of the City of New York today. My show is not until September but there is a lot to be done. The prints all have to be framed, I have to think of a name for the show, and posters have to be made. Grace Mayer is going to do the framing.

6/1/46: At last I have all the prints made for O'Keeffe. What a relief. I hate to do a production job like that. I had to make six sets, one for her, one for Stieglitz, two for Jim Sweeney, and a couple for friends of hers in New Mexico. All the time I have been working on this job the weather has been foul so I really didn't lose any time for my personal work.

I am looking forward to a party Nancy is having Tuesday for Cartier-Bresson.

6/4/46: Today Stieglitz told me about his father. He was the real master of the household. If he said black was white it was white and there was no argument about it. He told me about burning the diary he had kept in detail from the time he was nine until he was twenty-nine. His mother advised him to do it as he had a jealous wife and it could cause trouble. I hope I don't get a jealous wife and have to burn what I am writing now.

6/6/46: Had a good time at the party for Cartier-Bresson last night. I, along with several others, had a little too much to drink. It was the usual punch but I think it may have been beefed up a bit. I knew many of the people there—Dorothy Norman, André Kertesz, Morris Engel, Helen Levitt, Minor White, Ann Armstrong, Willard Morgan and his wife, Barbara. Henri's wife is a Javanese girl and very attractive. She told me she is not impressed with New York. Minor is going out to San Francisco, so I won't have the use of his enlarger, which I am going to miss.

6/13/46: Went to the museum and helped Grace frame some of the prints. Picked up the case of 4x5 film that I got with the help of my Veterans Administration priority. I found out that at last my Speed Graphic has arrived. Beaumont is coming to the museum tomorrow to help us sort out some of the prints for the show. Had a letter from O'Keeffe. She wants another set of prints for someone in New Mexico. Saw Stieglitz coatless and tieless. He was full of the devil, said he had some stories to tell me, some of them about Thomas Hart Benton.

6/18/46: Beaumont was a big help when he came to give Miss Mayer a hand with picking out the prints for the show. I was over there this morning to make a couple of negatives. I picked up my Speed Graphic and now I am eager to go to work with it.

6/24/46: Life has been pretty full lately, so full there is hardly time for living it. I haven't even had time to write. Having my Speed Graphic and learning to use it the way I want to is a challenge. I will feel that a new door has opened for me when I can use it properly. I will be able to say things I have been

seeing and feeling for some time. It is exciting despite another seemingly insurmountable problem: Where the hell am I going to get an enlarger? And what with—even if I can find one? The things I am doing are practically from the hip, and anyway the viewfinders are not very accurate. With an enlarger, I can correct some of the things by cropping.

Another fine letter from O'Keeffe. I made another photograph for her at the museum. She sent me a check for the balance of her bill and included a very complimentary quote from a letter she had gotten from Jim Sweeney. Had some good talks with Stieglitz. I am going to miss him when he goes to Lake George. Yesterday I went to Coney Island with Helen Levitt and Elinor. The beautiful people there were wonderful. The feeling was so strong that at times tears actually came to my eyes. I don't know why. People were trying so hard to have a good time that it hurt. I hope to be able to photograph out there. There is so much, it is impossible to see any one thing. I was paralyzed yesterday, but I am sure that if I go a few times by myself I will be able to get some of the feeling down. The paper said there were more than a million people there yesterday. How wonderful! I find that such a crowd seems impossible, even in America. I tried to make some photographs but my Graphic is so new to me that I muffed most of them. I saw well, though, and I know I can lick the technical things. Elinor went home today. I am glad and sorry. I know I will miss her, but right now I want the time to work with no interruptions, no matter how pleasant.

6/25/46: I wandered around on the Lower East Side with my Graphic today. It is hard for me to use. I see wonderful things, but on the prints they don't look so wonderful. I take them all with enlargements in mind, and when I see the contact prints, I am disappointed.

It is real summer, and as long as I can dress for the weather I don't mind. I bought a Reis Model A tripod today. It broke my heart to stick out $70.85 for it, but I wouldn't have been satisfied with anything else. (I know that both Weston and Ansel use one.) Now, when I get my 8x10, I'll have a proper tripod for it. Made five new negatives at the museum, also had a bunch of prints to make. I have had two twenty-five-dollar weeks in a row there. My bill for June was $47.90, which will take care of my rent and light bill. I am going to

the Newhalls for dinner tomorrow. Beaumont is writing an article about the show for *Art News*. I am anxious to hear from Harry how he likes his new job in Chicago.

6/28/46: Had a good evening with the Newhalls. Beaumont cooked a good supper, and we sat around and drank wine and soda and swapped stories until late. Ferd Rehyer, a writer who is nuts about New York, came over. He is just starting a book on Atget which could be an important contribution. Nancy is a great admirer of Stieglitz. She has collected a wealth of material about him, which she hopes to use for a biography sometime. I know that Nancy has some troubles with O'Keeffe, but maybe she can get around that. It was really a good evening. Everyone was completely himself and I felt very much at home. Beau played a record that Ansel had made when he was here. Good piano playing, not that I am a judge. Met Harold Clurman there. He is the man who produced William Saroyan's play in New York, *My Heart Is in the Highlands*. He also wrote a chapter in *America and Alfred Stieglitz*.

A card from Ann Armstrong says that Steichen wants to see some of my photographs. I will be going downtown Tuesday, so I can see Steichen then. Found a place where I can do my enlarging at a buck an hour, which will be a big help for the museum work and also for my Speed Graphic negatives.

Ferd wants me to call him Monday so that we can have dinner and he can show me around the Chelsea Hotel on 23rd Street where he lives. I look forward to seeing him again.

6/30/46: The last day of June. I didn't dream that I would still be here. It has been an exciting month although I don't think my production of photographs is up to par. Too many things to do. Trying to make a little money, getting my show ready, breaking in my Speed Graphic, and getting used to the hot weather. Some of the things I've done are good, so I can't kick. Harry got started in his new job and that makes me happy. July promises more excitement. I should get my 8x10, and now with a darkroom to use I should begin to do better with my Speed Graphic. My bank account is pretty well down so I shall have to limit my expenditures. I can do that. Went to Coney Island again and there were more people there than last week but I didn't seem to mind the crowd so much. I don't feel my photographs were successful. I will keep trying.

7/2/46: With all my money tied up in photographic equipment and with only a small amount of film on hand, the rumors about the coming film shortage are scaring me to death. I hear that, due to a lack of silver, the companies are going to close up the film departments.

Went to see Walter Lewiston today. An odd guy to say the least. It was hard to make head or tail of what he wanted to see me about. He has unlimited financial security and for the last sixteen years has been traveling around the world making 16mm movies. He is making a film of New York—in a non-Hollywood way, he says—with a cast. He is getting sound for his Bolex and will need a cameraman. I can't figure out if it is for fun or what. Went to see Nancy and Beau. They are going to his farm to spend the night. They are curious about him too.

7/5/46: Had a quiet Fourth of July and I am rested. Went down to see Stieglitz and I took Ferd. Stieglitz was feeling good, so he showed us a lot of his photographs, many of which I had never seen. He really is the best; my stuff looked like cheese. I told him I thought I might well throw my camera away. Selma and I went to lunch and left Ferd there with Stieglitz.

The next day I called Beaumont; Ferd was there and they wanted to talk so I met them at the Mayan while they had lunch and I had a drink. Beau recounted their experience with Walter Lewiston. Beau said he was very interested in me and I would soon get an invitation to spend a weekend at his country place. Life now is pretty rich. It seems the broker I get the more exciting things are. There is a limit, of course. I have a feeling something will turn up; it always has. Tomorrow I want to photograph on the Lower East Side with my Graphic.

7/7/46: Walked miles yesterday. Couldn't see much. The light was dull, and I kept seeing things that needed bright light. I invited Selma for dinner and impressed her with my cooking. Everything came out well and at the right time. I am always surprised when that happens. Stayed with Selma and we had a sunbath on the roof. Then we went to Coney Island and she was quite moved by the spectacle. There is so much there that just picking out something to photograph is a terrific job. To get the spirit of the place down is hard but something that I

want to do. It is a wonderful part of New York—a million people taking their hair down, hicks for a day. It's like all the county fairs in the country in one place. And every Sunday. The wonderful expressions. People arriving on the crowded trains, raring to go. People ready to go home—hot, sticky, just plain tired, bored, disappointed, sunburned, stomachs tortured by too many hot dogs, corn on the cob, frozen desserts. I think I will never come here again. How am I going to get that stuff down?

7/8/46: Mondays are always tough. When I was working in an office it was tough because it followed a weekend. Why is it tough now? I make enlargements on Monday, feeling like I am fighting the clock. At a dollar an hour the prints for the museum are killing me. I should allow plenty of time to assure good prints, but at fifty cents a print I feel I have to hurry. The last couple of weeks there were so many prints I could not give each one the time it needed. Also, by the time I have prints for the museum I am too tired to do a good job on my own pictures.

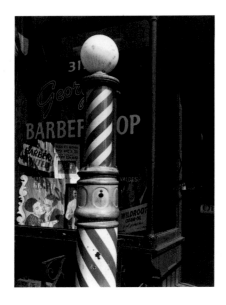

Amsterdam Avenue near 125th Street, New York, 1946.

7/9/46: Went to see Stieglitz and was shocked to hear that he is in the hospital with a heart attack suffered Saturday. That was the day after I took Ferd to see him. He is improving, and Andrew says he will be O.K. in a few days. Went to see the Newhalls with some new photographs for the show. Ferd was there and he is eager to do a book on 125th Street with my photographs. Beaumont cooked a very good Italian dish with cheese and tomato sauce on toast. Later we all went to look over 125th Street.

7/10/46: At last I have my case of 5x7 film, so I am well stocked for a while. And knowing there will be a shortage, I will try to make every sheet count.

I feel guilty for having let Stieglitz show us so many prints last Friday. I could see he was weary.

7/12/46: Yesterday was a shocker. In the afternoon I called Mary Callery to see how Stieglitz was. Mary was breathless. She said she was just going to the airport to pick up Georgia. Stieglitz had had a stroke yesterday and was in critical condition at Doctors Hospital. I know that he is old and cannot go on forever, but it is still a bad shock to know that he

is so ill. He probably cannot recover from such a setback as this. And the questions he has asked so many times—what will happen to the Marins, the O'Keeffes, his own photographs, and the Place?—I have been able to think of nothing else since I talked to Mary. She has been very kind to me and said that I can call her any time to hear how things are going at the hospital. The Newhalls are very upset. I feel helpless; there is nothing I can do.

7/13/46: A sad day. Stieglitz died early this morning and even though I knew it could not be long, it is a shock. I will miss him terribly. He was wonderful to me these last few months. It is good that he could be himself right to the end. Just a week ago he showed us some of his prints. Even though he was tired, he was Stieglitz at his best. I photographed hard today. I could think of nothing but Stieglitz. I feel better photographing. The funeral will be private. No fuss, just as he would have wanted it, I am sure.

7/16/46: Haven't been able to write. I did get some of my best photographs yet while I was so upset about the loss of Stieglitz.

7/21/46: The days have been exciting for me. I will start doing some of my work at MOMA this week. I have become well acquainted with Ferd Rehyer through the Newhalls. I am photographing as well as or better than I ever have. I am full of things to do, and I have no spare time on my hands. It seems like a very good life. My equipment is about as complete as I could wish. I am broke but what the hell, you can't have everything.

7/24/46: Had a very nice evening at the Newhalls'. Helen and Ferd came for supper. Dorothy Norman and Paul Strand came over for a while. Paul told me that I should go back to Detroit as there are too many photographers in New York. Dorothy buttered me up by buying three of my New York photographs for thirty dollars. She also wants me to make photographs of the Place: the nail holes, the blank white walls. I can't do it as I don't have any feeling for it. I remember Stieglitz there and that is great for me. The stinking mess between Georgia and Dorothy about the Place, whose fault it is I don't know. I don't want to take sides. It was An American Place that I loved. I even smoked while I

was there, something I would never have done if Stieglitz was there. As far as I am concerned, Stieglitz was the Place.

Found a telegram from *Fortune Magazine* waiting when I got home. One of their researchers saw my pictures being framed at the Museum of the City of New York. They would like to talk to me. So this morning I took some photographs to their office in the Empire State Building. They looked at the photos and asked where I have been hiding. Debbie Calkins, the coordinator for the art department, talked to me. She said they would like me to make photographs for a story being written by George Hunt on the Manhattan traffic mess. I talked with Hunt, and we liked each other. I was terrified when they asked me what my fee would be as I have never had a job like that. Mrs. Calkins saw that I was at a loss to answer so she said they were thinking of fifty dollars a day or by space used, whichever is greater. I almost collapsed.

7/26/46: Worked for *Fortune* today and I am tired. I made a lot of photos; the negatives look good. How will they like them? I'm beginning to get the spirit of the project, so maybe Monday will be even better. I will try to talk with George Hunt when I take the prints in.

Dorothy Norman and Jerome Mellquist are being difficult. I have made up my mind that I am not going to make any more photographs for them. Dorothy has gone back to Wood's Hole and that is good. I have a lot of my own work to do. *I never did make photographs of An American Place. In a Christmas card I received from Dorothy in 1988, she asked if I had the prints she had wanted forty-two years earlier.*

7/28/46: Made enlargements yesterday of some of the things I've done for *Fortune*. They look good to me, but of course I'm not really sure what *Fortune* expects. It was such a beautiful day that I would have liked to be out photographing but I don't want to overdo it. I will have to take it easy on my personal stuff until I complete this job.

8/4/46: Such a hectic week I've had no time to write. I was really tired from making fifty bucks a day. It does put a certain amount of pressure on me. It seems to me that I have done very little so far to earn my money. To get the feel of the pressure of the traffic without having the sounds of the truck

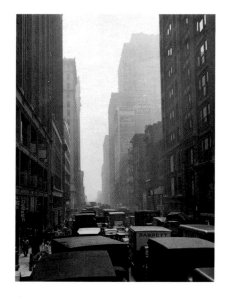

33rd Street between Fifth and Sixth avenues, New York, for *Fortune* magazine, July 1946.

Sixth Avenue, New York, for *Fortune* magazine, July 1946.

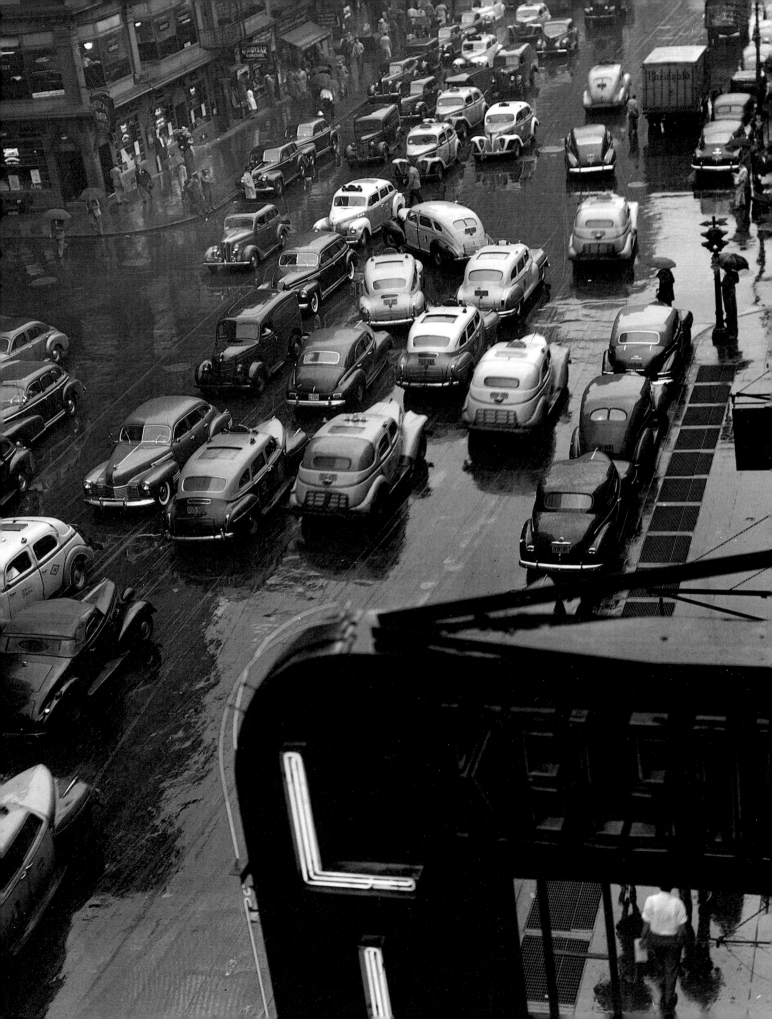

engines and the horns is difficult. Traffic jams seem terrific when you are caught in one. I am usually above the scene, looking out a window of a building or on the top of a truck which George has been able to arrange for me. I have yet to find a real traffic jam I could photograph. I hope to be in the right place at the right time soon. Have seen Nancy, Beau, and also Ferd several times, and they are happy about my good fortune (my new job).

8/5/46: Had dinner with Ferd last night at the Amsterdam Hotel on Fourth Avenue. It is an old drover's hotel where Ferd used to go when it was booming in the 1920s. The dinner was fine in the 1905 atmosphere. He told me a very good thing I must remember about forgetting the story angles and sticking to photographing my way. I needed the warning. I could get myself screwed up. I am just a simple guy who would rather photograph than eat. If I get so much joy out of that, why worry about stories? That's for editors and writers. Life goes on about me, and I'm a living, breathing part of it. I feel things—the people, the buildings, the streets—and I have something to say about them. My medium is photography. Thanks, Ferd old boy, for making it clear to me.

Rode with a truck driver today through the garment district. It was exciting. The driver let me get up on the roof of the cab and I got some wonderful traffic jams on those crosstown streets. George Hunt is enthusiastic about the photographs I've been making.

8/12/46: Have almost finished the *Fortune* assignment. I have to make the prints in the morning and that will be it. They are nice people to work with—Betty Dick, Deborah Calkins, and Gloria Hoppe—sensitive and understanding, something I did not expect to find at a big magazine.

I went up to the Place and O'Keeffe was there. I have great respect for her. She talked about Stieglitz a great deal. She told me about the shelves of pills and medicines he had at home. She threw them all out along with his clothes. I think she was wise. His photographs will remain to speak for him. She said she was glad I had had the time with him that I did. I am too, as it was the high spot of my time in New York. She asked if I would walk home with her. I did and she invited me for supper, but I had an appointment at *Fortune* so she asked me for tomorrow.

8/19/46: *Fortune* is using the photographs, so I guess they are satisfied. I am going to invest in a set of Harrison Color Correction Filters. It's a lot of money to spend but I am going to do a little color work and would like to do it right. I doubt that I will ever want to do it for myself, but there is a big demand for color and it pays very well. Maybe by concentrating on color for earning a living I could keep my first love, black-and-white photography, for my personal work. I have to decide between furniture and equipment, and as I have gotten along without chairs so far, I guess a little longer will not do any harm.

Got a wire from Harry to call Art Siegel about teaching at the school of design. I called but Art was not there. I don't think I want to go out there anyway. Bill McCuddy is coming to New York on September 2, and we are going to drive through New England for a few days.

8/21/46: This is the first day I've been completely free of *Fortune* and it is a relief, much as I like the people there. Photographed this morning but the light was bad. Went to see O'Keeffe, who was busy cataloging Stieglitz's possessions. So many paintings were left with him to look at that it is difficult to tell to whom they belong. She has recommended me to some gallery as a photographer and warned them that I am expensive. I saw Marins, Doves, and Demuths that I had never seen. That was exciting. Georgia warned me about collecting things. She said that three shirts, one pair of shoes, one necktie, and two suits are all that anyone should own. All the time she was telling me this she was sitting in the middle of about a thousand paintings, all of which she now owns.

8/30/46: It is a long time since I've done any writing. It has been hard ever since Stieglitz died. I've been having an interesting time and have been photographing well, which is always a great spirit improver.

Had a fine dinner at O'Keeffe's house Monday. Henwar was there—I like him and hope to see him again. (Henwar Rodakeiwicz (?) was a documentary filmmaker who worked with Willard Van Dyke when they made films on New York City, Edward Weston, Georgia O'Keeffe, and others. At one time he lived in Taos.) The Newhalls are back after a couple

New York, 1946.

Lower Manhattan financial district, 1946.

of weeks at Black Mountain College. I am glad to see them, and I think the two Siamese cats I cared for are also glad . I was there for dinner last night with Charles Sheeler and his wife, Mosha. She is fascinating—the accent, the gestures, and expressions. She was a famous ballet dancer in Moscow and apparently had some experiences she would like Nancy to write about. Cartier-Bresson was there also.

I have ninety-six prints framed for the show, but I keep finding better ones, and the number continues to grow. My invitation list is complete and the publicity prints are ready.

9/15/46: I am annoyed at not having written for two weeks. So much has been happening. Bill McCuddy came and stayed five days. The show, now grown to 165 prints, is ready to hang. In the morning Beaumont is coming to hang the pictures. He has had a big mural made of the *Summer Street Car* I did on 125th Street. I did a stinking job for *Mademoiselle* magazine—four pictures of night spots. The girl I worked with, Gerri Trotta, was nice and sympathized with me, knowing I don't know how to do this sort of thing. I got sixty dollars for the job. A check came from *Fortune* —they paid me by space used—for $1,375! I worked fifteen days and expected $750, so I was happily surprised. Went to Paterson, New Jersey, Sunday to photograph. A good change of scenery. Rows of single houses instead of rows of apartment houses. Nancy and Beau came up to develop their negatives made at Black Mountain College. I can hardly believe I am forty-one years old today. That is practically middle age.

10/15/46: So much has been going on, many unforgettable experiences and I have made no record of them. My journal seemed to die with Stieglitz. Last night, talking to Ferd, I realized the importance of keeping it up. I will try to catch up roughly with what has been happening. My show opened September 24 and it poured rain. Even so, about two hundred people came, including Ferd with his daughter, Faith. Dorothy Miller also came from Detroit. One print has been sold to date, to Dave McAlpin.

I have been photographing freely and have had some periods of staleness. To beat that I created a project to make photographs of numbers. Any place at all, on houses, streetcars, any place as long as I can isolate the number to be

the only recognizable symbol in the print. Ferd encouraged me to do it and I have no idea where it will go. I have a feeling that it is just a gimmick. It seems the ultimate in abstraction, and I had never even heard of abstraction until I came to New York.

I have applied for a Guggenheim and gave Steichen, Beaumont, and Ferd as references. I really don't feel I am ready for it yet, and I don't believe I'll get it.
Went to the Newhalls' for dinner and looked at Wright Morris's book *The Inhabitants*. I like the photographs, but I don't see the connection between the text and the pictures.

10/17/46: Made some more of my number photographs. I wonder about them. After my show I had a bad block and just could not see anything. I had technical difficulties and things did not look promising. Ferd and I got talking about the numbers. He seems to get more kick out of the results than I do. I'm leaving the prints with him, and when we have collected a good set we will show them to some people.

10/20/46: It is like fall—cool and cloudy all day. Went to see the Alberses on 70th Street to photograph some of Annie's textiles. I met Josef and Annie Albers at the Newhalls' on Friday night. The Newhalls had spent a couple of weeks with the Alberses at Black Mountain College. Mrs. Albers's textiles are quite beautiful but, I think, hard to photograph. The weaving and blending of the colors is so subtle I am not sure I can do it since I don't know much about photographing in color. Went to Ferd's this afternoon and Berthold Brecht and Peter Lorre were there for a while. They are working with Charles Laughton on a production of Brecht's *Galileo* for the Experimental Theatre. I didn't get a chance to talk to Brecht. Peter and Ferd did most of the talking. Peter is a very sharp guy. He has two terrific worries: autograph fans who at times literally tear those guys to pieces, and ways and means to keep his income tax as low as possible. Brecht seemed a nice, quiet man, very plain to look at but gentle and alert. He and Ferd had been to my show, and he was quite interested in it. Later we called Berenice and went to dinner with her at The Barrow. Lisette Model and her husband Evsa came along and we had a good time. Having just returned from San Francisco, Lisette was full of the city. I look forward to seeing her photography. I made four negatives with my 8x10 camera.

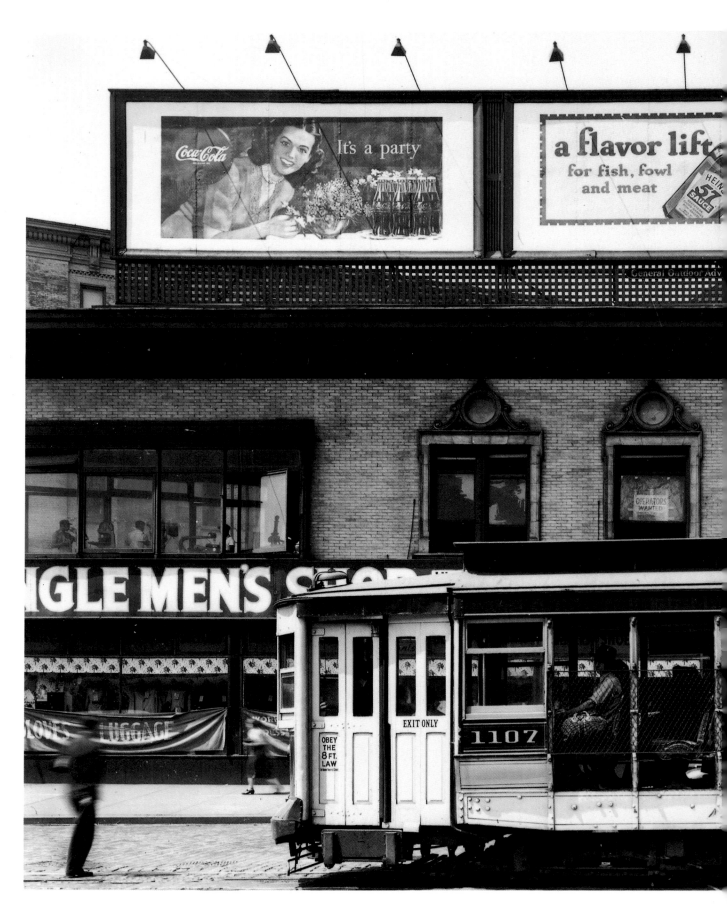

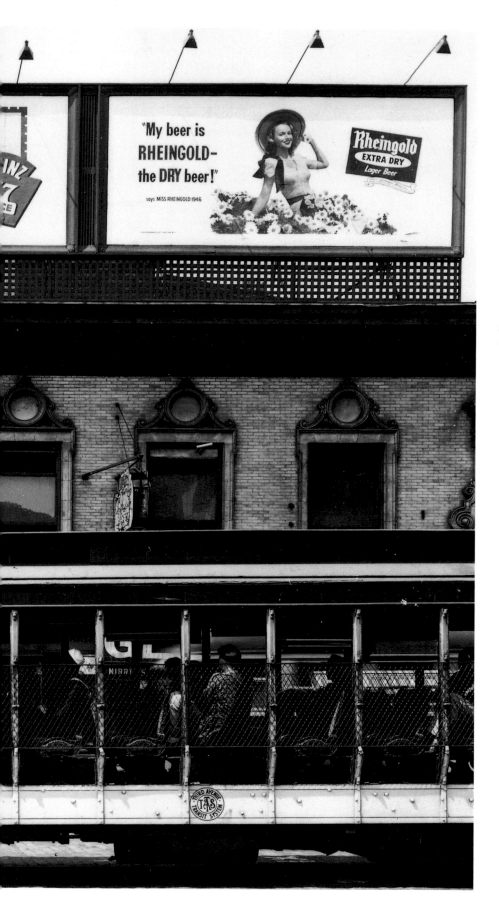

Summer street car, 125th at Broadway, 1946.

Berthold Brecht in New Jersey, 1946.

Tscachbasov in his studio at the
Chelsea Hotel, New York, 1946.

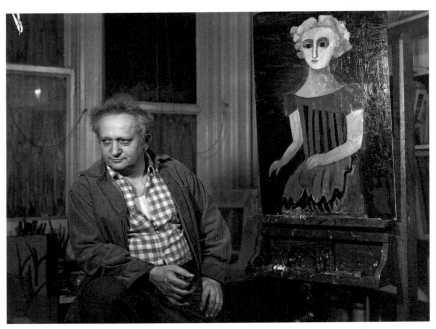

Hard to see in that format at first. I worked down by the Fulton Fish Market.

10/25/46: Things are exciting again. Not much money but plenty of fun. I worked with Peter Elgar on the state department film with the Eyemo: churches in Harlem, a crowd on Wall Street, and a couple of pigeons making love on Watt's head in the graveyard at Trinity Church. Not too exciting; the fifty bucks I am supposed to get is the most exciting part. I am afraid the film will smell of old corn. Later we went to Tchacbashov's studio in the Chelsea Hotel. I made a couple of negatives of Chuck and one of him with Esther. I developed my negatives when I got home so I would have full holders for today. Ferd, Brecht, and Ruth Berlau stopped by. Brecht had Charles Laughton's car and they came to pick me up for a picnic in New Jersey. Ferd wanted to show them a house that we had seen when Bill McCuddy was here in September. We call it an old mill. Actually it isn't a mill but just a handsome old stone house built in 1701. Ferd dreams of buying it and living there. Brecht is quite a guy. He is nuts about work clothes and wears them all the time. He always wants to stop and look in the windows of stores that display them. I made an 8x10 of Brecht and Ferd together and one of Brecht by himself. And Ferd made one of me. We all sat on the same tree trunk. I will be glad when the negatives are dry enough to print. Tomorrow promises to be a hectic day. First, I must go and make some enlargements. Then if I can make it by 11:30 I will shoot a couple of traffic sequences for Peter. *Fortune* sent me an order for some prints.

Berthold Brecht and Ferdinand Reyher, New Jersey, 1946.

10/27/46: Just got back from a wonderful weekend with the Tchacbashovs at their summer place in Woodstock. I went to eat with Ferd and take him the photographs of Brecht. He has been trying to reach me all day to tell me about the trip. He is happy about the pictures, and I must say I am too. The country was at its very best this weekend. The leaves have turned and the whole countryside is a riot of color. We went into Kingston on Saturday, where I was able to photograph. The Hudson River towns are steeped in early American history and, while they are still colorful places, they have the deep functional feeling of real people living in real houses, not just museums, restored buildings, and historical landmarks. Ferd shares this feeling, which is important to me. He is a very sensitive guy and one of the few people I can talk to with

absolute freedom. He has done a great deal for me, and I, in my small way, have helped give him a better understanding of the thought processes and problems of a working photographer, particularly one using a large view camera like the man in the book he is writing.

My negatives of Kingston look good. I haven't develped the one I made of Sam. I am interested to see it. Will the photograph be as grotesque as he seems to be? Have an offer with the war department making movies in Alaska for $2,644.80 a year plus 25 percent for service out of the country. Not much dough but Alaska has always been a dream of mine. I will have to investigate the cost of living, etc. I heard from Peter Elgar that the film I made for the state department is perfect.

Storefront church, Harlem, 1946.

10/29/46: Talked to the Newhalls and Ferd about going to Alaska. I wrote to the war department for information which would help me make my decision. Went to a Russian movie with Ferd and Brecht and it was a stinker. Brecht is very pleased with the picture I made of him. We went to the Newhalls and talked a lot about Stieglitz. Nancy is doing a book for Oxford Press. Dorothy Norman has written a lot about Stieglitz, and she always treats him like a god. I feel that she makes Stieglitz seem like some kind of guru. I don't feel that way about him. I am hoping that Nancy will depict him as a warm and wise man with some frailties and imperfections. She is thinking of printing two hundred photographs, and I think that is a mistake when there is going to be a preponderance of text. I said I thought she could present the work with sixty photographs, and Ferd agreed with me. When I arrived home there was a telegram from Betty Dick regarding a possible assignment for *Fortune*.

10/30/46: I am off to Buffalo on the first leg of a *Fortune* story on the housing mess. A development in Buffalo is bogged down by various shortages and I am supposed to show the worst side of it. The problem is that the work is being done by a number of small contractors who do not have the political clout to get the needed but short supplies. The contrast will be in a Long Island development, which is being handled by a powerful and rich contractor who can get all the supplies he wants.

1ST SPIRITUAL·PSYCHIC·SCIENCE
CHURCH

1
CANDLE
SERVICE
SUNDAY

313

Berenice Abbott, New York, 1946.

11/2/46: Happy to get back to New York after my two days in Buffalo. The weather was depressing with rain or the threat of rain all the time. The man from whom I had to get my information is a champion of free enterprise, which he interprets as "get all you can while the getting is good." My assignment was to show the delays in building homes for veterans.

I had a difficult time with magazine jobs. The idea of working from a script, trying to illustrate editorial opinions that had already been formed, was something I was not ready to cope with. I think I may have been antibusiness at that time. I was still feeling a little holy about photography, and hated to mix it up with business.

When I got home there was a special delivery letter from the war department saying that, if I accept the job in Alaska (only it turns out to be Canada), I will have to report for duty on November 6, which is impossible. I lay awake most of the night trying to decide, and this morning I wrote and said I could not make it by November 6.

11/3/46: An odd, quiet Sunday. I printed my Buffalo stuff this morning. It is kind of meaningless to me. The negatives are good, the prints are good. Everything looked so dreary. What is more depressing than rows of houses in various stages of construction, and in bad weather?

Went to lunch with Ferd and Berenice at the Royal Cafe on Second Avenue. We talked mostly about Atget. Then we went back to Berenice's where I made a portrait of her and one of Ferd. She has a lot of lights, but I just used one. I was still thinking about the war department job. If I go I would like to take my 8x10, but I guess I would settle for the 5x7 or the Graphic. I would like to take my typewriter, and I will take along a pound of Amidol, some Pyro, and Pinakryptol Green, as I am sure there will be some periods when I can make some photographs for myself.

11/5/46: Haven't heard anything from the war department, so I guess they have given up on me. It seemed like a last great adventure. But, if I progress here as I did last year, I will have my share of adventure.

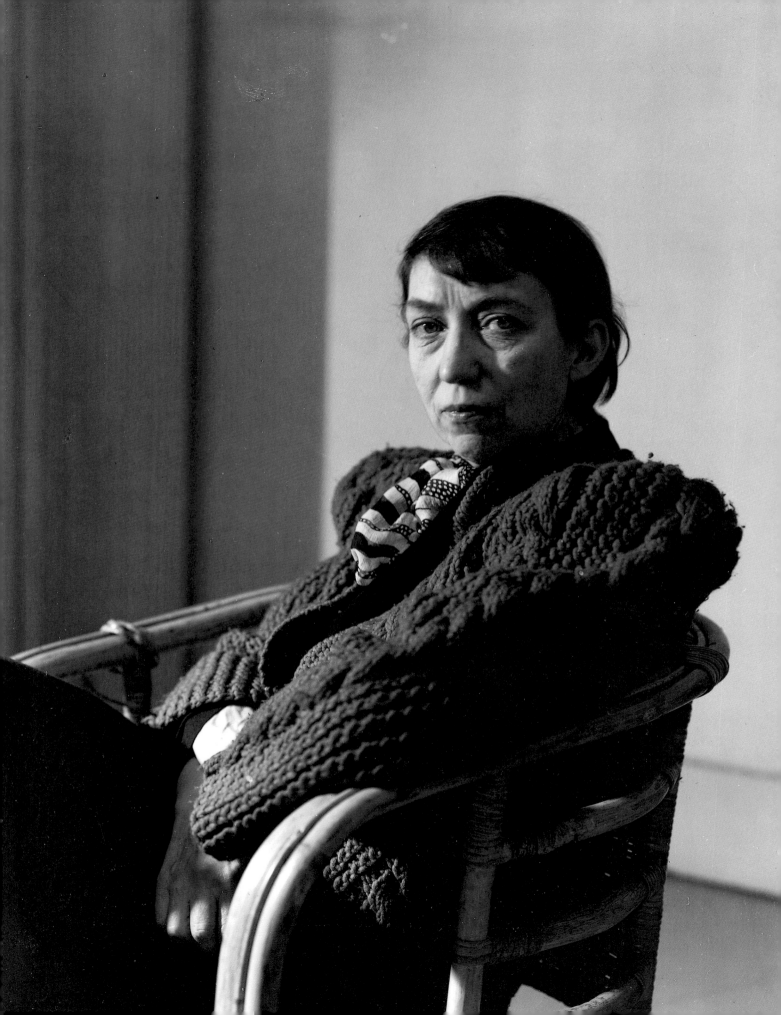

I took my Buffalo pictures to *Fortune* with very complete captions. I think the pictures are meaningless, but they are delighted with them. I went to Long Island to complete the project. A really big operator, Bill Leavitt, is putting up a thousand houses a year out there. It is a real feat of organization, the mass production of decent-looking houses at reasonable prices. He is a nice guy, steady, boss worshiping, not very deep thinking, staunch Republican, ex-G.I. officer type, rear echelon. He showed me around the development. I made a few photographs to show that the houses are actually being completed and occupied.

11/6/46: Had another letter from the war department and they want me to report to Canada on Monday. I will tell them I am not going. Saw Ferd after making four 8x10 negatives down on Seventh Avenue. We had a good talk about trying to make fine prints. In the anxiety to make super prints one can almost exclude the real creative aspect of a photograph, which is the seeing and feeling. Ferd compared it to becoming obsessed with style in writing. My negatives look great.

11/9/46: Dick Ekstrand, one of my South Pacific buddies, and his wife Grace are here for a few days. I hadn't seem him since Hollandia, New Guinea, in 1944. We went to Miyako where they enjoyed themselves. Strangely, we ran into Nancy and Beaumont who were entertaining one of *his* wartime buddies. We then got a bottle of wine and all went to the Newhalls' for some good talk.

11/10/46: Went to Paterson today with Dee Knapp, Eleanor Callahan's sister, and we both made some photographs. I had a weird experience in the darkroom. I mixed my developer with my usual careful carelessness and everything seemed in order. I desensitized my negatives and after five minutes looked at them under the safelight and there was not a trace of an image. Thought maybe I was trying to develop in plain water, so I mixed some A,B,C, Pyro and still there was nothing. I dumped the Pyro and used some Amidol that had been used once. The development was very quick but the negatives look fine.

Received a wire from an engineer at the war department named Shanahan. I called him and he tried to talk me into going. They are going to Churchill, a thousand miles north of

Winnipeg. Sounded like a bad deal to me so I told him I could not make it.

Ferd has become quite a fan of mine. He is a persuasive guy and has a lot of people wondering about me—even the Newhalls and Berenice. Then, when I develop negatives for five minutes and find them blank, I come back to earth. I have another five years before I get to where Ferd thinks I am now. I printed the Paterson negatives and, Amidol or no, the negatives are fine.

11/11/46: The anniversary of my discharge from the navy. A year ago right now, I was on a train en route from Chicago to start this adventure. What a year! I feel there has been a great development in me. I can feel it meeting people. I have a confidence I lacked before. The scope of my seeing and feeling has enlarged, and I believe I can photograph anyplace now. The day called for some celebration, but in true Webb fashion I had forty cents after the weekend. I went to the bank and found it was a bank holiday. A nickel downtown, a nickel back, a nickel to call Ferd, and a package of cigarettes and now I am down to a penny. Luckily, I have plenty of food in the house. But gad, how many things I wanted!—a soda, and the hot dogs smelled good when I passed a stand downtown. Tonight I feel like a bottle of wine. After going to the bank this morning I went downtown to see Faith about some work I am going to do for her firm. I went to the Place and talked to Andrew. He misses Stieglitz as much as anyone. I have some prints to make tonight and then I will get to bed early. Last night my negatives were dry enough to print at 11:30. It was 2:30 by the time I got to bed.

11/12/46: Went to the museum first thing this morning to photograph the stuff for Faith. A man was there representing some advertising agency and he picked out a batch of photographs that he wanted me to give him for nothing. It was some kind of a racket and I bowed out.

11/13/46: Alice [Holtman] and I had dinner at Frank's Chop House last night. Not an exciting evening. Nights at home alone are very necessary. I have been involved with trying to make a few bucks and that and social life don't seem to go together. Tomorrow I go out with the 8x10 and that will cool me off for any social activity. Lugging that heavy contraption around all day will make an evening at home quite attractive.

11/14/46: The 8x10 was fun today. It has taken me a little time to see in that format. Today was the best yet. I seemed to set my camera up in the right place. I made only three negatives, but I did a lot of looking. I don't mind the economy, but I do need a lot of practice with the big camera. I have holders for only six negatives, and the film is so scarce and expensive that half a dozen photographs are enough for an outing. I did find a package of XF Pan that I think may be good. Had a wire from *Coronet;* they would like to see some of my photographs, but I found out they pay only twelve dollars for a print. I said I would bring some for them to see.

11/16/46: I made some photographs from Jackie Judge's windows in the Empire State Building and while I was there I made a portrait of Jackie with the 8x10. I wanted to experiment with natural light and ordinary surroundings. Technically the negatives I made of Jackie are good but I am not happy about the way I used the background and the way I had her pose. The city negative I made is beautiful, but I am having a time getting a good print. Maybe I should mount the negative.

I met a guy last night at Dal Holcomb's who had been in Brisbane, Australia, during the war. We got into quite a discussion about where we had made our pub calls. It is surprising how much I have forgotten about my stay there. The last streetcars run on 42nd Street tomorrow so I will go downtown with my Graphic to make some pictures. Since coming to New York I have become a great streetcar fan. Ferd and I are going to the Strunskys' on 8th Street tonight to Ira Gershwin's birthday party.

11/17/46: Not often do I welcome a rainy Sunday but this is an exception. The party at Lew and Emily Paley's house was the kind you hate to have break up. Everybody seemed to feel the same and it was five o'clock before I got home. It was a warming experience for me. The party was loaded with talent, real people who have accomplished things and been recognized: Sam Jaffe, Oscar Levant, Fred Saidy, Yip Harburg, Zero Mostel, Charlie Jackson, and of course the guest of honor, Ira Gershwin. Yip Harburg played all the songs from *Finian's Rainbow* which is just going into production. Fred Saidy and Charlie Jackson are producing

the show. Oscar played the piano and told a number of wry jokes. Zero Mostel did one of his hilarious routines. Ferd seems to know them all and he saw to it that I was included in many of the conversations. He told them I was an up-and-coming photographer and had been making portraits of people on Third Avenue. Abe Berman, a cartoonist for the *New Yorker,* was interested and said he would see that there was a story about it in his magazine if I got going on the idea. Ira was listening and said I could put him down for the first portrait but thought I had better come to his hotel for the sitting. All the people there appeared to be great New York fans and I found something to talk about with most of them. No one seemed to have too much to drink and nobody seemed to need the stimulation. Mosha Strunsky, Emily's mother, is a gracious and beautiful lady. It was a party I will never forget.

11/18/46: I made a portrait of Ira Gershwin today. He wouldn't let me do it on the street. He was at the Madison Hotel at 58th and Madison. The light fell off badly and the exposures were difficult but passable. Ira wanted a picture smoking a cigar and I did it that way. I think they are not very good. Actually they are not bad when printed, but I am disappointed. Ira said he likes them and gave me a check for one hundred dollars.

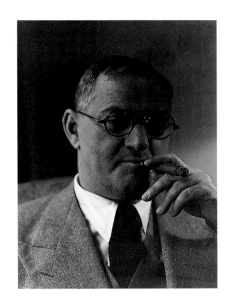

Ira Gershwin with a cigar, New York, 1946.

11/21/46: Photographed on the Lower East Side yesterday on Hester and Suffolk streets. It was a pleasure to use my Graphic again. Saw many of my old pushcart friends who gave me a big welcome. I started my second year in New York by making three 8x10 negatives at the museum. A year ago it would have been hard to visualize my present position. I expected that by this time I would have been squeezed into some routine job slot. Having a show and so many good friends and being able to live by my wits wasn't dreamed of at that time. I have made more than five hundred photographs in the year. Many of them stinkers, but enough good ones to surprise me.

11/24/46: Went to Coney Island with Dee and Ann Armstrong. The light was beautiful and there was a crowd in spite of the crisp weather. The girls are both good workers and Dee much the best. I didn't mind having them along and they didn't bother me a bit. I think I can help them a lot. I seem to

impart some of my enthusiasm, an ingredient that I think is a must for a budding photographer. Coney Island was not as I remembered it. In this uncrowded season it looks clean and neat. I found a few things that excited me. I made a portrait of Ann.

11/25/46: Dull day. I have my prints from yesterday all mounted. There are three pretty good ones beside the one of Ann. I found a package of sports-type 4x5 film at Gillette's on Park Avenue. I shot three pieces of it to try it out. It is very fast but I won't be able to tell how good it is until I enlarge it.

11/27/46: Wonderful light today. I was out with my Graphic on the Lower East Side. It was nice enough for people to be sitting out in the sun. Stopped and watched a group of Italians playing their beloved Bocci, which is something like lawn bowling. I took the Third Avenue El to Grand Street, walked on Hester and Orchard streets. I saw a lot of things but not for photographing. I was experimenting with the sports film, which took some of the spontaneity away from my seeing. I walked back up the Bowery to 14th Street and stopped in a saloon across from Luchow's to have a beer and some of the free lunch.

It was quite a shock to hear of the death of Moholy-Nagy. I feel badly for Harry as I know he revered him. I know how numbing it was for me when Stieglitz died, and from what Harry has written, his relationship to Moholy was similar to mine with Stieglitz.

I am getting pretty broke. I still have my checks to come from the state department and *Fortune*.

11/28/46: A cold but sunny day. I went downtown with my Graphic to make some pictures of Macy's Thanksgiving Day parade. It was fun to see the kids, but it was hard to find something to photograph that meant anything .

Dinner at the Newhalls' last night was an experience. Walter Lewiston was the other guest and I have seen enough of him.

11/29/46: My economic position is deteriorating. So much so that I answered Minicam's request for some prints by sending

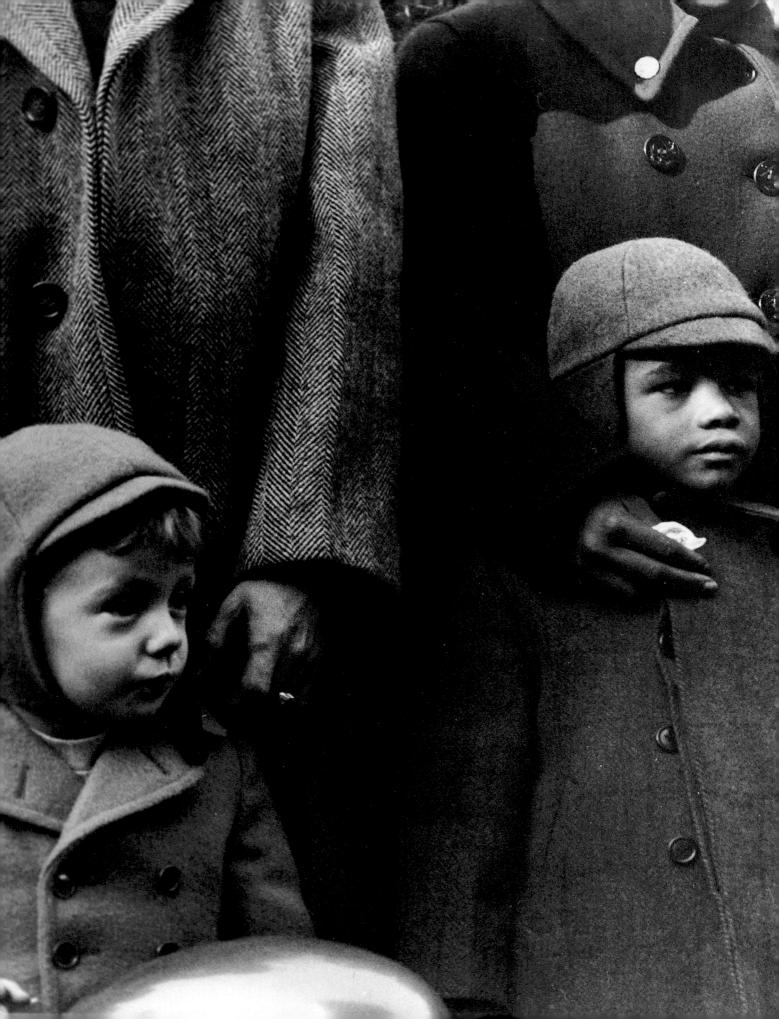

them a few. Also wrote a rough draft for a feeler to Ray Macklin at *Life,* which I am sure I will never send. Doing these things cleared the air and took my mind off my money problems.

12/4/46: Made some enlargements of the Macy's Parade negatives and one of them is a sweetheart. The negative is thin but I could make a good print. It has the same quality Dorothea Lange has in her things made in dull light. I took some of my prints to MOMA, and Steichen wants to buy some for the collection. Had a letter from Roy Stryker. He saw my show and said he is impressed with what I have done. He asked me to drop in to see him when I am downtown. I wish he would give me a little work to do. I have not received my checks from the state department or *Fortune* and I am working on my last ten bucks.

I photographed on Third Avenue today. Quite exciting, but I spoiled my best negative. Think I'll go to Fifth Avenue tomorrow with my Graphic and see if I can capture some of the crowd feeling. In spite of being quite broke I am in good spirits. My photography is alive. In it I find joy without measure. It grows continually, and with it I grow poorer and richer.

12/5/46: Had a note from Betty Dick who wants to talk to me about a small job for *Fortune.* One of the editors has an idea that it would be good to run a page of views of New York City from the Empire State Building. They are interested in late afternoon and evening. It can be done at my leisure over a period of time. I think I will enjoy it. Had a card from the museum. They want a photo of Alfred Lunt playing with his toy theater. These little jobs are all right although they seem trivial. They keep me going.

12/6/46: This was a hectic day. I went downtown to photograph the Lehman Building for *Fortune* and the most atrocious conditions confronted me. The smoke from the coffee roaster almost completely blotted out what was already hopelessly dark. I made a couple of negatives that were just barely printable. Then I rushed to the museum to make the pictures of Alfred Lunt. A *Times* man was doing an interview and Lunt was exhausted by the time I got to him. My synchronizer wouldn't work so I used open flash. The negatives were fine and everyone was happy.

12/8/46: Photographed around Wall Street. Stopped at the Chelsea but Ferd and Brecht were hard at work on *Galileo* so I came on home. I have my negatives developed and printed. The prints are washing. It is like my early days in New York when I had very little social life.

Yesterday was an odd one. I started out with my camera and came back without making a negative. I took the subway to Christopher Street and walked all the way home to 123rd Street. There is so much to see in New York, the stores, the people, little street incidents. It was a good walk. I stopped at the Greek's and had a shashlik. A snatch of conversation I heard on Seventh Avenue at 22nd Street, "I had a winner today but I didn't play it." I am almost broke. Neither of my checks has come and I am facing the weekend with something like three dollars. At the last minute, the mailman has brought me a check from Minicam for $15.00 and another from Miss Seymour for $7.50. Something always seems to turn up.

12/9/46: I didn't help my financial crisis by going out to dinner with Ferd tonight. We went to Dick's, and in spite of the fact that the bill halved my total wealth I enjoyed it very much. I doubt if I will ever be out of the woods as far as finances are concerned. There is an excitement about being almost broke that I can't explain. When one wants as little as I do it is not so tragic.

12/10/46: Delivered the Lunt prints to the museum and then went downtown. Saw Roy Stryker but only for a minute. He had to attend a meeting but said he does want to see me and will drop me a note.

12/11/46: Went to An American Place this morning hoping to see Marin but he didn't come in. I made a picture of Andrew working. He gave me #36 of *Camera Work* with sixteen reproductions of Stieglitz photographs, and I am happy to have it. I went to Scribners' to pick up the photographs Ferd left there. Had a good talk with Burris Mitchell. He told me that, after the bad luck with the Wright Morris book, they are not about to try any more. He seems to like the photographs very much and the whole idea Ferd has outlined. I took my photographs to Steichen so he could choose the ones he wants to buy. Lisette Model was there. She looked at my pictures, and, surprisingly, she liked them.

12/12/46: Went to the museum with nine negatives to make and eight prints. Two days so far this month have netted me fifty-two dollars. That pays my rent for February and then some. I might even be able to eat.

12/13/46: Nice cold, clear day. Went to Mary Callery's to photograph some of her sculpture. Had lunch with her and a good look at the Picassos. I mentioned that she must have one of the biggest collections in the country, and she said, "In the world." She said Walter Chrysler has more but she has the important ones. We talked about Dorothy Norman whom Mary loves as much as I do, and also O'Keeffe and Stieglitz. No startling disclosures about anyone but some interesting tidbits about everyone. In the afternoon I went to do some of my "out of the window" pictures for *Fortune*. Went to Lisette's house on 4th Street. She wanted to show me her photographs. She has something but I think overenlarges some of her negatives. Her things are pretty bitter; they make you wince. I believe she has found an approach that gets a lot of reaction. It has become a style. I like Lisette very much and enjoyed seeing her work. Like all of us, she has her limitations as a photographer. I can feel her work, but I don't have much bitterness in me. As Stieglitz once said, my work has tenderness without sentimentality. It is hard for me to hate. Wanting so little in a material way, I have been spared a lot of disappointments.

12/16/46: I made enlargements of the museum negatives today. I didn't have any of my own work to do so the session was short. This afternoon I went looking for a package of 4x5 film, was able to buy four, and am raring to go. In the windy and cold weather I think it is better for me to use the Graphic, hand held. I would like to get some of the Christmas feeling downtown. The crowds, the people who stand on corners collecting money for various charities. A letter came for Harry from the Open Stair Dwelling Corp. (our landlord), informing him that his lease will be up on January 1 and that Webb is living in his apartment, contrary to rules. They offered him a new lease. I will see if the Veterans Administration can get it straightened out for me. I am going to stay with the Newhalls' cats for a week while they go to New England for the holidays. I got my final instructions on feeding, etc., and about not worrying when they crap in the bathtub.

12/17/46: It was a dull day. Almost raining but not quite. Went to the museum to deliver the photographs and also to take the prints to Mary Callery. I went over to see Dee at MOMA. Steichen had been in and made a selection of prints for the museum and those he wants to buy for himself. I am pleased. I was prepared not to like him when I met him, I guess because of my support for the Newhalls. He seems very nice. I found another package of film—5x7 Isopan—which will be good for work at the museum. Made a good dinner for myself at home: baked sweet potato, steak, and baked beans from Horn and Hardart.

12/18/46: Took my Speed Graphic downtown and found it hard to work with in the crowded streets. The people ringing the bells and collecting money just did not want to be photographed. It was so cold I went to see Miss Rose at Open Stair Dwelling Corp. to see about keeping the apartment. I told her pretty much the truth but she didn't want to understand my point of view.

12/20/46: Had a letter from the apartment people and they say that, if I get a letter from Harry saying he does not wish to renew the lease, I can take it over. I feel good about that. Earning the money to pay the rent is so much easier than trying to find a new place to live. I like it here. I can live simply and quietly. I have a kitchen and a place to work and sleep, and thirty-eight dollars a month is as cheap as or cheaper than any other place I could find. Now that I'll have the place in my name, I can think of making some improvements—a chair or two, a studio couch, a record player, a phone. New York is now home to me. I can't think of living anyplace else. I wrote a letter to Harry bragging about the no-snow weather we've been having and telling him what a bugger Art Siegel is for not getting in touch with me. Also, I enclosed the thing he should sign so I can have the apartment. When I went out to mail the letter, it was snowing like mad. A telegram from the Barbizon Plaza was waiting for me when I got back. It was from Art Siegel. I finally located him at the Newhalls' and we had a good talk. As in the old Detroit days, Art and I stopped in a delicatessen to have a beer and a sandwich and talked on. He has been worried about me, that I would become indoctrinated with the awe and wonderment that the Newhalls have for Stieglitz and his circle. I could have told him that the Newhalls are more hung

up on Ansel than on anyone else. He is eager to see my new photographs and hopes that I will add something new to photography. He talks about new approaches and techniques. I am not a bit interested in gimmicks. He wants me to come and teach in Chicago, but I am not ready for that. I am learning too much at the moment. I do hope to teach at some time in the future.

12/24/46: Had a good time last night. Went to Gran Tocino with Ferd, Berenice, and Lisette and Evsa Model. Had a heated discussion with Evsa about the merits of Weston's photography. They all feel that he is not important. I feel that he has made a great contribution and that his influence will be felt for a long time. I don't quite understand why he limited himself to the 8x10 camera. I stayed with the cats at the Newhalls'. Not being a cat lover from way back, I was surprised at how sensitive I am to their feelings about me. I find myself currying their favor, thinking of special amusements for them, and possibly overfeeding them. Art called in the morning and said that his wife Barbara is coming. They will stay at the Newhalls' and take care of the cats. Barbara is very young, a nice girl.

12/25/46: Christmas Day. It was so beautiful I had to go out and make a few photographs. The light was amazing. One of the truly special mornings of the year. Ferd, the wonderful bugger, gave me a check for fifty dollars. It was tough for both of us. I hated to take it and he was afraid of hurting my feelings. The dinner at the Birnkrants' was a treat and they were nice to me. They were pleased with the photographs I gave them of their kids.

12/27/46: I am a little worried because I am not photographing with as much vigor as before. Having company for the holidays is probably the reason. I have a strong desire to get out and photograph but the cold seems to bother me this year. Last year I slept with only one blanket and this year I need two. Also, this year I find myself wearing gloves, something I rarely did last winter. Civilization is no doubt softening me. Maybe I should have gone to Alaska. Maybe I am getting old.

12/28/46: Saturday is a good day for me to do my Empire State Building pictures. *Fortune* has given me a pass and a key, so I

can work when no one is around. I made a few negatives, but the light turned very bad. Maybe the smoggy scenes will turn out to be spectacular. The view is awesome from this forty-ninth floor, and getting it on film the way I see it is something I hope to master. Later I saw Art again. He picked about twenty of my prints and wanted me to give them to him. I gave him three, which I think hurt his feelings, but I don't believe he should ask me for my work just for old times' sake.

12/31/46: The last day of what I think has been the most exciting and fruitful year of my life. The inevitable sadnesses—the death of Stieglitz, Harry's unhappiness, my mother's illness and my inability to do anything about it, and a few other things—were completely overshadowed by a fabulous series of great joys, my ability to cope with New York, to be able to photograph the city with love and tenderness, to get some recognition for my efforts, and to find true and understanding friends. All I really wanted was the time to work and enough money to keep me going on a simple scale. The fact that I made such good use of the time is gratifying. I think I understand now that work, not worry about material things, is the key to happiness for me.

The Siegels left for home today. I am glad and sorry to see them go. We had some nice times but I did get tired of hearing Art say all the same things he was saying in 1939. I think teaching at the school in Chicago has not helped his development. He is glib, and when talking to beginners he is awesome. They worship him as we did in Detroit seven years ago. It is hard to be humble when you are an accepted big shot. When you stop being humble you stop learning.

1/1/47: No New Year's resolutions. I am so happy about 1946 that I haven't the guts to want much in 1947. I will settle for the time and energy to photograph honestly and freely. The holidays and social life knocked hell out of my work schedule the past couple of weeks. Stayed with the cats at the Newhalls' last night. The party at Chuck's earlier was dull so I left at two o'clock and walked through Times Square. It was still thronged with celebrators wearing paper hats and blowing horns and whistles. I didn't see any drunkenness in the crowd of mostly well-dressed young people.

I slept until almost ten o'clock this morning and then went

From the Empire State building, New York, 1946.

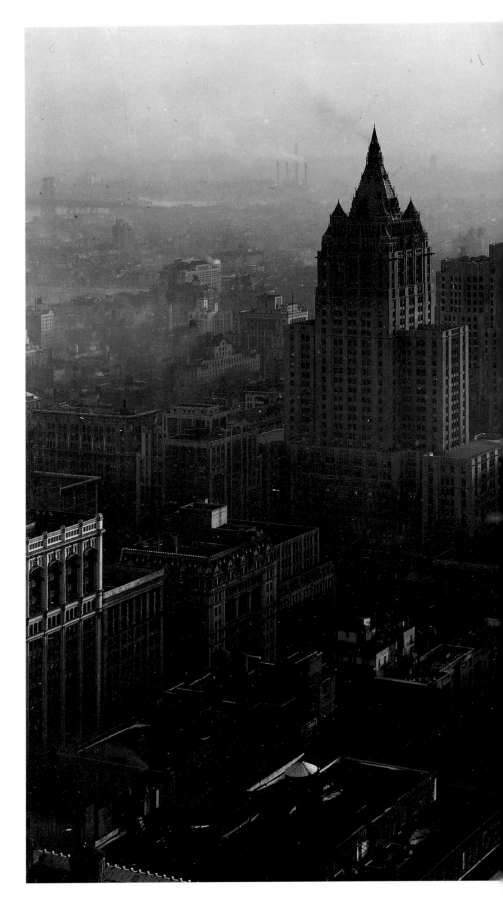

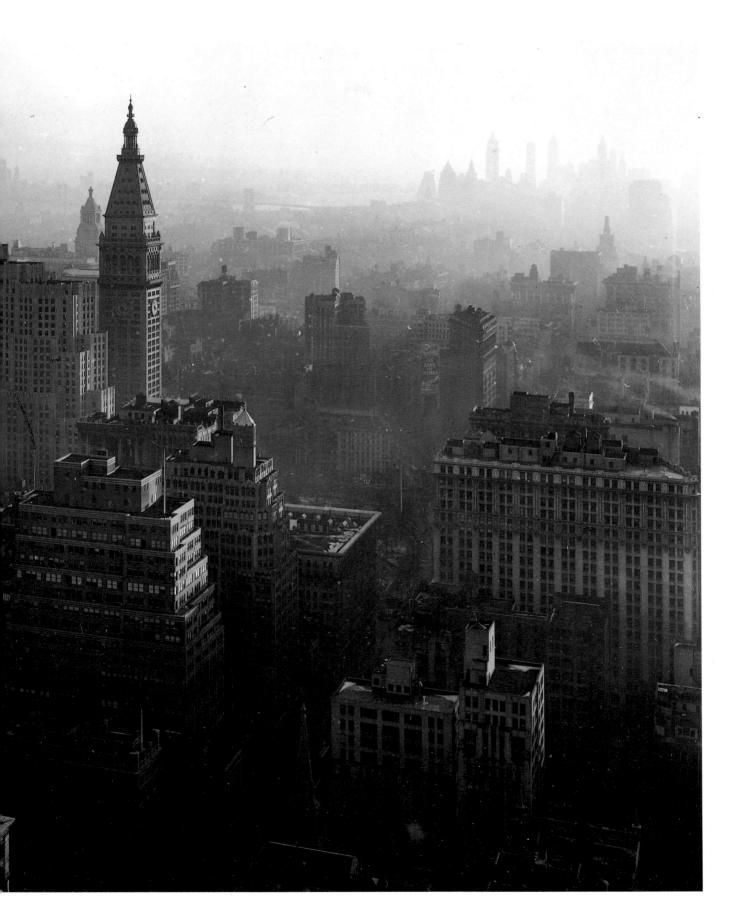

out with my Graphic. It was cold and began to snow so I gave it up and went to the Chelsea to see Ferd. We went to the Automat for dinner. Cartier-Bresson called and invited us to the museum tomorrow for the showing of the film he made in Paris during the war.

1/2/47: Cartier-Bresson's film is a good documentary and potent enough so you could overlook technical things that were probably caused by wartime conditions and the problem of getting film. It seemed to be a series of interesting but unrelated newsreel pictures. Not understanding the language was no doubt the reason I could not relate some of the scenes to others. Ferd liked it and thought it good.

1/6/47: A very fine day. I am sure to have my quota of new photographs for this first week of the year. I used the Graphic and made twelve, and from them eight prints which I will mount. I feel that I am reaching out for something. The point for me is to see things that move me, to see them in practical relationship to the camera. In the early days of my New York stay I was working exclusively with a view camera on a tripod. I was not able to photograph a lot of what I saw because people were involved and they just don't stay the way you saw them at first. When I got my Speed Graphic, which I could hand hold, I was able to photograph people, even in motion.

The vision is in itself a new thing, a discovery. When I walk down the street, I see hundreds of things that move me but at this point are not photographic for me. For instance, the people I see on streetcars and buses were interesting before I was able to photograph them. I was using a view camera then and found that, by setting up the camera at a car stop and waiting until a car came along and stopped, I had the people there helpless and looking out the windows and wondering what I was doing. I just tripped the shutter. I have a strong feeling about midtown, Fifth Avenue, in the 50s. I like to walk there but to date I haven't been able to make a decent photograph. I think I will do it someday.

1/7/47: A dull day and it is just beginning to snow. My prints are made for the *Fortune* portfolio—the photographs from the windows. Now that I have caught up with my work I have time to worry. I can't see my way ahead too far financially. I

have very little coming and no jobs for sure in the future. At a time like this my innate optimism deserts me. Never for very long, but I do wonder if I am doing the right thing. Why I worry about this stuff I don't know. I have yet to be hungry and I have always been able to pay my rent. Getting this off my chest, the old optimism and confidence are returning. I will stick it out on the premise that, if I continue to work honestly and loving photography, everything will turn out all right. For over a year it has worked nobly.

1/8/47: My optimism has been vindicated. Roy Stryker wired me that he has a job for me, a view-camera job on a new building being built by Standard Oil in Rockefeller Center. It may not last for long but it is a beginning. I start work tomorrow.

1/9/47: Stryker has been a big name to me for several years and, surprisingly, he wasn't awesome. He is a dynamo and whether or not what he is doing is right, he seems very sincere about it. He gave me carte blanche to do the job in my own way. I was shown some of the file books and that kind of scared me—they all looked like FSA pictures. I must force myself to be myself. I didn't get out on the building today, spent most of it talking to Roy, looking around the office, and meeting the people.

1/10/47: Spent the day climbing around the new building and I am pooped tonight. It's a nice healthy tired though, and I earned thirty-five dollars. I still did not make a lot of photographs but I soaked up some understanding of how a modern building gets built. The few workmen I met were helpful. I am going to get a pair of coveralls and will mix with the men and learn a lot of useful things. The building is so exciting to contemplate that I believe I will enjoy working on it. I developed some of the negatives when I got home and they don't look like much. Roy said he supposed I was like Walker Evans and would want to develop my own negatives, and I said I would like to.

1/12/47: This afternoon Dee and I went out to make some photographs. We worked on some of the Third Avenue El platforms and then walked out on the Brooklyn Bridge. As always, it was a stimulating spectacle. Dee was thrilled with it. Went to Dorothy Norman's big party at night—quite a bash.

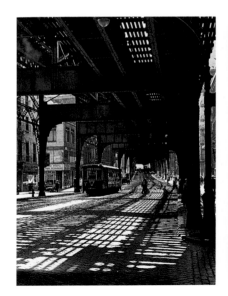

The Bowery under the El, New York, 1946.

From Chatham Square El station, New York, 1946.

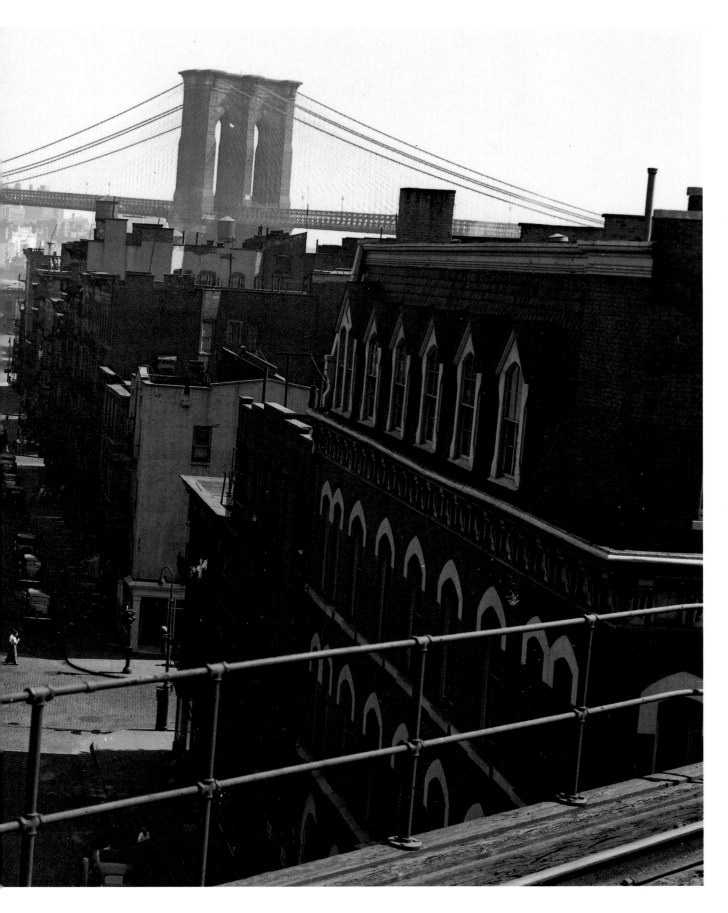

The house was lavish, jam-packed with Stieglitz photographs and Marin paintings. A great mix of guests. Aside from Luise Rainer and Max Lerner, I believe almost everyone else has been a contributor to *Twice a Year*. They were nice people and not many seemed to know each other. After enough scotch and bourbon had been soaked up, everybody knew everybody. Harold Clurman's wife, Stella Adler, was the belle of the ball. Henwar came late and Johnny Ferno and he had a good time. Johnny's wife, Polly, is a dancer, knows Brecht, and will probably do the dances for *Galileo*. Dorothy was very nice. Her house is one of great wealth. I was flattered to see, among a batch of Stieglitz photographs on the wall, a photograph of mine.

1/13/47: My cold is knocking me out. I donned coveralls and roamed the new Esso building. It is a tough job and I found out that four of the experienced men at Esso had tried it and all came up with zero photographs. I am beginning to understand what I am up against. I am going to bed early with a hot rum toddy and a couple of aspirins.

1/17/47: Had an argument with Roy today about captions and giving away the photographs to any and everybody who wants them. He didn't seem to be mad at me for not agreeing with him.

1/18/47: Out early this morning to do a little photography on my own. Went to the Brooklyn Bridge but it was not a clear day. I met a telescope buff on the bridge and enjoyed hearing him talk about his telescope experiences; for example, with one of his 20x51 scopes, he can read the street signs nine blocks away, and in the Bronx where the blocks are really long. He said that if he had seen one of his friends walking across Manhattan Bridge last Sunday when it was clear, he could have recognized him from where he was standing on Brooklyn Bridge with his 8x40s. After leaving the bridge, I walked down Park Row and dropped into O'Rourke's Bar for a beer. It is a place right out of the nineties. I talked to the bartender who said I was welcome to photograph in there any time.

1/19/47: I struggled with the building photographs and am getting discouraged. When I began working for Roy, I checked out my darkroom so I would be sure not to have things go wrong there. Since I've begun work on the building I have spoiled several negatives by fogging and I seem to have all

kinds of technical problems. I am unhappy with what I have been turning out and finally went to Roy to tell him I thought I had better quit. He was upset and assured me that I am doing fine, much better than any other member of the staff, each of whom had tried his hand at the job.

1/23/47: My cold is better. I worked yesterday and today and feel better about the work. Roy stopped me when I came into the office and asked me to go to Portland, Maine, tomorrow night to do a story on the Montreal-Portland pipeline. They are going to try to adapt the high-test gasoline pipeline, built during the war to carry aviation fuel, for transporting heating oil from the tanker to Montreal.

1/24/47: I am on the *State of Maine Express* en route from New York to Portland. This morning I made a few negatives of the new Esso building from the windows of the Sinclair Oil Co. Had lunch with Roy, Harold Corsini, Gordon Parks, and Arnold Eagle. Roy seemed a bit jerky. Maybe that is the wrong word, but he does so much want his boys to like him. As far as I can see now, the photography department at Standard Oil Co. is making photographs that look like Stryker photographs from the Farm Security days. I am worried about that but doubt I will ever fall into that trap.

1/25/47: Arrived in Portland on time. It is like spring here. The last thing Roy said when I left the office was, "Stay a few extra days and try to get some good snow pictures for the file." I seem to be a jinx to people who send me out on jobs. I walked and walked, looking over the town, and I made quite a few negatives. The light was not bad, and I believe I made some good things. The ship won't be in until tomorrow or the next day. Boone's, the famous lobster house, was closed for repairs but I found a worthy substitute at the Casco Bay Sea Grill. The lobster stew was great.

1/26/47: Impossible day—foggy and rainy at times. The only things of interest I could find were the pavement cobblestones on the old streets around the waterfront. Except for the Sea Grill, eating is a problem here with prices as high as in New York.

1/28/47: The weather almost washed out my *Esso Greenville* pictures. The tanker did not arrive at the lightship last night until after dark. This morning there was a pea-soup fog and

just the top of her superstructure was visible. About noon the fog lifted and the sun came out for a few minutes. I made one 4x5 Kodachrome when the light was at its best. I hope that it might save the day. The pictures of the connection to the pipeline are about as dull as I have ever done. And the last vestiges of ice on the streets have melted.

1/29/47: Came back from Portland last night. As the train pulled out of the station it began to snow, and when I saw the paper in New York the headline was about the big blizzard in New England. I think the snow for my snow pictures is still falling. Went to the museum this morning and made twenty-three negatives for them. It was quiet at the office. Had a good talk with Roy. He kidded me about getting out of Maine before being snowed in. He appreciates my problem of pressure, and I think he is pulling for me to do well. I want to like and respect him, and I want to keep this job if I can without doing any harm to my love of photography. After our talk I felt better.

2/5/47: Went to the Cartier-Bresson show at MOMA. Enjoyed it very much. It was a bad night with rain and snow but there was a good crowd. Henri is an important man. I feel that some of the quality has been sacrificed for the sake of quantity, but I think that is the fault of the museum rather than Cartier-Bresson. Today was the coldest day of the winter. There were no workmen on the upper floors where I have been working with the steel men. I bought an Omega D enlarger today and hope to get it next week. When I went to see Georgia, Jim Sweeney was there. We had a good talk about the Bresson show. Georgia felt that by being more selective they would have had a much better show.

2/7/47: I thought this day was uneventful until I realized that such things do not exist for me any more. This morning Roy said I might ease off on the building. Despite the wonderful and rare aspects of this job, it is bad for me in spots. If I could accept it as a means of earning a living without involving my feelings about photography, it would be a nice set-up. There will always be the battle of whipping my photography in line to please Stryker.

2/9/47: Had to get my work plan written for Roy. I can see that making such a plan does have value. I hope it will help

me get something out of this job. Roy is a nice man and this is a great opportunity for me to get some editorial experience.

Berenice thinks the Cartier-Bresson show is poor. She thought the Weston show was bad too. I found myself defending both Cartier-Bresson and Weston.

In spite of bad weather I made some photographs on the building. That job is a jinx for me. I don't seem to get anything good, even technically. Gordon Parks is letting me use his Rollei tomorrow. I am going to start early and take advantage of the good light that hits the structure until about eleven o'clock. I can photograph the men setting the face stones on the tenth floor.

2/11/47: This is a funny world, and I have a funny job. For some reason I can't seem to get a decent negative, let alone a good print on this job. Roy called me into his office just before closing time. Ice jams along the Ohio River are tying up the Standard Oil barges plying the river. I am to fly to Cincinnati tomorrow to do some pictures to supplement the Rosskam River series. I will hear more about it when I see Roy in the morning.

2/12/47: I am in my room at the Gibson Hotel in Cincinnati. It being a bank holiday I had a time raising money for my trip. I even had to pay for my own air ticket. Ferd let me have seventy dollars, and Roy borrowed a hundred from Lenscraft. A good trip to Cincinnati by way of Washington. Cincinnati seems a good place. Went to Covington, Kentucky, for dinner—a one-pound T-bone steak for $1.50 in a gambling joint. Reminded me of the old speakeasy days in Detroit.

2/13/47: Got an early start in my rented car and soon located the towboat *Peace* on the river at Carrolton. I enjoy the river jargon the crew speaks. Had a lesson in throwing the lead line [a presonar procedure for checking the depth of the water]. When the lead man on the bow of the boat hollers "Mark Twain," the water off the bow is twelve feet deep. A lot of folk singing goes along with the sounding as the lead is only thrown every minute and the time in between is filled with song. One lead man called, "Mark four, 'd rather be out with the captains than out here leadin' this cold cold water." Had lunch aboard with Captain Springer. Very good. There is

no ice around here so the captain got busy on his radio-telephone trying to find some. There was a bad ice gorge near Gallipolis so I am hopping off for that town tonight.

2/14/47: Got in touch with Bob Heslop and he invited me to Point Pleasant, West Virginia. He is an old-time river man, sixtyish, and he knows every pilot on the Ohio River. He and Milt Miller took me to an ice gorge at lock 23 near Pomeroy. A gorge is a place where the ice piles up due to a stoppage downriver. Being on the river and meeting the river people is a great experience. The river towns are handsome; some of them date back to the eighteenth century. The river is spoken of with respect and pride as a proud parent speaks of a precocious but headstrong child. For more than a hundred years the ice breakup has been an annual worry. They seem to fear it but at the same time hope it will raise hell. They speak with pride of the great floods of 1887, 1913, and 1937.

2/17/47: I finally got some pictures of a boat in the ice gorge. The towboat *Weir* went up this morning to try to break it up. She did a lot of good, breaking the ice and getting it moving in the river current. The danger is past unless a big freeze comes in the next few days. I said goodbye to my friends in Point Pleasant when I boarded the New York Central train to Charleston to connect with the C&O to New York.

I was happy to be back in New York and received a warm welcome at the office. Roy enjoyed my description of my experience on the river. He said the thing he likes most in photographers is curiosity and enthusiasm. He thinks I have both. With a strike on at the building, I have a few days off to make some photographs for myself on the snowy streets of the city.

2/21/47: Went to the office and talked to Roy. He outlined my next assignment. I will go to New Orleans to photograph the last trip of the steam towboat *Sprague* on the Mississippi. After the trip to Memphis I will have assignments at the refinery in Baton Rouge and in some of the Louisiana towns and countryside. I finally got the new 9½ Dagor lens that I ordered and it is a beauty.

2/24/47: Another week starting and I am up to my ears with photographing for myself and Standard Oil. Wish I could

pretend I was doing it all for myself. Made some negatives on Riverside Drive and then down on Third Avenue between 32nd and 42nd streets. This afternoon I was up on the building and it was bitter cold. It is still hard for me on the building. I will be glad to get off on my trip south. I will use my view camera a great deal on this trip and that is what I need to get my feet on the ground. Ferd suggested that I make ten photographs every week for myself, photographs that I won't even show to Stryker. Just knowing that I am making them for myself might make a difference to me. When I talked to Steichen today at the museum he advised almost the same thing; after the talk with Ferd I was ready to agree with him. The thing is that my work will be better, even from the standpoint of Standard Oil, if I continue to expand on my own. I enjoyed my talk with Steichen today. I didn't agree with everything he said. He and Beaumont do not like each other at all, but when he compared Cartier-Bresson's photographing to Joe Louis's boxing, it was almost exactly what Beaumont had said about Henri. I may have smiled but I did keep from laughing out loud.

2/27/47: February is about gone and I can't help being happy about the last year. How lucky I was to refuse the advice of several people, including Stryker and Paul Strand, to go back to my old job in Detroit as there are too many photographers in New York. It has been the richest, most productive year of my life. Lots of credit is due to Stieglitz, the Newhalls, Ferd, Betty Dick, Mary Callery, and Georgia O'Keeffe—and the nameless hundreds of people I have talked to on the streets when I am out with my camera. I used Gordon's Rollei on the building and made close-ups of the workmen's faces. My enlarger came and I have it all set up. It is beautiful.

3/4/47: Too cold to work on the building so I spent the day in the office catching up on my captions, then stayed downtown and had dinner with Roy. He told me about the FSA days, when his old friend Rex Tugwell got him to quit his teaching job at Columbia and come to Washington to organize a group of photographers to document the Dust Bowl era in the early thirties.

3/6/47: The men were raising steel on the building today. I spent most of my time up there recording the operation. It was a good day for me. My Indian friends played a trick on

me that was breathtaking. They are now working on the thirty-third floor, and the last three floors are managed on ladders, one floor at a time. The open spaces between the ladders are covered with boards so that one can walk from ladder to ladder with little danger of falling from one of the girders. While I was up on top they removed the boards on the thirty-second floor so that when I came down I would have to walk on the beam from one ladder to another. I suspected that it was a trick on me. I thought I saw people peeking through the cracks overhead to see how I was coping. Actually it should be no problem to walk on one of the girders since they are close to a foot wide. I knew I had to cross, so I began, thinking how if I did fall I would try to place my camera on the beam to save it from being damaged. That thinking probably helped me and when I got to the next ladder there was a great burst of hand clapping from the floor above. Almost all of the steel men are Mohawk Indians from Quebec. I think they have an odd sense of humor.

3/10/47: I had yesterday off and the weather was nice so I went out on my own to make some photographs. I had no plans as to where I would go. I walked down Broadway to 116th Street, then east through Morningside Park and on to Third Avenue—a route I had never thought of traveling— and I found some magnificent New Yorkiana. I like what I did very much and it is better than anything I have done for Roy in the two months I have been working at Esso.

3/12/47: They raised the "topping out" flag on the building today. It was a small ceremony and I made some photographs with Gordon's Rollei. Gordon came up on top with me. Ferd came to look at the file books today. He and Stryker hit it off fine. I think my part on the building is finished.

3/13/47: It was like spring today. I felt good and thought about my date with (Ferd's daughter) Faith tomorrow night, like guys are supposed to do at this time of the year. I went out with my 8x10, using the new 9½ lens, really quite a wide-angle lens for the big camera. Faith cooked dinner for me. Her sitter for Jeremy was ill so we had to stay in. We had a very cozy time and enjoyed it. I would like to tell Ferd that I am sparking his daughter but I don't know how to do it. Jeremy will no doubt take care of that.

3/19/47: These are happy days for me. I am photographing better all the time, even on my work at Standard Oil. I am working in my own way and becoming freer. I like Roy and the people I am working with. One thing I must watch: my social life is using up a lot of my work time at home in the evenings. That is one of the evils of having some dough. I like people, like to talk and have a couple of drinks, like dames, in bed and out. I am a sociable guy. When I don't have any money, my activities are restricted and I have time to work at home in the evenings. Jesus, I want to do so much work. Must I plan to always be broke so I can do it? I think I will restrict my evenings out to two or three a week. Started to work on the New York Harbor story for Roy today. Went to the Gowanus Canal in South Brooklyn. I think I did some good things.

3/20/47: There was a peculiar light today, like it used to be in Detroit sometimes. The sun seemed to be filtered through a fog and the light was soft and the shadows very weak. I took the ferry to Staten Island and then the Brooklyn Ferry to 69th Street and I got lost. I never did find the waterfront. I walked for miles and will have to get a map of Brooklyn to find out where I was.

3/21/47: In the beautiful spring sunshine I photographed happily in Brooklyn using both the 5x7 and 4x5 back on the view camera. Also I made a couple of rolls from the old Rollei I bought from Sol Libsohn. Made a lot of negatives, developed the 5x7s and am happy about them. Had lunch with Nancy and Beau at the Golden Horn. Nancy said she doesn't think much of Stryker because he never hires artists. I found myself defending Roy. Who does she think is an artist? She finally admitted that Walker Evans and Dorothea Lange fall into that category. The Newhalls have been so good to me that I hate to have this kind of argument with them.

3/23/47: Photographed with the Rollei and it seems fine. The negatives are very crisp. I don't know how to use it yet, but with some experience I believe I will have some good pictures from it. Took a ride on the Myrtle Street El in Brooklyn.

3/26/47: It has been cold enough the last couple of days to make a eunuch out of the proverbial brass monkey. I was all ready for some fine spring weather, was excited about photographing the harbor for Roy and, bingo, it is winter

again. I suffered with the cold wind and did not accomplish much. Had a good time with Faith tonight. I bought some live lobsters. We cooked them and they were really something.

3/27/47: Still cold and windy but I went to Brooklyn anyway. Everything I saw appeared to be against the light, and I think I underexposed most of the plates. I had such a good time last night that nothing bothered me today. I am eager to go on to my assignment in Louisiana. I think I can do a good job there, and the experience will help to establish me. I don't always want to be tied down to a job like this, nor do I want to be a big shot photographer. Most of the things I want to do won't pay off in money very well. After I get my equipment complete I would like to work on a part-time basis and have more time for my own work. Money is really a bad thing for me. It is a time waster. Having it, I begin to want things I never thought of before. I eat too much and buy things I don't want or need. I hope to get over this rich new splurge and start transforming the money I earn into time for me.

3/28/47: Went to Brooklyn today and had a good time. It is great to have a job and say you enjoy it. I am lucky to be able to work with Roy. He has had a lot of patience with me, even though I have not performed heroically. Went to the Photo League to a new members meeting. They have a reputation for being very sincere, but when I am there I sense a phoniness that I can't quite put my finger on. Rudi Burkhardt, whom I like, was there. I have the feeling he doesn't fit there either.

3/30/47: Faith and I had dinner at the famous Angelo's last night and found it as good as advance notices. We get along fine and I like her. What we talk about I can't remember but it is always interesting. I can't see why more talking is not done in bed. Your body is relaxed, your mind is free, and there is something warm and soft, and pretty too, to touch. Tonight I dropped in for just a short time and stayed until two-thirty. Faith made a delicious shrimp dish and we talked and talked.

3/31/47: Worked most of the day in Brooklyn but was not seeing well. Had dinner with Roy at the Automat and then went to his house to look at FSA photographs. I don't know if I looked at too many or if I was just being too critical, but I was disappointed. I did see some that are fine—Walker

Beginning of Broadway at Bowling Green, New York, 1947.

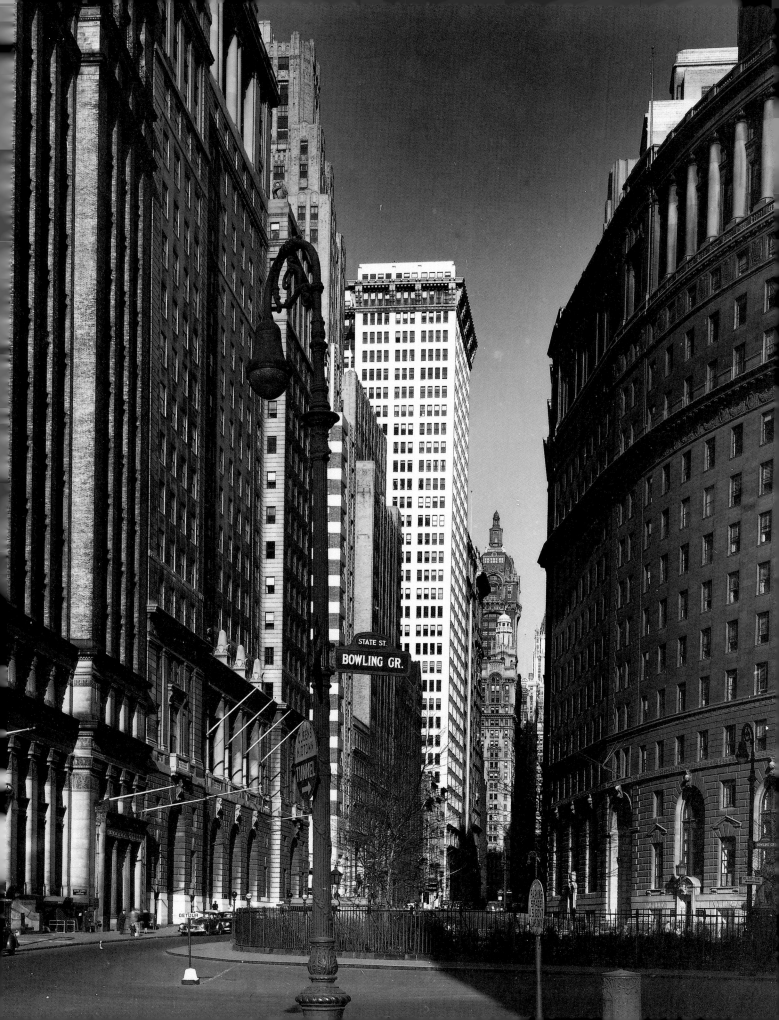

Evans, Dorothea Lange, Russell Lee, and a few others—but I would say most of the prints I saw are fair to mediocre. Seeing so many photographs of that nature is so repetitive that they tend to lose their individual sting.

4/4/47: My Louisiana trip has been postponed and I am in Philadelphia to work on a story for the Franklin Institute. Had a good day. Made six rolls of Rollei negatives, fourteen 5x7 and four 4x5. I find Philadelphia interesting. Some of the old buildings are wonderful. I am returning to New York tomorrow night for Faith's party.

4/6/47: Yesterday was tough because of the weather and today is tough because of last night. I got back on the train from New York at just eight o'clock this morning and, as it looked like rain, I went to bed. I was shocked when I awoke at ten o'clock and found the sun shining. I walked miles with the Rollei—to the University of Pennsylvania and to the zoo. In spite of my fatigue, the photographing was exciting. I wanted to use my view camera but I didn't have the energy. I am going to bed right now at seven-thirty.

4/7/47: A beautiful day. Made the mistake of hiring a car to take me around the city. Something about having someone waiting for you and having a meter ticking away is distracting. This is a stupendous job and I make the mistake of trying to do too much. I find myself frustrated when the light is fine and I can only be in one place at a time. I have seen so many things I want to do when the light is good. Roy told me not to try to get too much. I do work hard. I was out early this morning and made my first negative before eight o'clock.

4/12/47: I got back from Philadelphia Tuesday night and have been going like hell and getting no place ever since. Wednesday the Newhalls had a party for Brett Weston, who seems like a nice guy. I will be off to Louisiana as soon as I finish my Philadelphia captions. New York looked wonderful when I got back. How will it look after six weeks in Louisiana? Ferd and I had dinner at the Automat last night and then went to Roy's house. John Collier was there and we had a good time. Ferd and Roy seem to enjoy each other.

4/16/47: I am having another storybook adventure. I am in

Baton Rouge and things have happened so fast I hardly know how I got here. About ten o'clock Monday I learned I was leaving that afternoon at 4:45 on the Pennsy General for Chicago where I would have a layover from 8:30 until 5:00 p.m., when I would board the Panama Limited for Louisiana. In Chicago I called Harry at the school and went there to see him. Art was there too and asked us to have lunch at his house. Art cooked the meal himself. I could hardly believe it. He just opened a can of beans, but he did heat them. I just barely made the train. Arrived at early morning in Hammond and went by car to Baton Rouge. Went to the refinery this afternoon and it is very exciting.

4/18/47: This is really my first experience in the South. The "White Only" signs are hard to take or understand. The refinery with its noises and smells is something to see but so far I can't see it photographically.

4/19/47: Until I get a better feel of the refinery I think I will work around the town and see what I see. I did meet Ralph Wickiser, who is an art teacher at the University of Louisiana; he seems like good company for me. I worked in the Negro part of town today—nice signs, houses, and stores. They are quite beautiful, but also very Walker Evans-ish. That is a trap I must avoid.

4/22/47: I have been working aboard the old towboat *Sprague* and am getting an education in Mississippi River lore. I can do some things aboard with the view camera while the ship is in port. There will be too much vibration once we get underway.

4/26/47: Today is my second and last day in Natchez, Mississippi. After Baton Rouge and the trip on the *Sprague* it took this "crinoline crypt" to show me the South I dreaded to see. Last night when I was photographing downtown with my 5x7 view camera, I saw the seedy-looking door of the bus station topped by a White Only sign. While I was under the black cloth I heard feet scraping around. I came out and put the holder in the camera, pulled the slide, and snapped the shutter. I didn't say a word. Finally one of the men said, "You're a Communist, ain't you?" The sheriff showed up at about that time and asked for my identification. I showed my papers connecting me with Standard Oil, and the sheriff told the men to back off. I hear a lot about the gallantry of the

South, about its thoroughbred horses and women. I could see they had plenty of "sportin' blood" by the way the gallant young southern gentlemen heckled the girls in the picket line around the Bell Telephone Company office.

I did well on this trip. I worked on, mostly around the refinery. When I rented a car, being mobile enlarged my scope. Roy sent me ten boxes of 5x7 Kodachrome and a set of Harrison filters plus a light temperature meter. He told me to try it out and see what I can do with color. The film had an ASA rating of ten, but I used it on a big camera on a tripod. It was fun for me and I did get some fine color things. I even did some pictures of the refinery at night. One of these night photographs later became the first color photograph used on the cover of *Fortune*. With the car I was able to explore the countryside and became well acquainted with the bayou country west of the Mississippi. I met Elmore Morgan, a photographer from Baton Rouge, and we became friends. He helped me find my way around. I got to know W. B. Cotton, the public relations man for the refinery. He took me with him when he made business trips. One trip took us to New Orleans, giving me my first look at that city and my first meal at Antoine's famous restaurant. I was entranced with the old French Quarter.

Later in my stay, Cartier-Bresson showed up at my hotel. Roy wanted me to show him around the refinery. We had a good time. He always wanted to look at the ground glass when I was set up for a photograph. The upside-down image bothered him at first. I enjoyed seeing him jump around with the Leica. He is a nice, gentle guy. I had one laugh at the loading dock when Cartier went to the drinking fountain labeled "Colored Only." One of the men shouted a big "No," and Henri said, "That's all right, my wife is colored." The year before, when he and his Javanese wife were in New Orleans, they were forced to sit in the back of the streetcar.

5/19/47: Roy arrived Tuesday night. I went over to his hotel and we talked far into the night. On Wednesday and Thursday we took some trips around the country, I made some photographs, and we had some enjoyable talk. On Friday we went to Abbeville by a circuitous route through Church Point, Lafayette, New Iberia, and St. Martinsville. We arrived in Abbeville late in the afternoon. I met Bob Flaherty

and the crew who were filming *Louisiana Story* for Standard Oil. Bob, Roy, Monica, and I went to the ball game at night and saw Natchez give Abbeville a drubbing. On Saturday we went on location with the crew and watched Bob fake part of his alligator sequence on McIlhenny's alligator pond. I couldn't do much photographing while Roy was there as he was always on the go. I came back to Baton Rouge so I could go to the pirogue races with Elmore Morgan on Sunday. We left here at seven o'clock and got to LaFitte on Bayou Barataria around ten o'clock. The race was not much for me to photograph, but the people were having such a good time that I found some offbeat things to photograph that didn't have anything to do with the race. We were back in Baton Rouge late Sunday night and Roy called. He wants me to fly to Tulsa, Oklahoma, on Tuesday to do some pictures of a pipeline installation for *The Lamp,* an Esso publication. It should only take three days. And then he wants me to go to Abbeville for a few weeks to make production stills for Bob's film. I think I will like that. I won't have to work all the time so I will be able to travel around the country and make some pictures for Roy. I have to go to New Orleans for my plane to Tulsa.

5/24/47: Got back from Tulsa tonight. Not an exciting trip. Bad weather for one thing. Eddie Adolphe, the writer for Ed Sammis, *The Lamp*'s editor, is married to an oil heiress and he loves it. Being from an old (1912) oil family makes her an important person here. Many of the families in Tulsa are very oil rich and only one generation away from farmers and roustabouts, and great efforts are underway to make Tulsa a cultural center. A couple hundred young teenage kids were at the Mayo Hotel where I stayed. Some of the mother chaperones were like women out of a prairie schooner, dressed in five-hundred-dollar evening dresses.

5/30/47: Came over from Baton Rouge to Abbeville to work with Bob Flaherty. I am staying at the Audrey, not the most elegant hotel I have stopped at. Had dinner with the Flahertys last night and it was fun but I will forego that pleasure in the future except on special occasions. Ricky Leacock is the photographer and his assistant is Lenny. Benji Doniger does the sound track. *I was with the Flahertys and the crew until July 2 when the film was finished, and then went back to New York.*

It has been a great experience and I did make a lot of good photographs. I had considerable time to myself and made many trips around the country. One day, near Lafayette, I discovered the Ayers brothers. During World War I the three brothers, then in their teens, came from Tennessee to Louisiana to prospect for oil. They acquired some property and began drilling with a crude rig. At about 1,500 feet they struck oil. It was not very productive but it did bring in five or six barrels a day. They farmed the land and raised a few cattle and chickens. By the time World War II came along, they had three producing wells giving them twenty-five to thirty-five barrels a day. They tried to market the oil to the Standard Oil refinery at Baton Rouge, but the big company was not interested in such a small production. So the brothers, with the help of a retired refinery worker, built a small refinery of their own on their property near Lafayette. They sold the gasoline to their many friends and the years when oil was so scarce were no hardship for this independent group. I tried to get Standard Oil to do a story on this family, but they would have nothing to do with it.

Life in Abbeville was not dull. The Flaherty menage is lively to say the least. Bob Flaherty is a great human being, he loves his work, and is generous beyond the call of duty. One day he asked me what I like to drink. I don't drink much, but on my last trip to New Orleans I had tasted some Jamaica rum that seemed good so I mentioned that. A few days later he brought me a case of rum, enough to last me five years. When Roy was coming, Bob asked what he liked. Roy had about two drinks a month, but when he did have something it was always Irish whiskey. I told Bob, who greeted Roy with a case of Jameson's. I guess all these treats were bought with Standard Oil money.

The Flahertys' cook has Thursday nights off so Bob takes the crew to dinner at one of the local restaurants. The catch is that, like most places in that area, the restaurant has a slot machine. Bob loves to play the machines, which he does every time we go out on Thursday evenings. And, every time we have to buy our own dinners as well as Bob's. He is such a lovable guy, no one minds.

The work on the film all through June took us to Weeks and Avery islands to do sequences on the cypress swamps and on

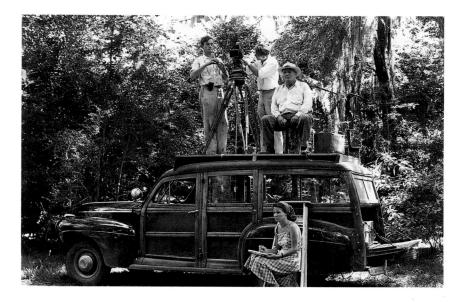

the bayou where a Humble Oil Company crew was drilling an oil well. The crew with Bob directing was fine and I learned something about filmmaking. I contributed a great many good photographs that were used for publicity purposes. When the whole crew left on July 2, I stayed on to make more photographs of the country. I spent a good month living in Abbeville and other towns, making hundreds of pictures for the New York file. During that time I got a letter from Don Shapiro, on old friend from the Detroit days. He had moved to California and told me about a camera he had seen for sale in San Francisco. It was a used AutoGraflex in 4x5 format for $175 which seemed a great bargain, so I sent him a check. When the camera arrived in less than a week, it was a pleasant surprise. It was in perfect condition. It had a ten-inch Bausch and Lomb Tessar lens. The big bonus was that there were four film magazines, each one holding a dozen pieces of film. Just the camera for me.

I got back to New York about the first of September and was happy to be home. One of the first things I did was to buy a new Chevrolet sedan. Roy has suggested I get a car as he has some things he would like me to do.

9/10/47: The Newhalls are back, so I spent an evening there the other night. Vera Nelson was there and she loves to cut hair, so Beaumont, Paul Strand, and I are well shorn. Finally, I have a telephone.

9/14/47: Having a car is fine and important for my work at

Standard Oil but is a pain here in New York. I have to keep it in a garage over on 125th Street and the fee is thirty dollars a month. I went to the Photo League the other night—a waste of time for me. Sunday I took Dee and Rip out to Montauk Point in the car for a swim in the ocean and a picnic on the beach. I made four 8x10 negatives and also a few sea things with my Graflex. I like the camera very much. It is big and heavy enough to keep me reminded that cameras are not toys and that photography is not some kind of social game.

Harry came on September 20 and stayed a couple of days. We had a lot of fun and were both tired by the time he had to return to Chicago. The day after Harry left, Roy called me into his office and asked what I know about New England. He said I should get packed up, take my car, and spend a few weeks up there touring around and see what I see. He will be interested to see the photographs when they are made.

9/27/47: I'm in Norwich, Connecticut, at the Wauregan Hotel on a wide-open assignment—just make photographs of what I see in New England. That is all the instruction I have. I have my 8x10 as well as all my other cameras. Had dinner with Roy and Bob Flaherty at the Coffee House last night. Jo Davidson, a flamboyant sculptor, joined us, and he and Bob put on a show telling tall tales of their experiences. Later, Arnold Eagle had a farewell party for me and John Vachon, who is also off on an assignment. John and Arnold are very funny when they are a little tight. Penny Vachon was not tight, but she lost her purse with forty bucks in it. I had a great time.

When I stopped in Salem, Massachusetts, I really worked and wrote, "I did a lot of work." I made four 8x10s, fourteen 5x7s, and thirty-three 4x5 negatives, as well as four 5x7 Kodachromes. I arrived in Salem just at dusk and it seemed weirdly dull in the same way a small Canadian town is dull. A couple of restaurants and a small bar were open. Small groups of teenage kids wandered the streets. I accidentally exposed a negative when I was reloading my holders tonight. I wonder which one it was. Probably the one negative that would have made this whole trip worthwhile, the negative I have been trying to make since I started photographing, maybe even the one everyone has been trying to make.

10/10/47: The weather being dull I decided to move on to Boston. There was not a room available downtown. I found a room in Lynn in a fleabag for five dollars. I called Roy to talk. I thought maybe I've been skimming too lightly. He said that is just what he wants and to stay another three weeks. I find it hard not to get involved as I do really enjoy talking to people and that interferes with the work. I met a wonderful Italian couple in Lawrence who invited me to have spaghetti with them in their home. I wanted to but I knew I could never get away. The man and his wife had both worked in the textile mill since they were kids and could remember when they were paid six dollars a week. It wasn't a very nice day but I still made twenty negatives.

I had to go back to New York to pick up more film. When I stopped in to see Steichen, he invited me to stop at his house in Connecticut on my way back to New England. He has a wonderful place and a remarkable three-legged dog he calls Tripod. I enjoyed talking to his wife about birds, of all things. We had to talk in the kitchen because she was waiting for a certain bird due to arrive at the feeder at four o'clock this afternoon. The bird was ten minutes late, but she was delighted when it did show, and so was I. I think Steichen is very proud of the house and the six hundred acres he has here. Just outside the house is a handsome pond that reflects the color of the trees.

10/29/47: I worked my way into New England as far as Massachusetts. As the weather has begun to feel like winter I've come back to New York. I missed seeing Ferd, but there is a letter from him sent from Paris. He will be home soon, and I look forward to hearing about his trip. I was surprised to receive a veteran's bonus check from the state of Michigan, for $465. It would have been wonderful if I could have had it this time last year. I am busy with my captions and making the prints from my 8x10 negatives. Steichen wants to see a body of my work so he can have a show for me at MOMA. I told him I think it is too soon for me to have another show. I haven't enough to add to what I showed last year. The Newhalls had a party for Ansel and we all had a good time. Enjoyed seeing Lisette and Helen Levitt. I bought some clothes today, a suede sports jacket and shirts and ties. I don't bother much with clothes anymore. I used to be rather a dude when I lived in Detroit.

I have been out photographing with the Rollei. It is a teaser for me. It keeps amazing me with the quality it gets and then it lets me down with the pictures I get. Maybe I am like Ansel and have the handicap of not being able to see well from the angle of my navel.

11/5/47: Went to a Photo League party at the Gwathmeys'. I am sick of that group. They claim to have the best school in the country but I see no signs of that. When I asked them how many schools they have been to around the country, they backed off and said New York. Had lunch with Bob Flaherty. We went to Cavanaugh's. He is a big shot there, and all of the old waiters bow and say, "Hello, Mr. Flaherty." Bob beams and bows back and sneaks a peek to see if I am impressed. He is a lovable old guy. He told me about all of the old whorehouses that used to be on 23rd Street.

11/10/47: Having a tough time getting together with Ferd. Roy just gave me an assignment in Pittsburgh to make pictures of the launching of a new towboat. Five minutes later I got a letter from Ferd saying he will arrive by ship on Saturday. I'll call him from Pittsburgh. Willard and Barbara Morgan had a party for Ansel and many of my friends were there, even Roy.

Despite rainy weather the pictures of the launching of the *Esso Louisiana* are fine and everybody is happy with them. I was impressed with the city of Pittsburgh. Hope I can go there to photograph some time. When I got back Ferd was home. We had dinner at McManus's with dessert at the Automat. Joe Losey had dinner with us.

11/30/47: The last ten days have been hectic. No time for anything, not even writing in my journal. Had Thanksgiving dinner with the Strykers and the Rosskams. I liked both Ed and Louise whom I had not met before. I leave for Montreal tonight to do some work on the refinery there. I should be back in three days and then early next week I go back to Louisiana to work on what is called "The Muskrat Story." That will be in the swamp with Lionel.

12/6/47: Just back from Montreal. It wasn't much of a trip, and the job was dreary. The most exciting part was the trouble I had with the Canadian Customs at the border on account of my equipment. The Imperial Refinery had to put

up a bond of $296 before they would let me in with my gear. It was bitter cold there and I am glad to be back in New York. It was a beautiful day here; I photographed on Mott Street with the Rollei. I saw two women sitting in a doorway and asked if I could make a picture of them. They seemed pleased. When I had finished one of the women said I should take off my coat so she could sew on a button that was loose. I will take her a print next time I am down that way.

12/10/47: I leave for Louisiana tomorrow night. I am going by train, a plan that makes sense with a big snowstorm in the offing. The kids at the office had a going-away party for me. I sent a wire to Harry that I will be in Chicago. I also wired the Auto Garage in Baton Rouge that I will need a car beginning Saturday.

12/12/47: After a rather hectic evening with Harry and Art, I am now having breakfast on the *Panama Limited* en route to Louisiana. I enjoy talking to people on the train. It amazes me how much I have grown in the last two years—I meet people in various places and have something to talk about. I think I am easy to talk to as I am a good listener. My theory is that humility is a great plus if you are eager to learn. Sheer brilliance and too much intellectual jargon can be stifling and turn listeners off. Roy is an example of what I am trying to say. He has an amazing knowledge of a great many things, but at the same time he talks so simply that he never gives one the feeling of being overwhelmed by his knowledge.

Had a call from Roy to go to Tulsa to do some more work on a pipeline they are building in Oklahoma City. I did have my Christmas in Abbeville with the Normans, kinfolk of my friend Elmore Morgan. And I did get to Lafayette to visit the Ayers brothers. Only Robert was there. Doc and John had gone to Tennessee for the holidays. Three wells were pumping away. Their house is something. They have natural gas in one of the wells, which they have piped into the house. Little jets are burning all over where they can light their pipes. I finished my work in Oklahoma and was back in Abbeville to see the new year in.

1/4/48: Lionel took me to his camp in the marsh. On the way, he put a net out the back of his boat and pulled in about ten pounds of beautiful large shrimp. When we got to his shack

he started a fire going and put on a huge pot of water to boil. When it was steaming away he poured in a quart of gin and dropped the shrimp in. What a meal we had. Just shrimp and bread, but what shrimp!

He has two sons, Sidney and Minus, both trappers; we visited their camps. They are college graduates with attractive wives who stay at the camps with them for the three-month muskrat season. The camps are surprisingly neat and clean because the women have a knack for making them homelike. We ate venison and wild duck. The venison really stank, literally, but the duck was delicious. I enjoyed photographing and I am sure I have some good pictures.

1/5/48: Had a good day. Went to visit some trappers on Onion Bayou—the Prejean family and the Cade family. The Prejeans are French and speak no English; the Cades are colored and speak both French and English. I think I have some good photographs of the muskrat business and am ready to call it quits. This year the catch is small, but the higher prices will compensate. Rats that brought only $.75 last year are now selling for $2.00. And the nutria, last year at $1.50, are now bringing $5.00.

1/14/48: Damn the lapses in my journal. Writing a daily report for Roy is playing hob with it. This has been the best trip by far for Roy. I got a batch of contact prints back today showing some very good things. I have enjoyed photographing and have been blessed with fine weather. I came over to Baton Rouge from Abbeville in a driving rain. It has been fine every day since and I think I know better how to do the refinery.

1/28/48: Back in my lovely New York. It is good to go away just to have the joy of coming back. Had a good time en route with Harry in Chicago. I don't find Chicago a place to turn me on to photograph. I haven't made any pictures since I got back. I am busy with the New Orleans work to print and captions to write. Roy gave us all a scare today when he talked about rumors of a budget cut for his department.

2/1/48: I am taking this week off, more or less at Roy's suggestion. The budget is now settled and it could be worse. Last year we had 7.1 full-time photographers working and

this year we will have 4.1. That means about half-time work, which is just about what I would like. I have just finished paying for my car, have all the equipment I need, and will welcome some time to do things for myself.

With the money for Standard Oil's photographic project beginning to dry up, I am doing more work for myself, despite the usual winter problems with sticking shutters and cold hands. The dean of Ohio University at Athens, Ohio, came to see Roy about finding a teacher to head the new photography department, and Roy recommended me. I know I am not ready to teach and turned it down, but talking to Roy about it got me thinking. I believe I might like to teach eventually, but at the moment I want to photograph and nothing else. I feel I am still in the learning stage. I would dread having to answer questions like, "How can you make money with this type of photography?" There has to be an answer to that without being evasive. Ansel asked me if I would come to Yosemite to teach a short course in documentary photography, and I have a notion to take him up on it. At least I would not have to teach technique at his school, where the students would always be giving me tips. I think a lot about how I would teach. I have a pretty good idea about what I would hope to achieve but the method will take some thinking. I would like to impress that photography is a tool to supplement one's main interest in living, that it is a way of making oneself clearly understood, of communicating thoughts and ideas to others. My aim would be to have the student photograph whatever he has the greatest interest in. I feel there is nothing new in photography to be discovered. The only thing that can be added is a personal viewpoint.

2/26/48: My new phone rang this morning; it was Charlie Hoben from Florida State University offering me a teaching job at the school starting at $4,500 a year. If it were an eastern or even a midwestern school, I believe I would take it. But in a cracker state like Florida, I would have the KKK in my back yard within a week. I wrote to Elmore Morgan about the job. With his experience living in Louisiana he might be able to handle it. I talked to Steichen about teaching and he recommended starting new students out with a box Brownie, working first on seeing, and later on technique.

Ray Macklin at *Life* had called to see some of my color, and I'd

taken some to him. He appeared to be quite impressed. Later he called again to tell me that *Life* is launching a short-term Color Project—a weekly news story using a one-page color photograph from a 4x5 color transparency. The following week Prince Michael of Rumania was to arrive in New York on the *Queen Mary*; Ray asked me to meet the ship and get a color photograph of the prince coming down the gangplank. I was appalled as I do not see how I could make an interesting photograph of something like that. I told Ray it is not the job for me, and he seemed disappointed.

3/24/48: Tried my Sixth Avenue panel idea this morning and I might have missed it. It was surprisingly hard to do because of the cars and trucks that park for just a few minutes. Also the cars that come whizzing by from both directions that you must shoot between. You can't use part of a car in one section. You must have all of it or nothing. I am just getting ready to develop the negatives and I am holding my breath. I think I will have to limit my panel to one block. The cross street is impossible as the angle of my lens is so narrow that it will not cover both sides of the cross street. Roy is sending me back to Pittsburgh next week. The negatives for the panel look great—and now if I can make a set of matched prints! I went to Washington for a couple of days to make some color pictures of the cherry blossoms for Rene Leonhardt.

4/5/48: I have my orders for Pittsburgh today and will leave early Thursday morning. Roy says three weeks, but it could well stretch to four or five. Steichen's impressive new show, "In and Out of Focus," opened this afternoon. The photographs are well hung, and I am pleased to be a part of it. Harry's prints look fine and really stand out. The color is a flop for me in that large format. Overall the show is nice, but I feel the really great photographs are few and far between. Showing all the new names is Steichen's important contribution to photography. I think that may have been the Newhalls' weakness: they didn't show photographs that didn't have Ansel's approval, whereas Steichen can make up his own mind.

The Pittsburgh job went on until April 30, and I think it may have been the most productive project I have done for Roy. A week of solid rain gave me time to explore. I made a number of photographs of the wet, shiny streets.

4/20/48: I worked like hell today and turned out about thirty negatives, 4x5 and 5x7. It was a good day's work. I mulled over making a trip to Europe for Rene Leonhardt, and I would like to go if I can. He asked me to go to make photographs of the English countryside. Touring England and Scotland by car and by myself has great appeal. Then, if I could have just a month at the end to do my own work in black and white, I could have a nice batch of photographs to add to my own collection. I prefer to do my own work last and separately after I have become accustomed to the country. I miss New York as this is the best time of the year there. I have magazines and film holders to load. A kid in the lobby made me feel good. He wanted my autograph, thinking I was a ballplayer. With Forbes Field nearby, the Pirates stay in this hotel.

4/30/48: I am doing some work for Roy on the Esso Building. Actually, it is for *Architectural Forum*, in color. I am all set to go to England the last week in May. I went to dinner with Dee and then to the Newhalls'. Brett Weston was there and again he set up his easel and lights and showed his photographs, this time 11x14 contact prints. Nice prints but not much content, I thought.

I filed an application for a passport today. Sally went with me to be the witness. Lisette is doing some work for Roy and I think she is doing well. I think it may be harder than it was for me.

5/3/48: One of those days. I had a P.R. job for Esso that I hated, photographing a bunch of young Latin American lawyers who had been here for four months being trained and indoctrinated in American business methods. They were being given a farewell dinner at the musty University Club. After hearing a speech and the darnedest instructions on how they should all work to change the laws of their respective countries so that they would be attractive to American capital, I hardly had the stomach to photograph them.

5/7/48: The party at the Newhalls' last night was not up to par. Brett showed his photographs again and Ferd and I did not look while he was blasting them with strong light on the easel. We may have been considered impolite but I did not

feel like going through that again so soon. Brett seems like a nice guy and I would like to have a talk with him. He does so many things that seem to duplicate his father's work, I wonder if it is hereditary or from environment. His vision appears to be limited to things his father sees. It is too bad because Brett is a remarkable technician; he must have some vision of his own. I don't know Edward well but I have heard that he can be pretty sarcastic about any photography that does not fit his pattern. It could be fear of his father's scorn that keeps Brett in line. I can just imagine the ribbing Brett would get from his old man if he accidentally got a person in one of his photographs. He would no doubt be branded a documentary photographer, which is worse than SOB in that circle.

5/16/48: This was one of the bad days. It rained and I stayed in the house making and mounting some prints. I am having trouble making good prints and I think it is because my mind is so full of plans that I can't concentrate. I get in the darkroom and find myself thinking of England, Central America, Sally Forbes, or what I will say to Lieberman tomorrow if I should get to see him. To make good prints you must forget everything else. You are really printing when your brain and hands are no longer yours. They do the right things, you know the correct time to expose and develop, you don't think about England and other things. I like it best when I come home, develop my negatives, and can hardly wait for them to dry so I can print.

5/20/48: This was a big day. Leonhardt called to tell me that my passage was booked on the Dutch ship *S. S. Veendam*, sailing from Hoboken on June 11 for Southampton. The Leica and accessories came that my brother sent me from Germany. I doubt I will take the Leica to England as I feel I will need some time to learn to use it properly. As the time for my departure nears I seem to be busier than ever. Harry wanted me to come to Chicago before I sailed and he would come back with me to New York to see me off. I finally did drive to Chicago and enjoyed a couple of days there.

6/11/48: At last aboard ship on my way to Europe. I didn't really become excited until I began to pack last night. Harry, Dee, Emerson Wolfert, and his wife came to the boat with me. John and Penny Vachon came but were too late to come

aboard. I waved to them on the dock. The ship seems good even if on the old side. I am in a cabin for three. My roommates are both older; Scots, I believe. One is talkative and the other is silent and dour. We sailed at exactly 10:00, and I will be in bed early after a long, exciting day.

The voyage took ten days with a stop at Cobh, Ireland; it was really a delightful vacation. I was sort of adopted by a group of young teachers and students who were going to Europe for various reasons. Two of them, Kathleen Elliott, admissions director at Radcliffe, and Peter Elder, professor of medieval languages at Harvard, were near my age and became friends. The young people I knew only on a first-name basis.

6/18/48: Peter and I fulfilled a previously expressed desire to pee off the stern of the *Veendam.* I would not recommend peeing into the ocean as a balm to the ego. The ocean is so big and your stream so piddling. Doing so with a scholar like Peter helps.

6/21/48: I think this is the most exciting day of my life. London is much more than I had planned on. I told the elevator man here at the Waldorf just that and he is still beaming. My hotel is on Aldwych Circle between the Strand and Fleet Street. What an address! I went to a pub that was like a Third Avenue bar in New York. The people were nice and warm. I am excited and my weariness is gone. I came through Customs in three minutes, without a silly question or a silly answer. Henry Robiczk, Leonhardt's agent in London, was helpful and will soon be busy arranging a car and itinerary for my first trip in England.

6/22/48: Went out with the Rollei this morning and walked to the Strand, then through Trafalgar Square to Haymarket and American Express, where I had no mail. I went into Charing Cross Station and made a couple of negatives. Tonight Henry and I went to a little Greek restaurant in Soho and had quite a good meal. Food is strictly rationed in Britain now. Meals are restricted to a cost of six shillings and, unless one belongs to a club, this is the price you pay, no more. I will be ready to start on my first trip north on Thursday if we can arrange for a car.

6/23/48: A fine day. I have been out and made a roll of film on

Billingsgate Fish Market, London, 1948.

Waterloo Bridge, the Strand, and Victoria Embankment. Henry and I made arrangements about the car, a little Austin, this morning. I will have to get packed. I leave at noon for Buxton on my first trip, which I expect to last three or four weeks.

6/25/48: I left London yesterday and gingerly puttered my way along on the left side of the road through St. Albans, Bedford, Leicester, Derby, and Belper, where I spent the night. I had intended to stop in Buxton for a couple of days, but there was a fair on and no accommodations were available. I came on to Kendal, a gingerbread place with real people living in it. The English countryside is beautiful beyond words and maybe even beyond photographs unless the weather breaks. I did get around town between showers and made some pictures with the Rollei but no transparencies. I was told I might have a better chance of sun at Keswick, which is at a higher elevation.

6/29/48: My first box of film is packed and I am getting it ready to take to the Keswick post office. I am staying at a very old inn, the Pheasant, on the shore of Bassenthwaite Lake. The weather is grim and one can hardly go out of the inn. If it weren't for the pressure to make photographs, I could enjoy this stay. There are two young couples here on holiday; I particularly like Allan and Peggy. He is a fellow at Magdalen College at Oxford. He invited me to stop and spend the night when I get to Oxford and I look forward to that.

7/2/48: Had a good day yesterday. The sun was out about half the time and I made hay. I feel much better and now I have another thirty sheets of film to send in for processing. It is dull again today and I am stuck inside.

The Englishman is an amazing person. He has more than his share of dignity. I see a man out of my window wheeling a barrow. He has on rubber boots and old trousers but a fine sport jacket with a shirt and tie. I see people on bike tours with camping outfits riding along the roads with ties and jackets, all very neat.

Went to the race meeting at Carlisle this afternoon with Allan and Peggy. Bad weather but I made a few things with the

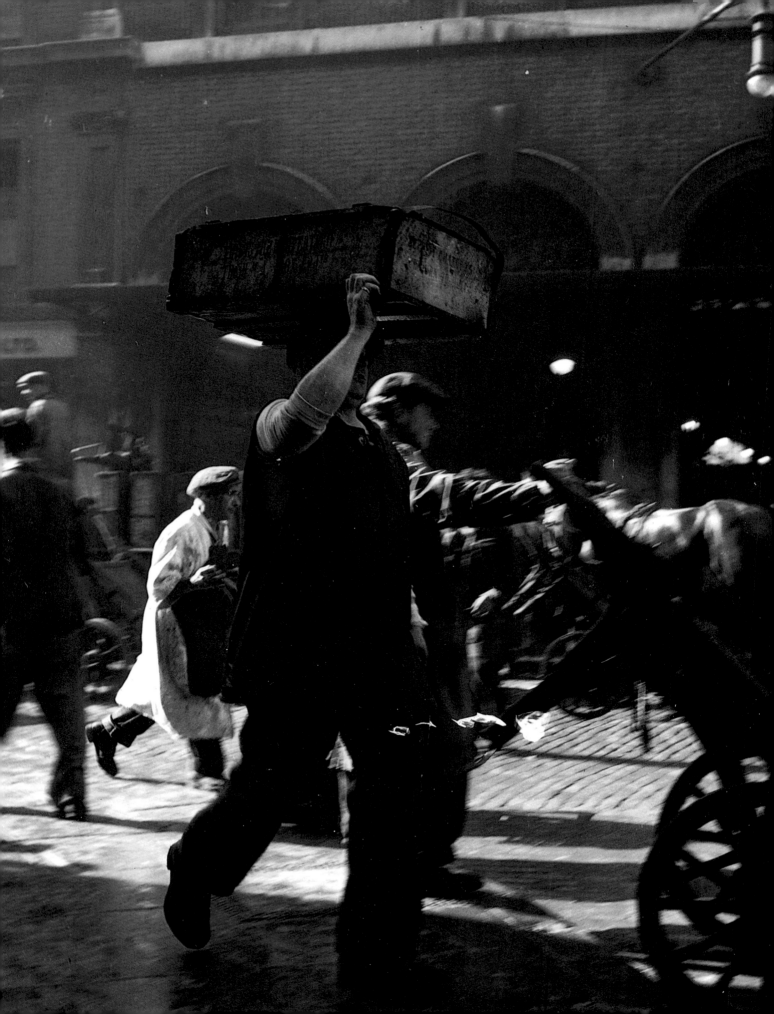

Rollei. I bet on a race and my horse won, but I had only bet two bob.

My stay in the Lake Country is about to end. I did manage to make eighty transparencies, many of them under trying conditions. The fact that my 5x7 Kodachrome had an ASA rating of ten didn't help. I went back to Buxton and found it disappointing. I stayed at the posh Palace Hotel and didn't relish the grandeur, the swimming pool, play rooms, or even the—so the sign said—American bar. The weather was bad coming from Kendal. I came by way of Settle, through Halifax and Huddersfield, industrial towns just as dreary as any other place where workers must live on low wages. The towns all seem to be in valleys and in this kind of wet weather smog hangs over them. As I was leaving Buxton, the weather seemed to be improving. The country was very beautiful but by the time I got to Miller's Dale the rain had begun again. I went on to Tidewell where I made some photographs of the stained glass windows in the Cathedral of the Peak which was built in 1359. After making twenty-seven transparencies, I went back to Buxton and sat out the bad weather.

I went next to Chester and then on to Liverpool to see Allan, and by accident ran into him on the street. We had lunch and a good talk and I will see him when I get to Oxford. Then had some good sun for an hour and made eleven Kodachromes, mostly around Conway Castle and on the way to Betws-y-coed in North Wales. The best stop on this trip so far. The sun was great and for the first time I used all of my holders in one day; quite spectacular mountain scenery and a river with white waterfalls.

I worked my way down the Wye River and for the first time felt I was doing well. The weather remained fine and I used all of my holders on several occasions. Went through the Cotswolds which I didn't find as exciting as I was told they would be. I did like Stratford-Upon-Avon and didn't expect I would as it has such a reputation as a tourist center. I did all of the tourist things I was to do, even Anne Hathaway's cottage.

7/21/48: Spent last night at Magdalen College at Oxford, the guest of Allan Hargreaves. He lives in a very swank quarter

and has a "man" who looks after him. It seems British to the core. They hang on to the old tradition of pomp and ceremony, the impeccable reverence. Allan wears a long black gown for almost all of his activities. A great part of the grounds is restricted to a chosen few. The faculty and fellows live like kings in a cold medieval building with oak-paneled rooms, and eat in a huge dining room that is like a church. The dinner was quite good and the conversation was focused upon what they called "the Truman airlift to Berlin." (I could not find any fault with their views.) The college buildings all look ancient. There is one they call "the new building," and I noticed that it was built in 1733.

7/30/48: Having a good time in London. Had to get my ration book if I am to accept invitations to eat out. Eating out in London is no problem; the catch is the six-shilling limit for meals and that means not very big helpings and little variety. Very little meat can be bought. I went to a Chinese restaurant in Soho and instead of rice, which is unavailable, they gave me spaghetti chopped to about the size of rice grains. The British seem to take the shortages in stride and I guess I can too.

This afternoon I went around London. It is great from the upper deck of a bus. I had not realized how badly London had been bombed. The great open spaces you see from the top of the bus were once blocks of buildings. Now they are fields of purple flowers. I rode with a girl who had been an A.R.P. worker during the blitz and she pointed out ruins of more or less famous landmarks like the Old Vic and the Elephant Club. You can see things from the top of a bus that you cannot see walking or driving along the streets.

I am lucky that I do not have to make pictures of the Olympic Games being held in London this year. Many of the events have been rained out and postponed.

8/2/48: Henry came back last night with Paulus Lesser, the other photographer who works for Leonhardt, and Paulus's brother Titus, a sculptor who lives in Holland and whom I liked. There will be a car available so I will be off in a day or two.

8/7/48: A good day for a change, and I made the most of it. I

Courtyard, rue Jacob, Paris, September 1948.

used all of my holders and even made a change of film in a darkroom in Canterbury late this afternoon. As soon as I had my holders loaded, the sun took a powder for the day. The country was good to see. Sussex is the heart of the hop-growing industry, and the drying barns are odd-looking structures.

8/14/48: Back in London. Looked up John Vachon's old girl friend Germaine Canova, and she invited me to dinner at her apartment. She is a photographer and asked me to bring some of my pictures. She is a radiant blonde Frenchwoman, close to my age I would guess, and lives in a nice place at 99 Harley Street. She has just returned from France with some steaks, so we had quite a fine meal. She and John met in Poland when he was on assignment for *Look* right after the war.

8/18/48: Have been in London almost a week and the weather has been terrible. But it was almost fine this morning and I made nine Kodachromes near London Tower and the Tower Bridge.

Received a wire from Rene Leonhardt. He says I should take a holiday and go to Paris for two weeks, on the house. If I see something I like I should make him a few photographs.

9/7/48: Packed and ready to leave for Paris. I was at Victoria Station in time to catch the boat train to France. I got the last compartment and spread my gear around. Just as the train was ready to leave, the door burst open and in came a great big man with a cello case, who was to share the compartment with me. It was Igor Piatigorsky, on his way to Paris from the music festival in Edinburgh. He was aghast when he saw all my gear. But he was nice, and we worked together to get some of my things stored under the bunk to make room for his things. I volunteered to sleep in the upper bunk. We had breakfast together, and as we rolled toward Paris we stood in the aisle so we could watch the handsome French countryside flash past. He seemed to know the towns we passed through and told me a number of things. When we arrived at Gare St. Lazare he introduced me to his wife and wished me luck in Paris. I took a taxi to 44 rue Jacob and fell completely in love with Paris before we reached the Hotel d'Angleterre. As soon as I had unpacked, I was on the street with my 5x7 camera. I made fourteen black-and-white and six color photos for René

before I took time out to have something to eat. I was entranced. The hotel and nearby restaurant Au Petit St. Benoit were everything Ferd had told me. And the light today was a photographer's dream.

The next two weeks turned out to be the most productive of my career. I was out early every day, always walking in the direction of the Champs Elysées and always running out of film before I could reach it. So, after two weeks in Paris, I never did see the Champs, and several of my friends in New York could not believe it. I did get to know well the area around St. Germain des Prés, which I covered on foot.

One day when I was in front of the Institut de France, I noticed a heart made by the paving stones and set up my camera to make a photograph. A man sitting on a stool was making a drawing of the Institut. When he saw me focusing on the pavement, he came over to see what I was doing. He spoke some English and we had a good conversation. He was pleased to see the heart and after some thought told me what the VP in the heart meant. Like me, he first thought these must be the initials of the stone layer's sweetheart. They really stood for Ville Paris. I made a photograph of him sitting on his chair making an etching of the institute. We exchanged names, and when I returned to New York I discovered that André Dunoyer de Segonzac was a famous French painter and etcher.

I have discovered how easy it is to use the Metro and have made several trips to Montmarte with my big camera. As in New York, the big camera attracts attention, and I meet many people on the street who want to know what I am doing. They are mostly very friendly.

9/10/48: Went to Montmarte today and found a little bar where the people took me in as a member of the family. The madame is going to get some mussels and cook them for me when I come up again. I am really having a great time. I see well here, and the light is wonderful. Even the girls are up to advance publicity. I am beginning to think that if I ever do get married it will be to a French girl.

I met a nice girl at the Bar Vert on rue Jacob, an American. She married a Frenchman in the 1930s and lived in Paris all through the Occupation. After the war she went back to the

Mme. Varlet, owner of the restaurant Au Petit St. Benoit, Paris, September 1948.

M. Varlet, owner of the restaurant Au Petit St. Benoit, Paris, September 1948.

André Dunoyer de Segonzac, French
painter, September 1948.

Pavement in front of the Institut de
France, Paris, September 1948.

Montmartre, Paris, 1948.

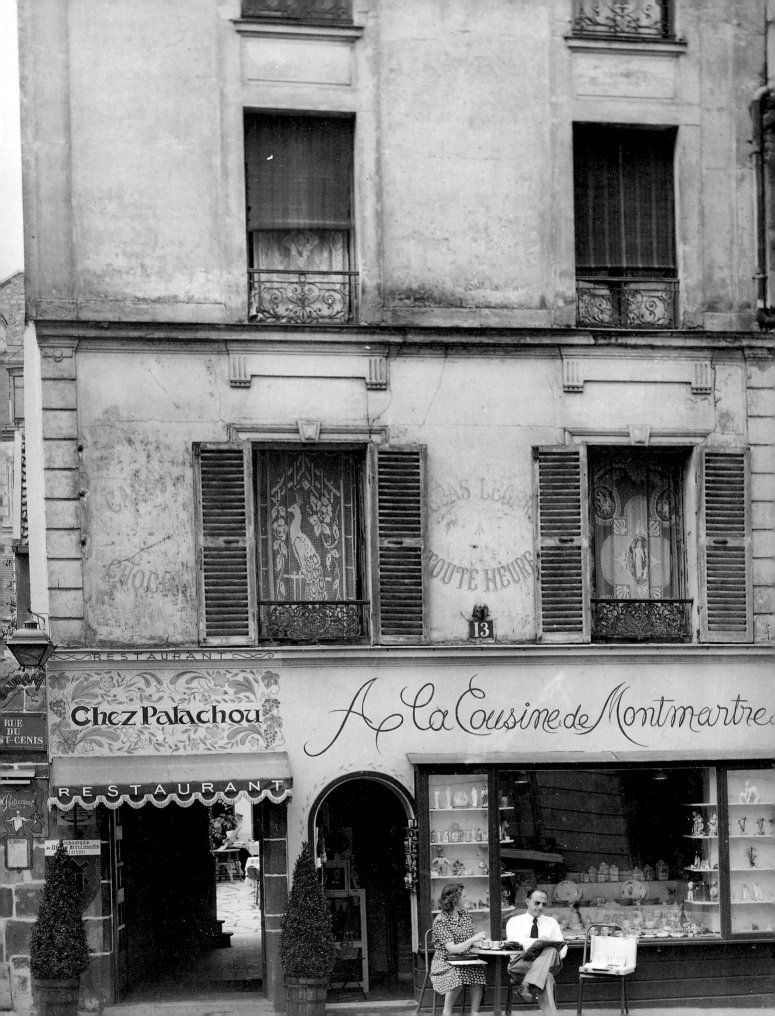

States but only stayed a month, missing Paris so much. She showed me around and I learned a lot of things from her. If she had not been so partial to cognac the affair might have had serious consequences. A year later, she had begun the downhill trek that is sad to see.

That first Paris sojourn was over far too soon, but it is something I will always treasure as one of my great experiences. By February 1949 I was back in Paris to spend four years.

September 19 saw me back in England, and I must admit it seemed dull after Paris. Had another trip to the west country and spent a few days in Bath. It is a remarkable architectural city, beautifully laid out, some of the buildings in crescents, all in a brown stone.

I had a time getting back home. I almost made it on the Nieuw Amsterdam, *but when I reached dockside in Southampton there was not a place left and I had to go back to London. Finally Henry got me an air ticket on BOAC for October 8. It was a seventeen-hour flight to New York via Shannon, Ireland, and Gander, Newfoundland. It was good to be home.*

10/18/48: Went to Evsa's show and enjoyed seeing Lisette and Marion Palfi. The Newhalls are in town; Ferd and I had dinner with them at Le Gourmet and it was both French and expensive. I have been so busy printing the things I did in Paris that I am getting a little stale. Went to see Walker Evans at *Fortune,* and he is enthusiastic about my Paris pictures. He kept sixteen of them to make photostats and advised me to return to Paris as quickly as I can.

11/3/48: I am doing a little job for *Fortune* on the garment industry in New York, working with Walker Evans, which is great for me. He is one of my idols as a photographer and he is a wonderful guy, too, and good company. We had a big thrill today. Yesterday was election day and everyone thought Dewey was a shoo-in. Walker and I were working in a room with four hundred sewing machines pounding away. Some lights flashed on, the machines all stopped, and it was one of the loudest silences I have ever heard. Then the radio blared forth announcing that Dewey had reluctantly conceded the

election to Harry Truman. Pandemonium broke out. I must say it was one of my most thrilling moments.

After the garment worker job, I went on a trip down south for Roy. I was in North and South Carolina and made a lot of photographs. When I got back all the people at Standard Oil went to work making Roy's Christmas film. We were all actors in the skits and all wore masks. It was fun.

12/6/48: Now I am in the doldrums and can't seem to do anything right. I went out with my 8x10, floundered around all day, and made six negatives. It was fun for me even if the negatives are not very good. There is a great danger when you try to make your living with something you love as much as life itself. There is a temptation to be a success along conventional lines. Success always seems to be there, a plum, just waiting to be plucked. But it is a phony plum, and it can kill you for solid work. So far I have avoided it but now the danger is greater than ever. I am beginning to want things and when I think of the cost in time, it is scary. The secret is to want little. I must think and write about this. I would now but the stew is burning and the Liederkranz cheese is beginning to run all over the place.

12/15/48: I have a new set of uppers and my mouth is sore as hell. Had six teeth pulled this afternoon and my plate was fitted right in and it isn't too bad. I had dinner with Ferd and didn't tell him about it and he didn't even notice. I know it is going to become painful but I believe I can cope.

Having been determined to get back to France, I booked my passage to Le Havre on the *SS America* for February 17. When I told Roy about it he was excited. He thinks he might promise me three months' work in western Europe and that I might be able to do some things for Esso of France. He gave me a job to make photographs on the Ohio River from Pittsburgh to the west. *I left the day after Christmas and had a harrowing three-day trip to Pittsburgh having to cope with one blizzard after another.*

1/4/49: I am in Pittsburgh and the weather is foul; I can do nothing but think about my dame trouble. Not that my dame trouble is so acute, but it is unusual for me. Here are two very nice girls for whom I have always had a yen but never

dreamed that either one gave me more than a passing thought. And here they are, both telling me in the same week that they want me very much. It must be my new teeth that are slaying them. And the letters they write! I guess I am kind of in love with both of them. But, if they could only see me now—I am resting my mouth which is a little sore, my teeth are out, and I have the feeling that I look like something between Popeye and Moon Mullins. I refuse to look at myself in the mirror.

I worked my way down the Ohio River as far as Cincinnati, photographing in the river towns. I turned south at Cincinnati and worked down through Kentucky to Knoxville. I made a good batch of new photos for the file. Roy said he was pleased with what I was doing and was sure he would have quite a bit for me to do in Europe.

I finished my last trip for Roy and was glad to be back in New York to prepare for my departure on February 17. I sold my car and found a tenant for the apartment. At the last minute Carl Maas asked whether I would mind if his son Peter traveled with me to France and would I look out for him. He seemed like a nice boy and I agreed. The boy who was taking over the apartment also bought my enlarger. The finality of the whole packing-up business was rather sad. Dee Knapp took care of my negatives and some of my things. There were quite a few farewell parties to be lived through. A big one at Roy's house with all of the photographers I ever knew.

Peter Maas turned out to be good company and we had a good time aboard ship. A group of young French war brides going home for a holiday turned out to be friendly. I had a French lesson every day to prepare me for life in France.

2/25/49: Paris looks different without the foliage on the trees but it still looks fine. Peter went to the Angleterre and I checked into the Hotel de Nice. I had a happy reunion with my friends at le Bar Vert.

I had to go to the Gare Batignolles to get my things through customs. One case of film was completely smashed but nothing was missing. The customs officer was sympathetic and finally agreed that if I paid the duty on the cigarettes I

could legally bring in, he would pass the rest of my possessions with no duty problem. It was just a token collection, but it was a nice gesture and very friendly.

2/28/49: I went to the Champs Elysées today for the first time and must say that it is impressive. I saw the little Renault I will get on March 15. I can wait. Everything seems more expensive than it was in September but still cheaper than New York. You get about 350 francs for a dollar. The food seems better here and costs much less than in New York. I wrote to my bank in New York, asking them to transfer money from my account to Paris so I can open an account here. The customs people opened my letter and accused me of exporting dollars from France. It was touch and go for a while, but I was finally able to explain that I will be bringing dollars to France, not sending them out.

3/6/49: I applied to the Veterans Administration here to take a course at the Alliance Française on Boulevard Raspail. I am enrolled and it is taking a lot of time. I go five hours a week, an hour every day, and have about two hours of homework to get through.

Gordon Parks came in today and Pete Maas and I had dinner with him and visited a few spots. It is too expensive for me to go out with Gordon very much. He likes it here. He is a good guy but has a tough thing to beat. Being a famous photographer and being colored has put him in a trying spot. I believe he would like best to live simply, but he is a *Life* photographer, which makes him famous, so he is trapped. He is a symbol to his race and they demand that he live up to his greatness.

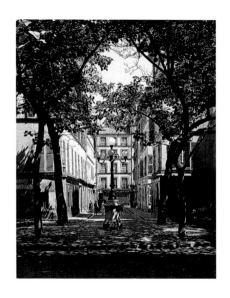

Place Furstenburg, Paris, 1949.

I went to see Robert Doisneau with Lew Stettner, and I liked his work very much but I could never do it. He is a family man and lives on the outskirts of the city near Porte d'Orleans. His wife and two children are charming.

5/25/49: Gordon Parks left for New York today and I will miss him. Lola, the dame we met at the Crillon where Gordon stayed, propositioned me to marry her and take her to the States where she would then give me a divorce and pay for it, if I wanted. Her idea of what it is like in America is quite common here in France. They meet Americans on holiday who seem to be carefree, generous, fun-loving people. She told

me that in America practically everyone goes to a night club every night and there is never a dull moment. She told me she had almost married a man from Omaha. She has been living in Paris for eleven years and thinks it is dull. How would Omaha fit into the picture? The Bobbs and Lucille, a woman I had met at a party in March, are back from Italy and I have seen them a few times. I took them to the Impressionist show at the Orangerie and I enjoyed it for about the tenth time. Lucille made a pass at me or vice versa.

6/1/49: Had fun with Lucille and the Bobbs last night at dinner at Au Petit St. Benoit and then to La Musette on rue de Lapp. Elmore was in form and we had a lot of laughs. The tourist buses kept coming and going, the tourists stolidly soaking up their fifteen minutes of Apache life. Somehow Lucille and I got together and it was the beginning of what could be an important love affair for me.

6/10/49: Things are happening to me. Things I hadn't planned or dreamed of. There is even a possibility that I may not be a bachelor forever. My friends from New York are going home and Lucille would like to return in September and become Mrs. Todd Webb. I believe I would like that and feel we will make a great partnership.

I am lonely with Lucille gone back to New York. Luckily I am busy working for Roy in Switzerland, Holland, and Belgium. I must say I am a little nervous about being a good husband and a good provider. How will it affect my feelings about photography?

6/28/49: I saw Mary Callery at the studio and told her about Lucille and she was kind of sore at me. She said, "You bastard, I thought you were going to marry me" (something I had never thought of). I sort of love her but she is too rich for me.

Early in July the Morels decided to rent a cottage in the village of Blonville on the Normandy coast. They wanted me to come with them and I offered to split the rent which was very small. It was a great place and we were lucky to have mostly good weather, something Normandy is not noted for. Deauville was only four kilometers away so there was some excitement. Pierre could only come on weekends but I was there with Luce

and the kids all week. Luce gave me a French lesson every day and François, age four, went shopping with me every morning in the market, where he also gave me a lesson.

After that vacation, Roy had some work for me to do in Holland and Belgium with a few days in Switzerland, and I enjoyed that. I got back to Paris about August 20, just in time to drive to le Havre to meet the SS America and Lucille.

8/24/49: Lucille is here now unpacking her things as I write this. It is all so natural and very nice. I was waiting at the end of the gangplank yesterday morning. Lucille came down and she looked wonderful in a yellow dress and her furry hat. She'd had a good trip on the boat and made many friends. The train ride to Paris was not such an ordeal. The tension of waiting and wondering was over and we both, with a few exceptional minutes, were quite calm. Peter was at the Gare St. Lazare with the car and we got the luggage home in a pouring rain. Had lunch at Restaurant Dessertaine and then home for a nap, a long one until eight o'clock, and then to Au Petit St. Benoit for supper. I am happy and so is Lucille.

Getting married in France is a time-consuming business. Getting letters from the concierge, the gendarmerie, and from eight or nine civil servants, having medical examinations, posting banns, and waiting ten days to see if anyone has objections. But things are getting done and the fatal day is fast approaching. My days are numbered but I have no qualms. Lucille is good and fine and generous. We look and feel good together, disagree enough to be interesting and forgive quickly enough not to be dangerous. She is the dame I have been looking for all my life. The thing now is to get to work and make some photographs. I am not sure that can be done.

9/5/49: I am trying to get my Paris series done for Roy. I have two days in now and not much accomplished. The planned job does not seem to work for me. I always get side-tracked when I come on unplanned things that move and excite me. There will be a great batch of unrelated pictures in the set. Six days in Paris is nothing. Nor is New York or any other place as exciting. Lucille is a help and enjoys going out photographing with me. Had a lot of mail over the weekend. Ferd with blessings. Also the Newhalls with blessings. Our wedding day

is Saturday, September 10. We will be married at the Mairie of the fourteenth arrondissement.

9/10/49: This is wedding morning. Lucille tries to pretend I am nervous. It's a nice day. Nice enough to be photographing. Maybe after the ceremony we will. . . . The ceremony is over, and it was simple and painless. Mary Callery came over this morning with flowers for Lucille and they went to the mairie together and Peter Maas went with me. They were the witnesses at the service. The ceremony was dignified and nice. The mairie was well decorated; about ten other couples were there to be married. The marriage laws were read to all of us and then each couple was called with their witnesses for the legal ceremony. We had to sign our names in a huge ledger, and I must say that we felt comfortably married. Mary took us down the street to her studio where we had champagne and cake. Then I took our small party to lunch at a restaurant in Parc Montsouris. We had a good time. Lucille and I are very happy. *A few days later we had our tandem birthdays, mine on September fifteenth and Lucille's on the sixteenth.*

9/18/49: Roy has written with an assignment to go to Provence and do some work on French agriculture and the docks in Marseille. We called Mary to say goodbye, for we knew she would be on her way to the States before we got back. She said, "But you can't go, you haven't got the keys to the studio and I have to tell you how everything works." It was a wonderful surprise and we were at the studio in minutes. We have agreed to stay a year, and she is comfortable about our taking care of her possessions. Her studio is a luxury place for this time, with a large refrigerator and a telephone. Such items hardly exist for the French in postwar France. With the key safely in my pocket we can begin our combination business and honeymoon trip to the south. Lucille has traveled a lot so she knows how to prepare, and we are well outfitted.

9/19/49: We are in St. Restitut, a tiny village in Provence. The landscape does not mean much to me, but I love the villages with the narrow streets, with the reflected light that is so fine for photography. No young people here, only children and old folks. At night the air is warm and lazy, footsteps clatter on the road and then just the murmur of

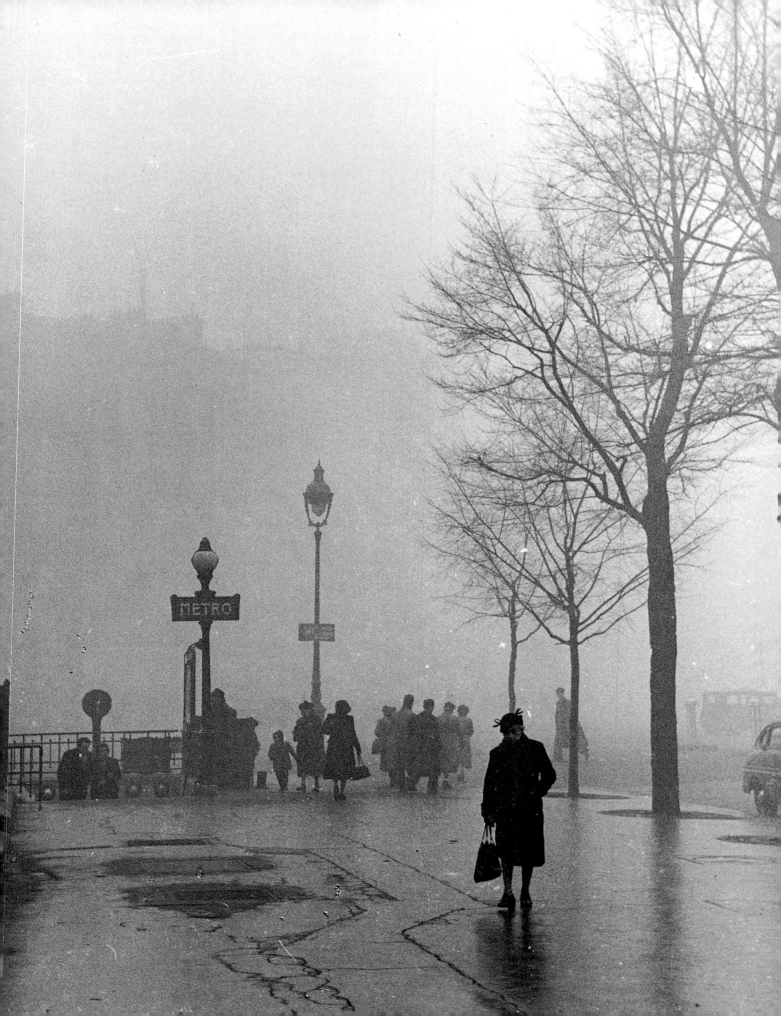

voices or the bark of a dog. The sky is spilling over with stars, millions of them as in the dry air of the desert in California. We eat the bad food at the tiny cafe, and because the patron is so nice, we sometimes think it is good. The country is arid and rugged. Lucille is happy, a good traveler and a good guy for company and everything else. And I think I am getting some work done. I see this light and I think about Van Gogh when he was working in this part of the country.

Schoolboy, Avenue Chatillon, Paris, 1949.

Fog at Metro Alésia, Paris, 1949.

Making our way back to Paris, we stopped in Saulieu where we had our first great gourmet stop. The town had an unusual number of restaurants and hotels. We went to the Hotel de la Poste and had a beautiful room which seemed quite reasonable. We went to the dining room and sat down to one of the most marvelous meals I have ever tasted. Later we discovered that it was rated one of the best restaurants in France. The white Loire Valley wine was so good that I asked the waiter if I could buy half a dozen bottles to take back to Paris. He asked the sommelier, who asked what kind of car I was driving. When I told him it was a Renault Quatre Cheveaux he shrugged and said, "No, the wine will be spoiled by the time you reach Paris."

It was about October 20 when we returned to Paris and Mary was still in her studio. She had been busy making a new piece of sculpture and had delayed her trip until early November. We were able to move into the studio since her work was just finished, and I think she rather enjoyed getting us started there. Just about the time she left, I had another job for Roy in Holland and that was good for us. We traveled around the country a good bit, and when we found ourselves near Ommen, we visited Titus Lesser whom I had met in London the year before. He showed us around that part of Holland and we learned about the country. He had worked in the Dutch Underground during the war and was involved in the movement of American pilots who had been shot down over Holland. He had a cave on his property where the men could stay for a few days while transport was arranged to get them back to England.

It was great to have the luxurious studio to return to. Having Lucille to talk to, my journal suffered and there are blanks sometimes a month long. We had some problems adjusting to joint living, but on the whole life was good in our fine house. I

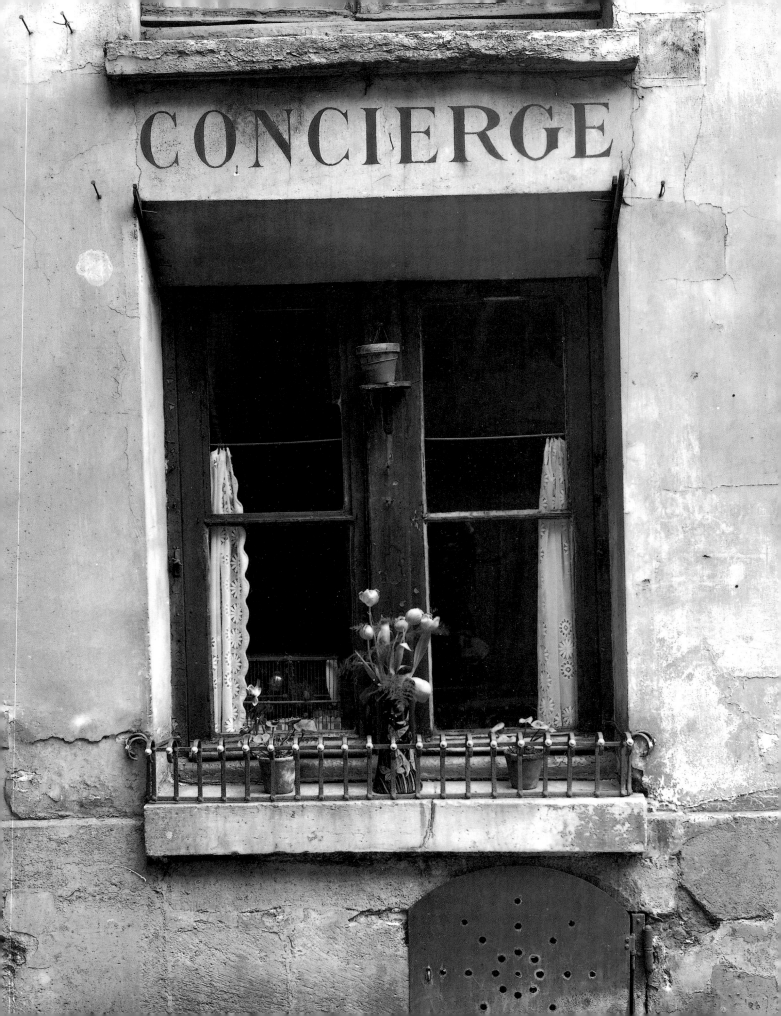

had a darkroom built for me on the balcony, out of the way of any traffic, and once that was working I was ready and able to make some photographs. The several jobs I did for Roy and the French Esso put some money in the bank and I could see my way to live for about six months which, at that time, I considered a luxury. I think Lucille would have liked to see further ahead. Our early days in the studio were punctuated by some bitter quarrels and I think we both felt our fine relationship was doomed.

12/10/49: We had a good human experience today. Before Mary went home she gave us the address of a man from whom we could buy champagne at a very good price. She thought we could write and he would send it to us. That seemed complicated, so we decided to drive to Avize, a small town in the champagne country near Epernay. After following the directions given us, we wasted an hour looking for a factory building. Finally, at the spot indicated there was a large farmhouse. It was the vintner's house in the middle of four hectares of grapevines. M. Varlet-Vatel and his wife were wonderful to us. We meant to stay as short a time as possible so we could get back to Paris before dark. The wine tasting and the talk about almost everything took about three hours or more. I just vaguely remember leaving around five o'clock. What a sight it was! This simple farmhouse kitchen, these two old people matching my dreams of what French peasants look like. The old man, sixty-seven, in an old cap and sturdy work clothes, heavy boots, mud caked, and Madame, rotund, pink cheeked, Breton looking. On the table, six open bottles of champagne. We had to buy our wine by taste, not by the label. Lucille, who drinks little but has good taste, kept insisting that a certain bottle was the best. M. Varlet-Vatel insisted that we sample them all again. And again Lucille chose a bottle from 1947, the best wine year of the century. Our host was so pleased that he sold us the last twenty-two bottles of that vintage. The price was 250 francs a bottle, which translates into about seventy cents each—for a wine that had won the Prix de Rheims. The old couple sat at the table, dusted off the bottles, put on the labels and even the foil caps. They insisted upon giving us four jars of cherries in cognac and a sack of good potatoes. Our biggest problem was getting back to Paris alive. The trip that took two hours coming lasted five terrifying hours returning, with stops at uncounted cafes for black coffee. There was a fog and on-and-

Passage to rue de Seine, Paris, 1949.

Concierge, rue Jacob, Paris, 1949.

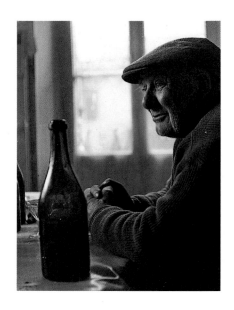

M. Varlet-Vatel, champagne maker, Avize, France, 1950.

Rue du Bac, Paris, 1949.

off rain, and I often saw four cars approaching when Lucille insisted there was only one.

We went to see the Varlet-Vatels a number of times and became friends. We asked Madame if there was anything we could bring her when we came again. She told us that after the war GIs had been stationed nearby. One day a young soldier had brought her a jar of "beurre de Cacahuete"—peanut butter— and she had thought it divine. We had peanut butter sent to us from the States so that each time we visited we could take her a jar. We began to have cold weather and discovered that our house could be bitterly cold. We got a wedding package from Harry and Eleanor and it was welcome—a fine Hudson's Bay blanket that was very cozy on our bed.

1/1/50: On New Year's Eve we had our first big party. We had about forty people and, with plenty to eat and drink, it was a success. We had the Morels, the Peinados, Mary's Chilean friend Severine, Robert Frank, Elliot Erwitt, Lew Stettner, Peter Maas, the Lessers from Holland, and quite a few others.

Everyone seemed exceptionally gay last night. I put some of our records on the wire recorder and we had dance music. The twenty-two bottles of champagne from Avize and the ten bottles of Remy Martin added to the spirits. No one got drunk and the last guests left at seven o'clock this morning. Lucille looked lovely, was gracious and charming and loved by everyone.

2/1/50: It was a beautiful day and I was out all morning with the Leica. It seems to have the best winter shutter of all my cameras. It is compact and good to carry with heavy clothing. And with Double X Pan, it is possible to work in very dim light.

I went to the Eastman Gallery with Pierre and de Janvry to look at the Weston show. It is not impressive. He has showed 125 photographs—too many, about sixty would be better. I am enjoying a visit from John Vachon. He wanted to go out for a whole day by himself, riding the metro, getting lost and talking to people. I think that is a healthy way to see Paris. Had a letter from the Callahans and they are expecting a baby soon.

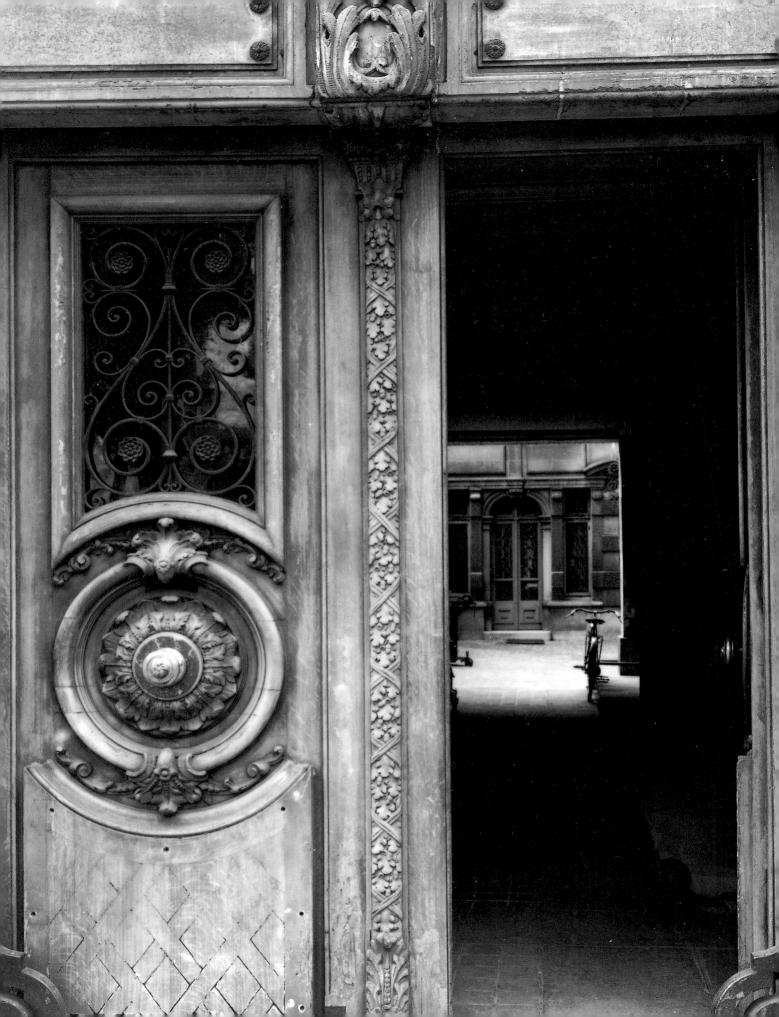

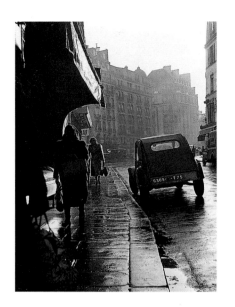

Winter, rue des Plantes, Paris, 1950.

Quai Bourbon, Ile St. Louis, Paris, 1950.

The winter passed and we had our share of good and bad times and company. The Callahans had a little girl in March and they were thrilled. I made new pictures of Paris and put a new exhibit on the wall every month. In May I had my first job for the Marshall Plan. The agency handling the detail was called Economic Cooperation Administration, and they paid only in francs. It was what they called "counterpart funds." For each dollar put up by the U.S., the French paid an equivalent amount in francs. They paid fifty dollars a day, and I didn't mind having the francs. I was sent to Denmark with one of the writers, Harry Backer. We were stationed in Copenhagen but traveled all over the country. We worked well together. After we returned to Paris I had a letter from the United Nations about a job for them.

6/5/50: The twenty-seven-hour trip from Copenhagen to Paris on the train went smoothly: we were in the house a half hour after the train arrived. It is really summer, 86° today. Jackie Martin, the woman in charge of photography at ECA, is pleased with what I've done so I think I can count on more jobs from that agency. I like this weather—hot and sunny. A little hot in the house but we can undress for it there. My darkroom is fine early in the morning so I do my printing then. Girls in summer dresses on bicycles and the Paris trees are beautiful. Maxine Backer took Lucille to the embassy commissary, so our larder is stocked with American foods we cannot buy in France: catsup, baked beans, peanut butter, pickles. She also got two bottles of Remy Martin and a bottle of Vieille Cure.

Our 1950 summer was fine. I did get a letter from Roy who seemed a bit put out with me for not coming home. We discovered the Marne River as a place to swim and went there almost every day.

8/31/50: August has been a hectic and uncertain month in many ways. Jackie Martin was able to tell me I was not employable by ECA because I had once been a member of the Photo League in New York. I never did have an interest in the league, and it is very unpleasant that it should stand in the way of some choice and lucrative work I would like to do. I wrote letters to Stryker, Steichen, Beaumont, Ansel, and Harry Callahan and had replies within a week from all of them vouching for my character and loyalty. The people at

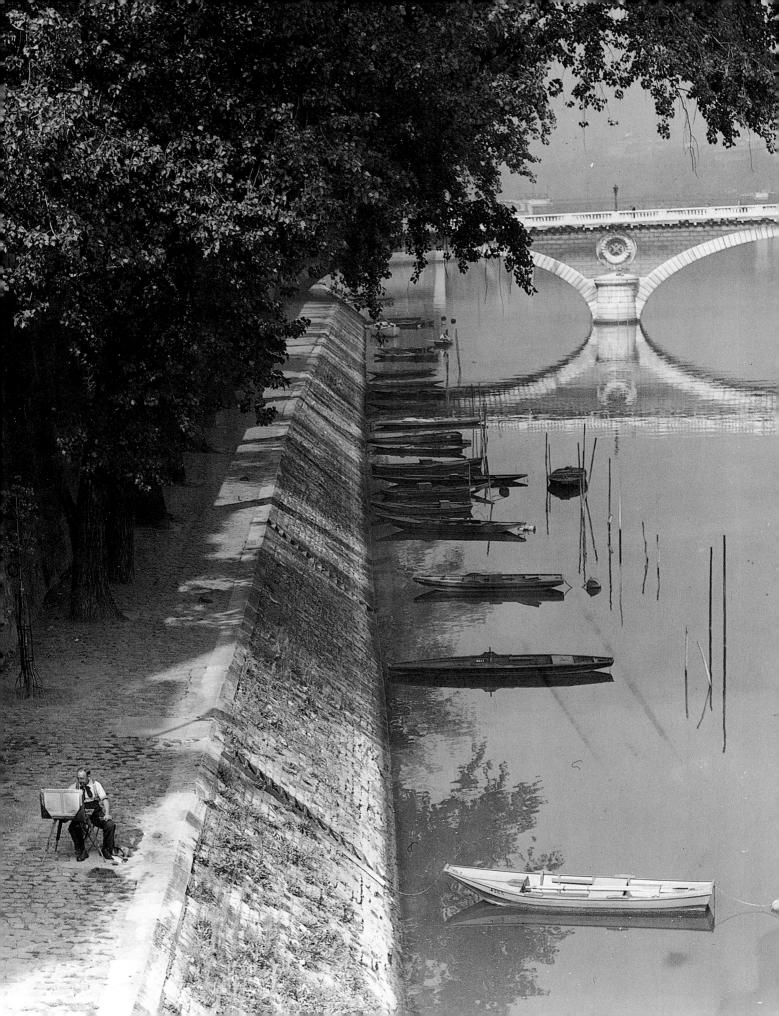

ECA were impressed and are trying to clear me for contract work. I was touched by the prompt responses to my letters from those whom I feel are the biggest and best names in photography.

We were depressed about the Photo League debacle but Paris is still great. Gordon Parks came back with his wife Sally and the three kids. They might stay for a year. We helped them find a house and get settled. They are a nice family and we enjoy them. Gordon had a job for *Life* to do the Fashion Collection and wanted to use our studio. We received five dollars an hour for the studio and it went on for two weeks. *Life* hired all the models in Paris they could get so that no one else could have them and they were around our house for the whole time, many of them doing nothing. Gordon seemed to enjoy it.

10/1/50: Dorothy Miller, one of my old girls from Detroit, came today, and I also had a call from ECA to do a color job in the Camargue. We gave Dorothy the choice of whether she and Lucille would stay in Paris or come to Provence with me. So, we all went south, had a very good time, and got the job done. We spent most of the time in and around Arles, where most of my work was located.

10/30/50: Just after our return from Provence, I had a call from the UN to go to le Mans to make photographs of the French Korean Battalion who were just readying to go off to war. While I went into the officers' mess to make some pictures, Lucille decided to wait outside for me. A great tall man, Charles de Gaulle, saw her and said, "You go inside, don't stand there like a scared rabbit," so she came in for lunch. They seem to have worked out my clearance at ECA and I have a nineteen-day contract to work in Belgium. We have a per diem allowance of twelve dollars; I think we can manage on that. When we finish this job we will have about half a million francs, which should take us through the winter. Mary Callery came back for a few days and asked if we would stay for another year.

We were not impressed with Belgium since we have seen just about every corner of it before. I was most impressed with the restaurant in Brussels that serves nothing but *moules*. There are at least twenty different ways; I think I tried at least ten,

all good. Pierre made his first trip to America and had a wonderful time. The trip to Belgium lasted twenty-two days. After only a few days I was given another assignment in Germany to document businesses being assisted by the Marshall Plan.

12/5/50: We have finished our first week in Germany. We are a team with Art Diggle as writer and Yvonne d'Anjou as interpreter and researcher. They are both good workers as well as good company. We landed in Frankfort last Thursday and worked there for three days. It is a sad place with awful bomb damage everywhere. I am impressed with the price of losing a war. Sunday we made a trip to Hamburg by car through lovely countryside. Hamburg seems better—more spirit, more rebuilding, and no American soldiers. It must have been a fine city before it was bombed out. The stories are going well. We work together and get things done.

12/6/50: Went to Kiel today and did some work at the Zeiss-Ikon plant. Came back in a blinding snowstorm and am concerned about the trip back to Hamburg tomorrow. This seems to be the way for me to work on stories. I am free to make the photographs, the thing I seem to be good at.

There is a great story where we were yesterday in the refugee camp of displaced persons at Schlesswig-Holstein where 1.8 million people are quartered in quite a small area. No possibility of work for them for there is no industry. A tough story but terrific pictures. Nine people living in a small room, no hopes, just misery.

12/14/50: My first night in Munich and I find it the best place I have been in Germany. We have just been to Zweissel, a small Bavarian town only ten kilometers from the Czech border. Happy, friendly people, a fine small hotel, the Gasthaus sur Post, like the Hotel de la Poste in France. We did a story there on an optical glass factory that made camera lenses for Zeiss. It was in Jena before the war.

We finished our ECA assignment. Art and Yvonne were great.

12/21/50: Gene Smith was in town, getting ready to do his Spanish Village story. He sort of adopted us, came three or four times a week and was a great talker, mostly about

himself. He was looking for someone who could speak Spanish
to go with him as an interpreter. Our friend Joaquin Peinado,
a painter, who was head of the Spanish Tourist Bureau in
Paris before the Spanish Civil War, was on the wrong side
and had been banned from Spain. His daughter Nina,
although born in Paris, spoke excellent Spanish and could
enter Spain. So Gene, his assistant Ted Kassel, and Nina
went off to Spain for a couple of months.

I found another Eliot Paul book, *The Life and Death of a
Spanish Town*. It was about the village of Santa Eulalia del
Rio on Ibiza in the Balearic Islands. I talked to Bill McGivern
about it, and he thought it sounded good. Just about then
Gene Smith came back from Spain. He was full of horror
stories about the police state atmosphere, how he had had to
smuggle his film out of the country in the hubcap of his car.
Nina said it was not like that at all and that we would have a
good time. So, early in July the McGiverns and the Webbs,
each in identical Renault Quatre Cheveaux, set out for Spain.

7/5/51: The trip from Paris to Spain was interesting. Our two
little cars were loaded with luggage. The McGiverns brought
their daughter, Megan, and the maid, Jane, making their car
more crowded than ours. We neared the Spanish border with
trepidation due to Gene Smith's scare stories. The people at
the border were very nice, and when I tested the waters by
saying that I had five cameras with me, the man looked at my
passport and said, "Well, you are a photographer, aren't you?"

We found a good hotel on the Rambla Central in Barcelona.
The Hotel Quatros Naciones has big, high-ceilinged rooms
with modern plumbing and three good meals for 115 pesetas
each a day. The exchange was 39.86 pesetas for a dollar.
During our week in Barcelona I made a lot of pictures. We
went to one bullfight and enjoyed it.

7/19/51: Being here on the island of Ibiza in the middle of the
Mediterranean is the fulfillment of a dream, the dream of
living and traveling in far-out-of-the-way places. Now we
have been here almost two weeks. Our two small cars were
lifted by a boat crane to the deck of the boat that brought us
from Barcelona, an overnight trip. Bill and I slept on the deck
and the girls had the only cabin available. We arrived at port
early in the morning. The first sight of the town with its

gleaming white buildings and cathedral-topped hill could not
have disappointed anyone.

*Next we stayed at the Pension Marimonte in the small village
of Santa Eulalia del Rio. It was very much as Eliot Paul had
described it in his book. We had a nice room, a bath that we
shared with the McGiverns, and three fine meals a day with
wine at a cost of twenty-one dollars a week. It was so
inexpensive we could hardly afford to leave. And we did have
a good time. There was a fine beach five kilometers away
where the swimming was great. I bought a snorkel, a mask,
and a pair of flippers and spent hours looking at the beautiful
underwater life. Many of the people on Ibiza are descended
from the Phoenicians, who settled the island centuries ago,
and they retain much of the customs and culture of their
ancestors. I made some good photographs of the life there.
After six good weeks, we loaded our cars and ferried back to
the mainland. Our port of arrival was Valencia where Bill had
a commission to do a story on the week-long feria that was just
about to begin. I would make the pictures for the illustration.
There were bullfights every day starring Luis Miguel
Dominguin, the subject of Bill's story, and we got to know him.
We learned much about the sport that was new to us. We went
on to Madrid and then went our separate ways, the McGiverns
to Italy and the Webbs back to Paris. I was very happy with
what I did in Spain and had a full and very fine show in our
studio.*

*Just after we were resettled, our neighbor Giacometti knocked
on our door to ask if he could put some of his work in our
studio for a few days while his studio was being painted. He
was a long-time friend of Mary's and we gave him permission.
He and his brother brought about one hundred pieces of his
wonderfully strange, gaunt sculpture. It just about filled our
30-by-50-foot studio and put our ping-pong table out of use. It
looked like a scene from Auschwitz, a hundred skeletal figures
shoulder to shoulder. I called Gordon, who came and made
some photographs for* Life.

*The ECA work in Paris was winding down and many of the
people were being sent home or transferred to other posts. Just
before the holidays we had a letter from Mary. She was getting
itchy about coming back to Paris, and we felt it was about
time to return to New York. So, in February 1952 I sold my*

faithful little car for the equivalent of six hundred dollars,
which paid our fare back to the States on the SS Ile de France.

5/17/53: It has been almost a year since I made an entry in
my journal. I thought being able to talk to Lucille would take
the place of it, but that is quite different, helpful and
enjoyable as it may be. Recording a feeling you have when
facing a problem, be it photographic, economic, or social,
certainly places a burden of wordy thought upon you.
Sometimes the thinking required to put these feelings into
words helps to clarify the problems.

The four great years I had in Paris came to an end through
lack of earning capacity and we were forced to come back to
New York, where we had a couple of meager years but
managed to survive. We found a small apartment on 81st
Street near Second Avenue. Lucille fixed it up and made it
look nice. Mary Callery came to see us and thought we had
done wonders with it but felt we still needed a couple of
paintings. I went to her studio on 68th Street and came back
with two very good Picassos which we hung on our walls.
Lucille job hunted and I made the rounds of editors, and we
got by somehow. Steichen was very good to me and included
me in several shows at the museum. I showed my Sixth
Avenue panel for the first time in one of his "Diogenes with a
Camera" shows. Eventually we found a nice house on St.
Luke's Place in the Village, which we enjoyed for the rest of our
stay in New York.

In June when we had a very hot spell, Mary came to the rescue
again by inviting us out to her place on Long Island for the
weekend. She wanted to go back to Paris for the summer and
asked if we could stay in her house during the six weeks she
planned to be gone. She had converted two barns to elegant
living quarters with Picassos, Braques, and Legers on the walls
and many pieces of sculpture scattered about. That six weeks
was a lifesaver for us. It raised our spirits, and we began to
function again. I made a place for a darkroom in the St. Luke's
house and began to photograph again. In 1954 we had a repeat
performance of our 1953 experience on Long Island. We met
and got to know Wally Harrison and his wife Ellen, Philip
Johnson, and Robert Leonhardt and his wife Mary Gay, who
lived in a Philip Johnson glass house nearby. I like Robert and
when he asked me if I would make portraits of his two

children, I was pleased to do it. I intended to do it as a favor.
The portraits were beautiful, and Robert insisted on paying me
$750, which was good pay in 1954 and a godsend to us.

During that summer I really became interested in doing
something about the early American West. I read all the books
I could find in the library about the settling of the West and
the Gold Rush. I found the history fascinating. By the end of
summer I had decided to apply for a Guggenheim Fellowship
to make a photographic study of the routes the goldseekers and
farmers traveled with their covered wagon trains. The summer
passed and I didn't write in my journal until September 21.

9/21/54: It is a stretch from April to now. Waiting for
something good to report. Our financial situation has improved
only slightly in the interim but many pleasant happenings
have occurred. In a good state of mind I would have written
about them. Beaumont gave me a show at Eastman House in
Rochester. I am not sure anyone saw it. I didn't see any
announcement, review, or publicity. I gave up carting around
my photographs to show editors. The only time you really get a
good reception is when they call you. All this year I have been
trying to make photographs I thought an editor would like.
That was nonsense for me. Photography has always been a
wonderfully exciting experience for me, an effort to explain or
transmit the exciting feeling I have always had about living.

Sunday I read in the papers about a man, sixty years old, who
had just completed a walk from San Francisco to New York.
He is writing a book, *The Grand Walk*. The same night on the
radio we heard Aldous Huxley being interviewed by Clifton
Fadiman in a discussion about "this age of speed." Huxley felt
people travel too fast, by plane, fast trains, fast cars, and see
little of what they pass. I have always had this feeling where
photography is concerned. I believe I get more and better
photographs by walking around a few streets than by
traveling all day by car. The act of stopping and finding a
place to park is enough nuisance to make you pass up what
close examination could make a "must" photograph. Reading
about this man's trip and hearing Huxley gave me the strong
desire to make such a trip myself. My best thinking is often
done when I am walking. This is the level and speed to record
a slice of America. As I think back to my boyhood dreams,
this is one of the most recurrent, this and floating down the

Mississippi in a rowboat. It fits right in with my new great interest, the westward expansion in the 1840s and 1850s.

Now that I have something to focus on, I am alive again. I began making practice walks and am now doing ten or fifteen miles a day. I have begun to think of my cross-country walk in comparison to the treks to Oregon and California of the early settlers. I read that they traveled about twenty miles a day; I figure I can walk at about the same rate. I have haunted the New York Historical Society and the New York Public Library, looking for clues about the migration west in the mid-1800's. Ramona Javits at the library is sympathetic to my project and has helped me by making lists of places that might have material to help my cause. She also bought fourteen of my New York photographs for the library collection.

11/22/54: In spite of not writing I have gone along with my plans for walking across the country next spring and summer. I did get my application in for a Guggenheim and there are times when I almost have hopes of getting it. I have five sponsors: Mary Callery, Marshall Davidson, Grace Mayer, Georgia O'Keeffe, and Steichen. *Later, Walker Evans volunteered to be a sponsor when he heard about the project.* Miss Javits has put me in touch with the archivists at the library, giving me access to original manuscripts, diaries, maps, etc. Having had a chance to read some of the diaries has given me the idea that I should follow the route taken by those who took part in the Gold Rush. Some of the diaries give a good account of what the country looked like in 1849. Maybe I can find enough good excerpts to try to match the descriptive ones with a photograph of what the same place looks like today.

Walker Evans has been helpful and hopes I can get a commission to do an essay for *Fortune*. Ruth Lester at Life wanted me to talk to John Bryson. I did; he is interested and will take it up with the National Affairs editor.

1/20/55: I have now finished planning my itinerary, and it looks impressive to me. The mileage totals about 3,700. About 1,400 miles will be by boat from Pittsburgh to Independence, Missouri, on the Ohio, Mississippi, and Missouri rivers. As I look at the distances on the plains and the desert, I think of the possibility of getting a bike after Independence. That is

the longest part of the trip with great stretches of nothing. I would still have to push the bike up the steep slopes, but that would not be as hard as carrying a heavy pack.

1/21/55: John Bryson called from *Life* yesterday and asked me to come in. He wanted to talk about my trip as someone in Special Projects is interested in the idea. They were at a loss, as I was, on how to pay for this kind of project. We left it at an advance of five hundred dollars and my film and processing. They will return all of my negatives to me ninety days after my return so that I can work on my book.

2/4/55: Last night at the Leonhardts' we met Margaret Truman. Robert had told her about my project. She said her father would love it and that I should stop and see him when I get to Independence. She took my address and I forgot about it.

I went to the opening of *The Family of Man* and am disappointed. The photographs are all overenlarged to billboard size. All the beautiful qualities that make photography unique have been sacrificed to make these giant prints. Last night at the Leonhardts' I had objected to Tom Hess's strong criticism of the show. As an art editor he had had a preview of it. Now that I have seen it, I must agree with him. Only one print in the whole show is not blown up beyond recognition as a photograph—Steichen's 8x10 contact print of his mother.

4/16/55: At twenty to eight this morning the doorbell rang. I went downstairs in my bathrobe and the mailman apologetically gave me a special delivery letter from the Guggenheim Foundation saying that I have been awarded a fellowship of $3,600. It is a big day for us—the culmination of dreaming, working, and planning.

I was off on my trip the next day. Lucille became a partner in the employment agency where she was working, so we both were happily busy. I had covered almost a hundred miles in New Jersey, coming back to New York each night during the first two weeks of April while I was waiting to hear about the grant. I plodded along through New Jersey and Pennsylvania, not finding it very exciting. My first good stop was in Harrisburg, where I contacted a visiting nurse who was sure

she could arrange for me to make photographs of an Amish family. She was overconfident, and when she took me to see Isaac Huyer he said he would be glad to talk but no pictures.

He told me about a horse auction in New Holland six miles away that might be good for me. He said that because it was a rainy day the auction would be well attended since the men could not work in the fields. The auction was in a big barn, quite dark inside. As the Amish crowd sat on one side, the horses were brought into the center of the barn. I found a seat on the opposite side and put my Leica on a tripod. The light looked hopeless, but I exposed some negatives at a fifth of a second and had two or three very good photographs of Amish men in a natural setting.

When I got to McConnelsberg, Pennsylvania, I stopped at the Fulton House, and told the proprietor I had a diary of a man from New York who had stayed at the Fulton House in 1849. He thought he might be able to find the register for that date. Sure enough, he came up with the page for May 22, 1849, with the name of my 49er.

I had made arrangements to see Roy Stryker when I got to Pittsburgh. He wanted to show me around the Jones and Laughlin Steel Mill where he was working on a project. I stayed a night with the Strykers and then went on to Sewickley where I was to meet a Captain Way with whom I had corresponded. He had helped me get my skiff for the river trip; it was waiting for me at his place. The captain insisted that I paint the name of my boat on the stern. He made me a stencil, and I named the boat Lucille of New York. *That was on the stern. On the bow it was just* Lucille. *I had a lot of equipment to go with the boat, a good sleeping bag, pots and pans and a Sterno stove, canned foods, life preserver cushions, and a set of river charts for the Ohio, Mississippi, and Missouri rivers. I was to leave from the Highland Flying and Boating Club on the Allegheny River six miles from Pittsburgh Friday at 11 A.M.*

I went down the Ohio River through seven or eight locks to Steubenville, Ohio, where I spent the night at the Fort Steuben Hotel. According to my river charts it was fifty-six miles. I passed one steel mill after another and one ugly town after another. I was quite at ease after the first day

Amish farmers at a horse auction, New Holland, Pennsylvania, 1955.

as far as the boat was concerned and was enjoying the river very much.

5/26/55: My first night camping out, on the shore of Eighteen-mile Island. Have just had my dinner—clam chowder, baked beans, bread and butter. Now I am having my coffee, smoking a cigarette, and listening to a little radio given to me before I left. Just saw a mosquito. I will make a fire and create a smudge. It is a beautiful evening and I lie here in my sleeping bag, my air mattress as comfortable as a bed. The young moon moves across the sky behind a tree, just now clearly coming into the open. The many fireflies are often hard to distinguish from the stars.

As the weather improved I camped out most nights in spite of the mosquitoes. I think Shawneetown was the last memorable spot I stopped at until I reached Cairo near the Mississippi, where I turned north. That part of the river was hard hit by the flood of 1937. Now Shawneetown was almost a ghost town. Most of the people had moved to a new site back from the river, but a few were still residing in the old town. Most of the towns in that area were dry. Shawneetown remained the only place for miles around where you could get a drink. During the flood, bartenders were selling drinks out of the third-floor windows to people in rowboats. On June 1, I passed through lock 48 and reached Cairo, Illinois, where I turned into the Mississippi and went against the current for a change.

6/4/55: I left Cairo yesterday morning with all kinds of advice about how I should handle the big river. It was a big thrill to go around the point and really be on the mighty Mississippi. It does make a big difference. I traveled hard today for eight hours and made only forty miles using a lot of gas. I found a good place to camp and after I had my supper an old guy, Shorty Adams, an eighty-one-year-old Spanish American War veteran, dropped by from his camp. A very entertaining old boy. He came down twenty-two years ago from 1,400 miles up the Missouri River to get away from the severe winters up there. He is a real hermit but neat and clean. He fishes and has a small pension.

I reached St. Louis on June 6 and found new material at the Missouri Historical Society. I was able to make copies of several old diaries. I left after a few days and was appalled

when I turned into the Missouri River. It was running very high, and facing that brawling, muddy flood was frightening. I could only make a couple of miles an hour at full throttle. When my motor conked out, I had a hair-raising row to shore. I changed plugs and took off again. At an Evinrude agency in St. Charles, the man told me my motor was too weak for the river. He said he would return my motor and if I wanted to sell my boat he knew a buyer who would take it. I had had enough of the river so I made the deal. I was glad to be walking after sitting in that boat for a month.

I went through some interesting towns—Booneville, Arrowrock, and Marshall—all with river-related history. In the old days Arrowrock was a busy port on the Missouri. Now it has a population of 170. At the turn of the century the river flooded and changed course, and now Arrowrock is three miles from the river. I had a good walking trip to Kansas City.

After I left New York, a letter came for me from Harry Truman. Lucille forwarded it to me at one of my mail pick-ups. I had his private telephone number, and he wanted me to be sure to stop and see him.

Mr. President Harry S. Truman in his office in Kansas City, Missouri, June 1955.

6/18/55: Had a fine talk with Mr. Truman. He is a wonderful man, full of life and ideas, and he looks in very good health. We talked about the trails. His grandfather, Solomon Young, was a wagon freighter on the Santa Fe Trail in the 1840s. Mr. Truman is a former president of the Old Trails Association. He gave me letters to introduce me to people along the Santa Fe Trail who might help me. He asked where my camera was and I told him the receptionist had asked me to leave it with her. He buzzed the secretary and had her bring the camera into his office. I made a few pictures of him at his desk. He asked me to send him an autographed copy of the book for the Truman Memorial Library in Independence. He advised me not to try to walk across Kansas as the towns were too far apart and the weather too hot.

I went back to Independence to begin my trek in the wake of the Prairie Schooners. I had made only a few photographs on the rivers, but now I could begin to match some of the diary excerpts. I found that Mr. Truman was right. People stopped their cars and insisted I get in as the next town was forty or fifty miles away. The landscape was barren and hot, but

almost every time I accepted a ride, I saw something I wanted to photograph. I walked and accepted rides for 250 miles, as far as Great Bend, Kansas. I felt I was missing too many picture opportunities so at the Sears Roebuck store in town I bought a three-speed bike with a carrier on the back. I could ride fifty miles a day and stop whenever I wished to photograph.

I began to enjoy Kansas. I found many landmarks of the trail that I had read about in the diaries. I met hundreds of people and made many photographs. It was wheat country so I made pictures of the harvest. I stopped at the railroad stations along the way where the station masters and telegraph operators always seemed happy to talk and had many tall tales to tell. The grain elevator appeared to be the symbol of the Kansas town. It was the first thing to be seen on the horizon. I was impressed by the big sky and the flat land that stretched, treeless, in every direction as far as the eye could see. I thought of the pioneers trekking across the uncharted sea of the prairie.

When I got to Garden City I discovered a sizable herd of buffalo. I looked up Ralph Junger, the game warden who tends the herd. He wanted me to make some pictures of the buffalo and took me to the range in a jeep while he moved the beasts to another part of the ranch for grazing rotation. While he drove them with the jeep I was able to make some pictures I hoped would match some of the buffalo stories in the diaries of the early travelers.

I peddled on to La Junta, Colorado, where I stopped to make pictures of a cattle auction in progress. I met a man from New Mexico who told me to put my bike in the back of his truck, at least as far as Raton, New Mexico, which is at the top of a steep fifty-mile grade to the pass. From there it was only a three-day ride into Santa Fe.

I checked into old La Fonda Hotel. It was elegant in an old-fashioned way and, at the time, reasonable. I walked all around the town and was impressed by the architecture of the adobe houses and buildings. I found myself thinking I could live happily out here. The next day I rode to Española, thirty miles to the north. Because it was the Fourth of July weekend, the roads were crowded. I tried to call O'Keeffe in Abiquiu and

**Buffalo skull, Georgia O'Keeffe's Ghost
Ranch house, New Mexico, 1955.**

From O'Keeffe's Abiquiu house, 1957.

was surprised to learn she had no phone. So I sent her a card and rode to Taos, about thirty miles to the northeast, where I spent the holiday and enjoyed seeing and photographing the Indian pueblo.

On July 7, I made the ride from Espanola to Abiquiu, thirty rather uphill miles. I was tired when I got there. Georgia gave me a big welcome. She had a wonderful house and I was given a guest room with great windows looking out over the reddish mountains. I was awakened from a good sleep when Flora, the maid, brought me my breakfast in bed. That was the first and last time that has happened to me.

When it was time to leave, I said goodbye with sadness to Georgia and the people I had met in Abiquiu. Traveling was fine on the Vespa I had bought in Santa Fe. It was the perfect transport for my purpose. I could stop anyplace just by pulling to the side of the road. I made photographs, some around the Ghost Ranch and in the towns, Tierra Amarilla, Chama, and Pagosa Springs, Colorado. Near Chama I crossed the Continental Divide and the landscape changed completely. No more adobe houses, red mountains, and beautiful mesas. This is high mountain country with big pine forests, rushing mountain streams, and sporting and tourist resorts in nondescript towns.

7/25/55: Up early and left the spa-town smell of Pagosa Springs by seven o'clock. Made a few photographs and began the trip over the high mountains to Silverton, Colorado. Majestic peaks and pine-covered mountains, two high passes which required some travel in low gear. Silverton is almost a ghost town. Few people live here now, but many of the old buildings stand much in the same way they did when silver was king. I had a fine time photographing in the late afternoon light.

I rode on across the mountains through Ouray and on to Grand Junction, Colorado, where a uranium rush seemed to be in progress. It was on a different level from the early rushes for gold and silver that took place around the turn of the century. I didn't see much to photograph but did meet people who offered to show me around. One man took me in his plane to Baggs, Wyoming, to show me some property he was planning to work. Not much to see. Later I went to Moab, Utah, which called itself the Uranium Capital of the World.

Uranium mining is nothing like the Gold Rush that excited people in 1849. Placer mining made the Gold Rush a more colorful and visual event. Before mining for uranium begins, samples must be approved by the Atomic Energy Commission. There is no mass frantic digging. Uranium mining is big business from the start. I heard stories of big fortunes being made by big operators in Moab. In one saloon I saw a sign that read, "No deals under one hundred thousand dollars talked about in here."

I pushed on to Salt Lake City, and as the towns came farther and farther apart, I understood better the plight of the early settlers, who at this point were about to make the long and dangerous desert crossing with their tired oxen. Without my Vespa, I would have faced much the same problem. I could feel the desert sun, but I had a desert water bottle, maps, and a good road. I could travel over the sparse country at forty miles an hour, while the pioneers were lucky to make fifteen miles a day.

8/2/55: Up at the crack of dawn and after breakfast on the western edge of Salt Lake City I started my modern trek over the Great Salt Desert where the Donner party courted disaster in 1847. These many miles of snow white, glittering, salty sand must have been a horror for them. I saw beautiful mirages that looked like blue lakes dancing on the horizon, so real looking I could hardly believe they were illusions. I made some photographs but realized that to show what it is really like is hopeless. There is no scale, no relationship of objects to give any measure of the immensity or the inferno quality. The only thing I saw worthy of a photograph was an isolated gas station with a big sign, No Water for Ninety Miles. The hot wind sears, no trees, no habitation, no people, only nothing.

Strangely, the Great Salt Desert ends right at the Nevada line, where I faced a different kind of ugliness. On the eastern edge of Wendover, Nevada, just over the state line, is a bar and gambling casino. The parking lot is full, the bar is full, the gambling tables are crowded, and every slot machine is banging away with people standing in line to await their turn. I have the feeling that away from the gambling tables they would look like ordinary people. I heard one couple say that their vacation was finished. They were on their way from Kansas City to California and had been cleaned out in the

Virginia City, Nevada, 1955.

Bar in Genoa, Nevada, 1955.

first Nevada town they visited. The road is full of hitchhikers now, tough-looking kids, and I hesitate to camp out. I sound like a real moral Quaker. I stopped at this little hotel in Oasis and it was so quiet I decided to stay for the night. I am getting black from the sun.

8/5/55: Made the short run into Virginia City, one of the better Nevada towns for me. I love the old buildings, the way the wood has weathered. I am staying at the Silver Dollar Hotel next to a bar called the Bucket of Blood. Florence, who runs this hotel, is a town character—a Smith graduate, world traveler, often married, and full of the devil. Talked to Lucius Beebe today and he showed me around the town.

8/9/55: I am staying at Diamond Springs, one of the first towns on the Mother Lode. It once had a population of 17,000 and now has 271. A twenty-five-pound gold nugget was found here in 1849. I came down on Route 49 from Auburn through Pilot Hill and Coloma where James Marshall found the gold in California that had started the 1849 Gold Rush.

I spent several days making my way down through the historic gold towns of the Mother Lode—places like Drytown, Sutter's Creek, Mokelume Hill, Angel's Camp, Jackass Hill, most of them in Calaveras County.

My trip was winding down. I spent a few days in San Francisco with a night in a Chinese hotel on Cannery Row in Monterey. I had a good trip down the coast to Santa Barbara, where I saw my old prospecting friend Danny Tudor. He bought my Vespa as a present for his fifteen-year-old son Johnny, who is my godchild. I went by train to Los Angeles, where I caught my plane back to New York on September 1. My trip west took five months and the flight home nine hours.
Excitement on the road did not prepare me for the humdrum of trying to find an editor who wanted to publish my book. Quite a few were enthusiastic about the idea but felt I didn't have the right material in hand. I wrote an article for the New York Times *Sunday magazine about the trip and had my best reaction from the Vespa people for my report of how their machine had been such a factor in the success of my project. They were delighted and told me that in the first week they had made sales to ten photographers. If I wanted to make a*

future trip they promised to furnish me with a special machine that would enable me to carry more equipment. Also, I went to see Henry Allen Moe at the Guggenheim Foundation to show him what I had done. He seemed very pleased and suggested that I apply for further assistance from the foundation. Even though the date for registration was past, he said I should apply.

It was a long winter and I didn't seem to accomplish much. We were lucky that Lucille's partnership in the employment office prospered, as I was not making any money to speak of. Peter Pollack came to see me about having a show at the Chicago Art Institute. I finally got my negatives back from Life *so I could begin to make some of my prints, and did get some magazine assignments. I spent time at the New York Public Library where I had a card admitting me to the history treasure room and found material that will help me on my trip next summer.*

On April 6 I had a letter from the Vespa people telling me my machine was ready and I could pick it up anytime. And on April 13 I had another special delivery letter from the Guggenheim Foundation awarding me a six-month continuation of my grant to complete the project. My new Vespa scooter was great. I had larger carrying racks in front and back, with room even for my typewriter. I had four cameras this trip: two Leicas, one for color, my Rollei, and a new Omega that made an 8x10 print with no cropping.

On May 17 I left on my second western trip; I stopped the first night in Kutztown, Pennsylvania, 133 miles from home. Last year that would have been about my eighth day. On my third day, near Washington, Pennsylvania, I had a spill while riding on the hard shoulder of the road. A truck sped by and the rush of air pushed me off the pavement; I hit a soft spot and went over in a somersault. It ruined my wind screen and I had a bump on my head. Across the road, a young man sitting on the porch saw what had happened. He limped over, helped me get the bike, and took me to his house. He let me clean up and put a small bandage on my head. He had crashed in the Indy 500 the year before and was still recuperating. He urged me not to be frightened and to go on with my trip. It was getting late in the afternoon so I drove on to Washington, about thirty miles, and checked into a motel. At the local

hospital, an orderly put eleven stitches in my head; I looked like the walking wounded. I was a bit stiff but none of my equipment was damaged, and I was able to go on the next morning. That was the only spill I had in the 9,600 miles I traveled.

6/4/56: Another day, another state. Rolled into Nebraska this afternoon and am staying at the old-fashioned Hebron Hotel in the town of the same name. I spent the morning photographing in Marysville, Kansas, where I stayed last night. Had a haircut at Broadway Jack Thrumm's barber shop and got all the latest gossip of the town. One of the men in the barber shop took me to see Byron Guise, editor of the Marysville *Advocate*. He had seen many of my photographs and introduced me around as one of America's greatest photographers. I didn't have the heart to correct him. I traveled north today and the prairies seemed different from when I was traveling east or west. The river bottoms are rich land. I could see how the immigrant farmers must have drooled when they passed through here. At that time it was Indian country and they were forbidden to settle here. Not until 1854 were settlers allowed to take land in Nebraska and Kansas Territory.

6/5/56: In spite of the wind it was hot today. I am getting very brown. I am about ready for a hat. Gone are the rolling prairies; now it is endless flat plains country, the land of the Big Sky. In the old days it was a treeless empty place that jarred the immigrants. Here they could find no wood for the cooking fires and had to resort to buffalo chips for fuel. The first thing a settler did when he took land was to plant trees. Now each farm is a little oasis, the house surrounded by trees. I have talked to several people and all have asked if I know about Mari Sandoz. Fortunately, I have read all of her books. She lived north of here in the sand hill country and is very well regarded. The wind is whistling through the trees outside my window. I had better go outside and see if I can see a tornado and find something to eat.

I motored on, stopping at any historical society or library I came across, sometimes making copies of diaries with my Leica attachment. There were some heavy storms in the country I was passing through but luckily I missed the bad ones. I was disappointed in the Platte River as were most of

the immigrants. One wrote that the river was a mile wide and an inch deep.

6/10/56: I stopped at the Scotts Bluff museum to see the fine collection of paintings by William Henry Jackson. I know him best as a photographer. He made these paintings of the Old West from his sketches and notes from the 1860s when he was photographing out here. They are detailed and imaginative scenes. A photograph made of him in 1918 showed him just as I had known him in Detroit when I used to sell him his morning paper every day.

6/11/56: I stayed the night in Guernsey, Wyoming, where I read that some of the old Oregon Trail is still visible. I had a hard time finding it until a boy working in a garage gave me good directions. I was soon making photographs of the actual ruts made by the covered wagons. The thousands of passing wagons wore deep ruts in the soft shale; they remain there, a true monument to the old days of western expansion.

I made a number of photographs on the trip down the Columbia River. I arrived in Portland, Oregon, after logging 4,100 miles from New York.

7/11/56: I am back in Abiquiu, where I feel at home. Georgia just got back from Peru on July 4 and has been down with dysentery since. I stayed last night in Cimarron, New Mexico, which was on the Taos branch of the Santa Fe Trail. Had such a welcome from Georgia back in Abiquiu, it was heart warming. Beau and Chia, the chow dogs, remembered me in a dignified sort of way. Had a wonderful dinner with fresh things from the garden. Georgia seems much better and has held me spellbound with tales of her trip to Peru.

7/16/56: Georgia and I talk by the hour about everything. She tells me many anecdotes about Stieglitz, about their life when they had no money, when they lived at the Shelton Hotel and the little place on 59th Street. He was fifty-three when they were first together and at a very exciting point in his life. As he got older he became difficult. He was a very poor eater and would eat almost nothing the last few years. Georgia said she really believed he had starved himself to death. I don't recall that Stieglitz and I ever talked about food. Not so Georgia. Her bedside table is stacked with cookbooks.

*My stay in Abiquiu stretched to two weeks. Beau, the male
chow, had some kind of an accident; his back legs were
paralyzed and he had to be destroyed. It was a difficult time
for Georgia. Eliot and Aline Porter arrived for my last
evening, and we had a good time. On July 24 I began my trip
home, retracing last year's route on the Santa Fe Trail to
Independence.*

*The scooter trip from Abiquiu to New York was just a long, hot
ride. I didn't make many photographs. I enjoyed being home
again after living so many months out of a rucksack. I visited
a dozen publishers and was still making the rounds in
December. I was called by the advertising firm of Norman,
Craig and Kummel about doing a series of ads for Chanel
perfume for* Seventeen Magazine. *Chanel wanted to tap the
youth market. The ads were to be of a boy and girl in typical
teenage activities. I was leery of the job, but they insisted I try.
They wanted a simple approach and that appealed to me.
Luckily for me they had a wonderful model to work with—
Carol Lynley, at that time fourteen years old. The commission
was for an ad every month. They gave me the theme and
whatever props I needed and a stylist, Kitty d'Alessio, who,
with Carol, made me a success in this specialized field. I
worked on that campaign for two years until Carol was
drafted into show business. Beside the work for Kay Daly at
Norman, Craig and Kummel, I began work for architect Wally
Harrison, photographing his buildings all over the country.
And as always, prosperity began to make me worry.*

1/16/57: Have been too busy making money to give much
thought to the book. I have done little work on it. For some
reason, I have been worrying about the evils of the
advertising business. I hear Lucille talking of some agency
that lost a $30 million soap account. That much money to sell
soap? And it is only one of hundreds of such accounts. It is
part of our sickness, inflation, the ridiculous values of these
times. I feel that big-time advertising is little more than an
income tax evasion gimmick: "Rather than give it to Uncle
Sam let us charge it off to advertising expense." I wonder if
people are cleaner since they spent $30 million to sell soap? It
is perfectly possible that Madison Avenue could be running the
country in five years if they keep on selling candidates to the
highest offices to the public. Ironically, I am making money out
of this business now. Maybe that is what worries me.

In between my activities I took a course at NYU in magazine article writing, thinking it might help me with the book. I've found two old pieces I had written in 1934 or '35 and rewrote them during this course.

Time passed, and soon it was vacation that had our interest. A letter from O'Keeffe invited us to Abiquiu for our holidays.

We arrived in Santa Fe at 7:00 A.M. on June 21 and were surprised to see Georgia and Betty Pilkington at the airport to meet us. They must have risen at the crack of dawn to be in Santa Fe at that hour. Georgia insisted that we rest for the next few days. She realized we were from sea level, and with the Santa Fe altitude at about 7,000 feet, our systems would have to adjust.

We had a wonderful camping trip to Canyon de Chelly in Arizona, followed by several other trips around New Mexico and good times in Abiquiu. Betty was delightful company. She works for Georgia and went with her to Peru last year.

It was sad to leave New Mexico and say goodbye to Betty and Georgia. Back in New York we were dreaming of living in New Mexico.

We were both busy. Through my old friend John Rawson, who was working for the Marshall Plan in Paris when we were there and is now with the United Nations, I had a contract to document the General Assembly session this year. I enjoyed the six weeks of work and think I did well, as they asked me to do a job in Mexico early in 1958. The General Assembly documentation was exciting; I met, talked to, and photographed many world figures.

In February I went to Mexico for the UN. Lucille managed her vacation at the same time, so we were able to travel together. My work was to tell the story of CREFAL on Lake Patzcuaro in Michoacan. A few years ago the UN was alerted to the disastrous fall in the water level of the lake and sent a team to investigate. They determined the cause to be the cutting of trees on the shore of the lake to fuel the pottery kilns. Pottery was the local industry. CREFAL is one of the educational branches of the UN. They enacted a plan to teach the people to fuel their kilns with oil and also instituted a reforestation

program to restore the water shed. When I was there in 1958, the new trees had prospered and the level of the lake gained 17 feet, almost normal.

About this time I found an agent to promote my book on the immigrant trails. Bill McGivern, a good friend and fine writer, recommended I contact his agent, Lurton Blasingame. I did, and he was interested and offered to handle the book. It would be some time before there were any results, but I was relieved and felt in good hands. In the meantime, I was doing Chanel ads for the agency and was otherwise busy. The State Department was readying a show for the World's Fair in Brussels. They are borrowing the negatives of my Sixth Avenue panel and making a print twenty-four feet by four feet. It should be quite a mural. They are using some other photographs of mine too.

1/31/58: I was trying to stop smoking. The pipe is tough sledding. It tips my uppers, bites my tongue, and doesn't satisfy, but I will give it a whirl. I certainly don't inhale much and that is what makes one cough. I think a lot about success. I believe it means different things to different people. I would like to be free to photograph constantly and not have to worry whether things would sell. I would like to find an angel who would contract to buy 100 photographs a year, all mounted and beautifully framed, for $3,500 to $5,000 a year. I think I could really produce with an arrangement like that. Then we could live in New Mexico, have a car, and use my 8x10 and the other large-format cameras that I like. Pretty dreamy stuff—maybe I should go back to cigarettes.

One night, Ninki Hart, a friend of Lucille's, invited us to her house. Her cousin had recently returned from a trip to Russia and wanted to show his slides. He gave a competent lecture although I didn't think his slides were very good. It is a grim country, and the ability of the people to accept what we consider a very low standard of living and to see how all the efforts are aimed at the good of the country was frightening. That kind of selflessness, even though it is forced, is tough competition. I had the feeling for the first time that maybe we are falling behind, not just militarily but also in a world economic sense. From what I have read of our early history, we were considered by the French and English visitors to

have a wretchedly poor standard of living. We were considered mannerless boors and hopeless ever to amount to anything. I couldn't help but think of this as I looked at the worn people of Russia in their shoddy clothing. And yet, they had an eager, alive look and a kind of innocence. I think we had that when other nations were looking down their noses at us. Looking at history, we know that Spain was once powerful, then France, and then England. Now all those countries are struggling for existence. What can we expect? It looks as though our profligate spending and unparalleled standard of living will make our span as "top dog" relatively short. What history my generation has been witness to! The developments in transportation and communication, spurred by two terrible world wars, is enough to make your hair stand on end. When I was a kid, the automobile was still the butt of the "get a horse" joke, and the air was still for the birds. A mile a minute speed was still a dream. Electricity was a novelty for only the very rich. Now we have everything, and the moon is in sight.

By the time we were back from Mexico, a trip to Africa for the UN had reached the planning stage. The schedule: five months to visit almost all of the countries south of the Sahara Desert. It was my first visit to Africa, and I was excited. I will use excerpts from my journal to tell the story.

I flew from New York on April 11 and arrived the next day in London, where I had three days to spend on my own. It was just ten years ago that I first saw the city, and it is still impressive.

I was met in Togoland by Mr. Feiffer, one of the UN observers. Now I am in my high-ceilinged airy room in the Hotel de Golfe. Mosquito-barred bed, no bath or toilet in the room, but this is Africa, a bidet, French Africa. It is hot and humid, and I am worried about my film.

The UN mission, consisting of twenty observers, had the task of getting the people registered and making sure they had an opportunity to vote and to make sure the election was fair. This was the first time the Togolese had ever been able to vote. There was a lot to do, but everyone was eager, and I must say the UN people were patient and helpful. I went first to the town of Aflao with Pat Holm, the observer for that

area. Hundreds of people were trying to register; it was chaos. They didn't seem to know about queuing and all tried to get to the front at once. Luckily everyone was good-natured, and soon Pat had them in line. Most of the crowd were women, many carrying babies in slings on their backs. Somehow 250 were registered before we gave up. The chief of the town had us to his house for a bottle of cold beer. He told me he had ninety-six children but thirty-six had died. I didn't know if it was cricket to ask how many wives he had. The battle to keep the flies out of the beer was constant.

M. de Roussy de Sales, a Frenchman and one of the leading observers, took me on a trip to Sokode, 360 miles north of Lome to visit some of the other observers and their stations. We passed many primitive villages in the thick jungle with houses of mud with thatched, conical rooves. We stopped at some of them when we heard drums and watched the circle of dancing people. They were celebrating the end of Ramadan, a Moslem version of Lent.

The next morning we went into the mountain country near Lama Kara, called the Massif Cabrais—rough, rocky country where the people are expert farmers. They have no machinery; they do not even know the use of the wheel. They cultivate the land with a short-handled mattox and plant between the rocks. They terrace the mountainside, practice crop rotation, and use manure to fertilize. These people are the best fed and healthiest of Togoland. As the day of the election approached, I felt it was a hopeless project. I saw no understanding of what it meant to vote.

Village in Togoland, West Africa, 1958.

4/27/58: E day for Togo. Almost funny except for the serious aspect. No one seem to have any idea of how to run an election, and most polling places voted about fifteen people an hour. The lines form early in the morning and advance foot by foot in the hot sun. Luckily, the people are gentle, and few incidents of violence occur. The women bring their babies; pans of water are passed; snacks are sold.

On the way back to Lome we came to a village with a line longer than any we had seen. We stopped to investigate. Before people could vote, they had their right thumb dipped in indelible ink to ensure that no person could vote more than once. A budding young scientist or politician in the village

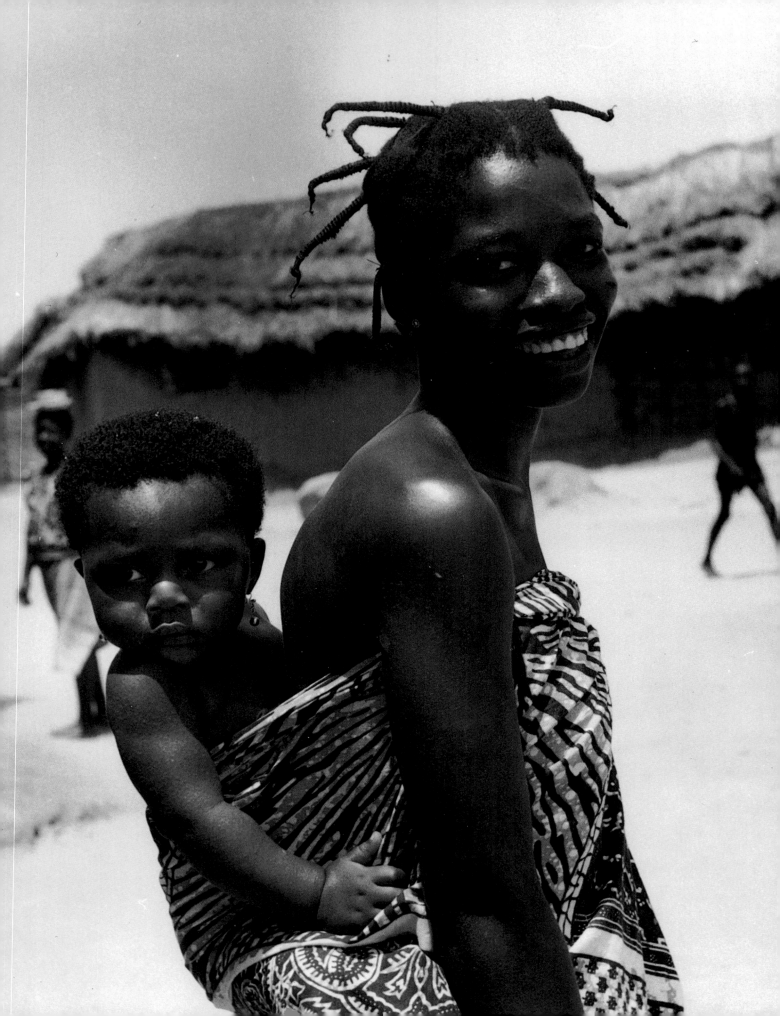

had discovered a way to erase the ink, so people were taking advantage of a bonus vote. I don't know that anything was done about it.

The day after the election is one I will never forget. Togoland voted to become a free country. Everything was closed and the people were in a holiday mood. Everyone was shouting "Ablode!" (Freedom!), and crowds painted their faces white and donned outlandish costumes.

My next assignment was in Ghana, the country just north of Togo. They had voted their independence from Britain the year before, and when I arrived the country seemed quite advanced, compared to Togo. I checked into the brand new Ambassador Hotel and had a hot bath, my first in Africa. I had a car and driver and an interesting itinerary, which would show me all the principal industrial and agricultural centers of the country. Ghana's chief export, cocoa, supplies 60 percent of the world's market.

5/18/58: What happend to my journal? I write a daily report for the UN and often a letter to Lucille. Now my Ghana trip is history, and I am sweltering in Khartoum. It was 112° yesterday; the thermometer on the terrace of the Grand Hotel is sitting on 120°.

After a few days in Khartoum, I went on a long train ride through the backcountry of Sudan. My first stop was Wadi Medani in the Gezira Triangle where the White and Blue Nile rivers meet. This is where the famous and choice cotton of Africa is grown. I photographed as much of the industry as I could. The harvest had just been completed, and no planting would be done for several months.

My next stop was Kassala, an oasis town near the Ethiopian border—also a large camel market. The two tribes I found most interesting were Rassaida—handsome, sheiky Valentino desert men—and the even more colorful fuzzy-haired Hadandawa, who wore dresses and carried huge swords. One of the Rassaidas showed great interest in me and conferred with my guide. I understood that he was inviting me to sit on one of his racing camels. I thought sitting up that high would give a better viewpoint to photograph the market scene. I didn't find out until later that he was inviting me to his camp

Sawing a log, Asaanti, Ghana, West Africa, 1958.

Togolese woman and child, Togoland, West Africa, 1958.

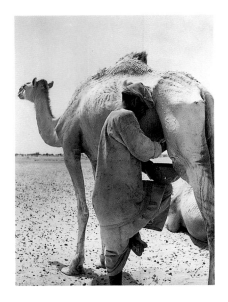

Milking a camel at the camp by the Gash River, Kassala, Sudan, 1958.

Camel market in Kassala, Sudan. The man at the left was my host for the trip to camp, 1958.

seven miles away on the Gash River. I got aboard the camel and found it a very unsteady platform for photography, and I was so high up that I needed both hands to hold on. When we finally reached the Gash River, it was absolutely dry. There must have been more than 100 camels, a dozen Bedouin tents, and lots of children and women. My host clapped his hands. A filthy-looking servant brought a filthy-looking leather bowl and began milking one of the camels. When he offered it to me, I could see specks of camel dung floating in it and determined not to drink any of it. I tried to explain that I was a Quaker and that my religion did not permit me to drink warm camel milk. Of course, no one understood. Just then a car pulled up with my guide, and I managed to make him understand how strict my religion was, so I was rescued from warm camel milk. I wonder if it was any good.

I made a stop in Dar-es-Salaam, the capital of Tanganyika. Of all the African countries I visited, I believe I enjoyed it the most. There is no segregation there, as we know it. In Moshi, I stayed in a hotel that had both black and white guests, and we all ate in the dining room together. I had not seen that in Africa. I had a very good contact in Tanganyika, a British civil servant, Eric Lovelock. Moshi is in the shadow of Mt.Kilimanjaro and is the home of the Chagga tribe. They seem the most advanced of any of the native people I have met in Africa. Each family has a four-and-a-half-acre tract; they grow coffee for a cash crop and food for themselves. They have a coffee collective to market the crop and are happy and prosperous.

Nairobi was another place in Africa I will never forget. Here I saw more animals in their native habitat than ever before. I photographed the king of beasts from about ten feet away as he stalked a gnu. My guide took me to some of the game parks in a jeep and certainly knew his way around. He found a mother cheetah and her three kittens for me to photograph.

I arrived home in New York on August 15, just in time to fulfill my contract to document the General Assembly at the UN.

It was good to be home with Lucille and I was very busy. Beside my UN job I had several ads to do for the Chanel account. Early in 1959 had a letter from Georgia inviting us to New Mexico for our summer holidays, giving us something to look forward to. In May Georgia called. She was in New York on her way home from a round-the-world trip and had just flown in from India. She came to dinner and regaled us with accounts of her travels. She was ecstatic about her trip. We made our vacation plans to go to Abiquiu in June and stay two or three weeks. We can spend a week at the ranch if we like, and I am sure that we shall.

Lurton at last has a contract for a book from Doubleday. Before they do the trail book they want me to do one about ghost towns. Lurton thinks it is a good idea; I already have a number of pictures for a book like that. I think I will take my scooter to New Mexico on the train and perhaps make a trip from there to get the other things I may need.

Firemen, Third Avenue antique store, New York, 1959. Part of the "Farewell to New York" series.

Trinity Church from Wall and Broad streets, New York, 1959.

5/29/59: Georgia came to dinner Saturday night. She was full of her trip, almost too full to talk about it. She said she would tell us all when we came for our holiday. I didn't feel so good yesterday and made the mistake of mentioning it to Lucille. Now I find myself in the middle of a complete medical checkup. Between the doctor squeezing and poking me and asking when I had my last Wasserman and if I had intercourse last night or this morning and tapping my knees with a hammer, it was quite a session.

I went back a couple of days later when I had more tests. When it was all over he said I must stop smoking and lose ten pounds. That made history as far as I am concerned. When the doctor said I must stop smoking, I took the package out of my pocket, put it on his desk and to this day I have never smoked another cigarette. I am sure if I had not taken his advice I would have been long since dead.

On June 20 we went to New Mexico by train. We had a great stay in Abiquiu and at the ranch. Georgia talked to us about moving to New Mexico and we began to think about it. Lucille went back to New York on July 17 and I stayed on, sold my scooter and rented a car to do some work on the ghost town book. I went to Colorado and did the towns on my list and then on north to Wyoming. I thought I had enough for the ghost town book. If not, I would do some more on the California towns the next summer.

During the fall I had a surge of interest in the 8x10 camera. Every Sunday morning I lugged the monster around downtown and made some good New York things to add to my collection. I also started a portfolio which I called "Farewell New York." We had pretty well talked ourselves into moving to New Mexico if we could find a way to exist out there.

1960 began with a lot of work with Lurton Blasingame, meeting with editors to talk about the books I would write. The only success was a contract with Doubleday to do the book on the ghost towns. That didn't have to be done until 1961 so I had time to work on it. Lucille made history on April 4 when she stopped smoking after a visit to her doctor for a circulatory problem that had been bothering her. She emulated me and quit cold and has not smoked another cigarette to this day.

Deserted house, Georgetown, Colorado, 1960.

Our house on St. Luke's Place was sold, and that seemed to fit in with our plans to move out west. We began thinking of California as a possibility as well as New Mexico. With the book contract from Doubleday we began to plan our holiday. I had to do some more field work for the book involving travel outside of New Mexico. So, we bought a car to drive out. On June 15 I got my advance of $1,500 from Doubleday, and we left two days later. Our first stop was Abiquiu. While there we went to Santa Fe, where we saw a store for rent on Canyon Road. Lucille liked it very much. That decided our fate about moving to Santa Fe. She rented it in January 1961 to open a book store. As we made our decision to move to New Mexico, we continued our trip to California, where I finished the work on my ghost town book. Lucille flew back to New York, and I had a successful time in the Mother Lode country in California and then in Nevada. I also photographed old mining towns in Idaho and Montana.

A call to Lucille from Cripple Creek, Colorado, gave me a pleasant shock: an ad agency had bought nine of my transparencies for $4,500 and we had received a check for $2,700 as my share. I worked my way through Colorado to New Mexico. I felt I had enough material to complete my book and had a few days with Georgia. She is happy about the prospect of having us for neighbors next year.

8/13/60: I left Abiquiu reluctantly as usual and not very early. We had our breakfast in the kitchen and a very good talk. She was excited over our move and got to telling me what New Mexico was like in the old days and how she had happened to come here in the first place.

Paul and Rebecca Strand had been out here probably during or soon after World War I. Paul was a conscientious objector during the war and was assigned to a rural project out here and had discovered Taos. Georgia first heard about it from him. When she came to New Mexico in the mid-twenties, Rebecca came with her. Mabel Dodge and Frieda and D. H. Lawrence were in their prime at that time. Mabel loaned Georgia a studio in Taos, which she used for several summers. Georgia told me about a forty-eight-hour drunken brawl that started in Santa Fe at Witter Bynner's house and finished at Marie and Henwar's house. Henwar's mother, a regal lady and the first woman to have graduated from

Heidelberg, was also a guest. She was acting hostess and tried to show Georgia to her room on the assumption that Georgia was also drunk. Her room was occupied by a Jessica something who was holding court there after having a fist fight with one of Witter Bynner's boys.

As early as 1929, Charles Collier, who had taught Georgia to drive her first Model T Ford, had told her about the Ghost Ranch. In Taos one day she saw a truck with that sign on its side, and when a cowboy got out she asked him how to get to the ranch. A day or two later she went there and fell in love with the country at once. As there was no accommodation available she was ready to leave when the boy of a family staying there developed acute appendicitis. She stayed in their place until the end of the season and returned the next year to spend her summer at the dude ranch. About 1939, Arthur Pack, the owner of the 55,000-acre spread, offered to sell Georgia a small house on nine acres in the middle of the ranch. She still has it and calls it her Ghost Ranch house.

I cannot possibly reproduce her description of the two drunken parties she attended. The forty-eight-hour one was really a Jazz Age humdinger. Georgia was then about forty-five and at an age to enjoy it to a degree. The other was a party at Richard Pritzlaff's during World War II. He invited about fifty GIs to a Christmas or New Year's party at his ranch in Sapello. Only three women were present—Georgia, her friend Maria Chabot, and another woman. Maria was very drunk and somehow got the boys fighting after slightly wounding Richard with a butcher's knife. The fight spread through the house and spilled onto the front lawn, Maria with a flashlight egging the contestants on. Richard furiously charged the fighters and restored a semblance of order. The drunken soldiers were loaded into trucks and taken back to camp. Can you imagine Georgia in such a situation? And yet, when she tells of both these parties, she has a twinkle in her eye. But, of course, Georgia has an acute sense of humor.

1960 wore on and I was busy doing several Chanel ads and fulfilling my contract at the UN. The man who had bought our house turned out to be Arthur Lawrence, the writer of West Side Story. *He wanted to do over the entire house and asked if we would consider moving if he paid our moving expenses. We told him that if we accepted we would be going to New Mexico*

and that was all right with him. He offered us $1,500, just about the cost at that time, so we set our sights to move just after the holidays.

One night we had Helen Gee over for supper. As she had been a friend of Steichen's for years, the conversation turned to his marriage to his twenty-six-year-old biographer. Helen told us of an encounter she had had with Steichen a couple of years before when he had been about eighty. He was staying in an apartment on 47th Street and invited Helen down one evening for some reason or other. He had gout, his foot was wrapped up, and he was using a cane. In the course of the evening he made a couple of passes at Helen and she shied off. Soon, he was chasing her around the room, showing surprising speed and agility despite the gouty foot and the cane. Finally they were both out of breath, though Helen felt he might be gaining. He asked if it was due to his age that she resisted him. She disclaimed any such idea and said it was just not a good time for her. She had a faraway look when she told us, "You know, I think I felt something once."

As we packed our things for the move to New Mexico we were busier than we had ever been. I had three Chanel ads to do, and then the agency sent me to Jamaica for two weeks to do a series of ads for the Island Tourist Bureau. Also, I managed to get off the first draft of my book to Doubleday. They were pleased with it, asking only for a couple of minor changes.

When we moved from New York I thought I would start a custom film processing business so I could forget about being a magazine or advertising photographer, but the business never got off the ground since I began to get some jobs soon after we got to Santa Fe. And our social life there boomed, certainly a result of our relationship to O'Keeffe. She was more or less reclusive and never mixed much with Santa Feans. Word got around that when we had a party O'Keeffe usually came, so we were overwhelmed with invitations. Also, Lucille's book store, which was a hit from opening day, added to our new circle of friends.

Just at the time we moved into the house at 208 East Houghton Street, our neighbors on Camino de la Luz, the Carnahans, moved to New York and we inherited a handsome year-old silver poodle, Folly, and also a handsome Siamese

cat, Oxygen, the same age as Folly. They had been daily visitors when we were next door to each other, so the Carnahans suggested that we might like to have them. We had them for thirteen years, taking them with us when we moved to Provence in January 1971. They are buried together in the French countryside.

On August 22 I embarked on a memorable voyage through Glen Canyon on the Colorado River. The party included Georgia O'Keeffe, Tish Frank, Doris Bry, Marshall Girard, Eliot Porter, and myself. It was a great experience and we all had a wonderful time. I must say I was disappointed in the wilderness aspect of Glen Canyon. In the first place the river was filthy and left you a deep brown color after a swim. The hum or roar of outboard motors was not unknown in the canyon, and the debris of campsites was everywhere. If it had been a clear-water stream, restricted to hand-powered boats I would have understood the tears when the river was gone and it became a lake.

Georgia O'Keeffe in Glen Canyon, 1961.

8/22/61: If the lake works out as expected, it should be a much more valuable wilderness area. The water will be clear once the silt has settled, and it can be stocked with fish. There will be 1,800 miles of shoreline instead of the present 320. I look forward to a trip in some future year when I can explore a shoreline far above the one we saw on the river. I saw meadows and benches far up along the walls that must be great, places that have never been trod by man. The side canyons will be spectacular, narrow inlets, and far up the walls there will be caves and caverns to explore. I think the prospect is one of the most exciting I can imagine.

My Doubleday book Gold Strikes and Ghost Towns was published on December 1, and it was a hot seller in Lucille's book store. I was disappointed with the reproduction of my photographs and had to accept the fact that it is more a history book than an art book. It really did sell well, however. Ten thousand copies were printed and in less than a year all were sold. It was enough of a success for Doubleday to give me a contract to do the trail book.

On December 7 Aline had a surprise party to celebrate Eliot's sixtieth birthday, and it was a dilly. A couple of weeks later we had another big party to celebrate Oliver La Farge's sixtieth. In January 1962 the Fine Arts Museum in Santa Fe hung a

Georgia O'Keeffe and Doris Bry in Glen
Canyon, 1961.

Georgia O'Keeffe rowing in Glen
Canyon, 1961.

show of photography by Eliot Porter, Laura Gilpin, and Todd Webb. It was well received, and my things held up very well.

2/3/62: Our Siamese cat, inherited last year as a kitten, is now in season, and it is the first time I have experienced such a thing. It is really frightening, the noises she makes calling her boy friends. I kept her shut in my darkroom at first and two tomcats paid constant court to her when they were not fighting each other. They sat on the windowsill and made all sorts of lewd love talk to her, and she was giggling and cackling right back. It got so noisy that this morning I let her out and so far not a boy friend has shown his face and she is frantic. She parades the roof of the house and the garden wall, yowling to high heaven.

2/6/62: Puss seems to be cured of her trouble, probably with kittens, and everything is calm in and around the house. Randall Davey wants me to make transparencies of his paintings and I am going to do it. In exchange, he is going to paint a portrait of Lucille.

4/23/62: I received my Doubleday contract for the trail book. I have the same advance as with the ghost town book. Looking in the museums and historical societies of the Southwest I have found a lot of new material. I need a few more photographs so I plan to travel over the western part of the trail. Georgia suggested I use her VW camper, which will be great for then I can camp out all of the time. And I can take my typewriter and have a place to use it.

8/6/62: On August 3 Oliver La Farge died, and we are saddened. We had gone to see him in the hospital a couple of days before and thought him much improved, but I guess he was just too frail to recuperate from the operation. His burial service today was proudly attended by Indians from the pueblos of New Mexico and Arizona, who carried his coffin and honored him for his concern for them.

In November Georgia invited me to lunch in Abiquiu along with Mitchell Wilder, director of the Amon Carter Museum in Fort Worth. After some general talk about art, museums, and photography, Mitchell announced that in conjunction with the University of Texas the museum was going to do two books on Texas architecture. He was looking for a photographer and

wondered if I would be interested. When I said I would he proposed that I have a show of my work at the Amon Carter Museum. He thought it would convince the museum board that I could do the work. I agreed to get one hundred photographs ready for a show in 1963.

1963 was a busy year for us, and we both accomplished a lot. As Lucille's book store flourished, I finished my book The Gold Rush Trail and the Road to Oregon. *I received an advance copy in September and again was disappointed with the photo reproductions. It was well received, however, and Doubleday sent me reams of glowing reviews from papers all over the country.*

The big shock of the year was the assassination of President Kennedy on November 22. A couple of weeks after my show opened at the Amon Carter Museum on Thanksgiving Day 1963, the board of the museum met and I was chosen to make the photographs for two books, Nineteenth-Century Homes *and* Nineteenth-Century Public Buildings, *that were to be published by the Amon Carter Museum and the University of Texas. My contract called for me to work in the spring and fall. In December I finished the photographs to illustrate two books, one by Brink Jackson and one by Winfield Scott. On March 20, 1964, I drove to Fort Worth to begin on the architecture project. It was good work and I enjoyed it. I covered Texas from end to end. As usual, the research and finding houses that had been built before 1900 was as much fun for me as the actual photographing. During the summer of 1964, I made all the prints.*

6/1/64: I went to Independence again, working on a story about the Santa Fe Trail for *Venture* magazine. I saw Harry Truman again. He is frail looking and seemed rather tottery, and I doubt he remembered me but he said he did. I took him one of the trail books and when he saw his picture he brightened.

7/24/64: Georgia's Polaroid camera came and I took it to her. She was like a kid with a fine new toy. She said it was better than Christmas. She wouldn't even look at the machine until she had studied the instructions. I wish more people would do that. Over lunch we made plans for a trip to Lake Powell in September. Paul Frank was one of the originals for the party,

but he has to have an operation for the removal of a kidney stone and has had to cancel. When I told Georgia about Paul it touched off one of her classic Stieglitz stories, told to me from time to time. Stieglitz had a stone that moved around for quite a few years. Georgia learned how to give him morphine shots and often administered them on trains, in hotels, and at Lake George. Finally, he had a bad siege and was taken to a hospital where Georgia's sister was a nurse. She was sort of odd, psychic according to Georgia. Her sister said Stieglitz would pass his kidney stone if he would follow her instructions. He hated anything to do with milk. The sister's cure was for him to drink two quarts of buttermilk a day for ten days. He resisted for a couple of suffering weeks and then in a disgusted rage he agreed to try the cure. He gagged and drank his two quarts for ten days and then, on the day she had predicted, he passed the stone. He was so mad that she was right he almost threw the stone out the window.

In late January of 1965 Lucille and I drove south for our annual holiday in Mexico, where we rented a house in Patzcuaro for six weeks. Alan and Alice Parrott came to Patzcuaro for a few days and we spent time with them. We had a good time, making trips to places we wished to see.

2/26/65: Today was my last Patzcuaro market day and it seemed particularly exciting. I don't know what I want to say about this primitive area and the marketplace. It is a way of life completely foreign to anything we have at home. Here, the setting, the great plaza with the beautiful trees is remarkable. In most towns the markets are on the streets, as in Oaxaca. They can be exciting but they lack the parklike background of the one in Patzcuaro. I spent most of the day at the market and I must have some good pictures of small, human situations. It has been one of the better vacations but I look forward to getting home and developing my negatives.

In August Harry, Eleanor, and Barbara Callahan came and stayed three days. Mitch Wilder visited at about the same time to pick up my pictures for the show in November. They were just photographs made in the West. After all, it is the Amon Carter Museum of Western Art. Beaumont is doing the catalogue. I think there will be about one hundred prints in the show. It opened on Thanksgiving Day and the reception was gala with champagne flowing. I was pleased with the way

Market on the Grand Plaza, Patzcuaro,
Mexico, 1965.

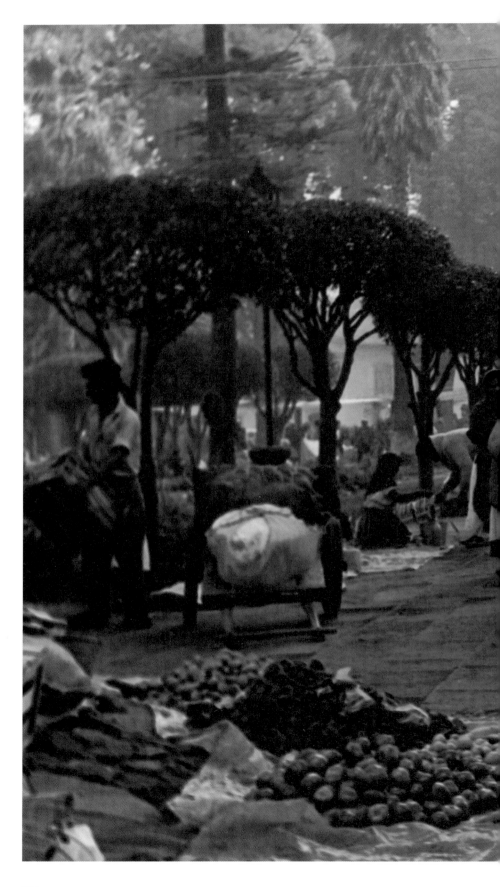

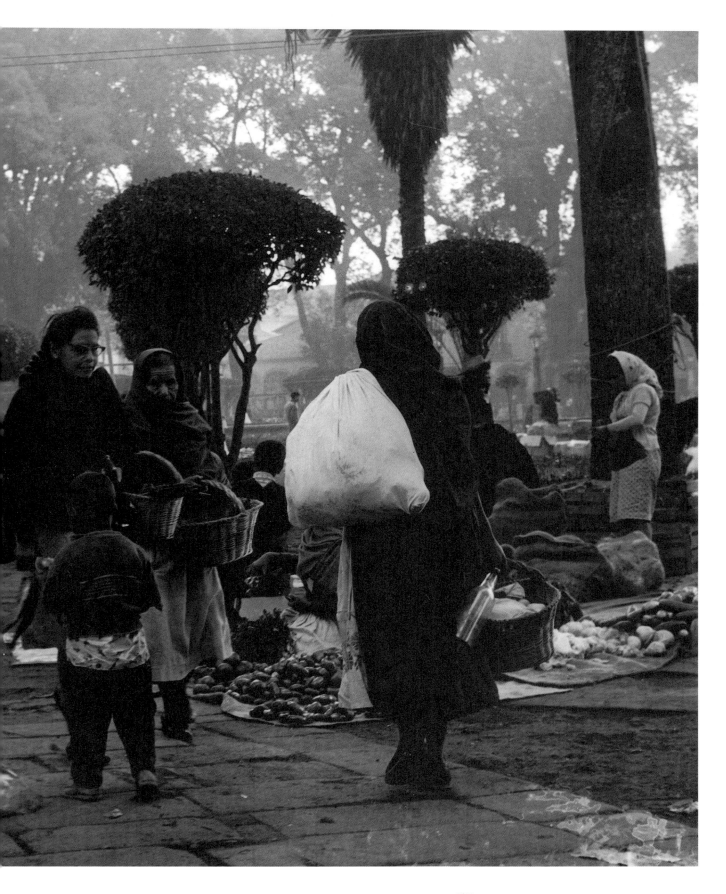

News reader on the Plaza, Patzcuaro,
Mexico, 1965

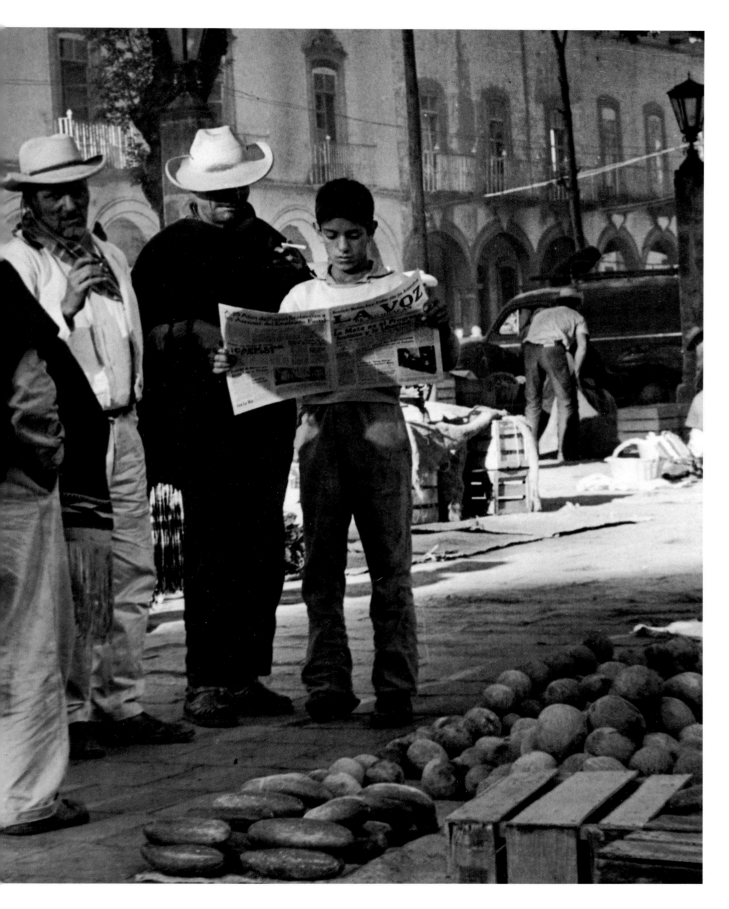

the photographs were hung and with the book. As soon as we were home I had to get my prints off to Philadelphia for the Guggenheim Fellows show at the Philadelphia Museum.

12/31/65: The last entry in this good old year 1965. It was a good year in every way. We made enough but not too much money and we have been well and happy.

4/5/66: There is a great deal of Easter activity going on now here in Patzcuaro. Passion plays, Resurrections, Stations of the Cross, and God knows what. I hope to make photographs of the events. Ralph Gray told us a story about last year's happenings in Erongaricuaro. The man playing Jesus was known to have an affinity for tequila, so was lodged in jail the night before to make sure he would be in shape to carry the cross to the crucifixion site. His friend, the man playing Judas, visited him several times during the night with the tequila bottle, and by morning they were both very intoxicated. Jesus, carrying the cross, fell down a dozen times during the procession, to the delight of the onlookers. Each town has some kind of fiesta and we will probably visit several of them.

I felt for the first time that I was beginning to get some significant photographs of Mexico. It is such a colorful and exciting place that I had found it difficult to say anything personal about it. The quaintness, the color, the poverty are all such obvious things, but at last I believed I was starting to have a personal viewpoint.

Had a letter from Harry during the summer. He is going to teach what is called a master's seminar at the University of California at Berkeley in August. He expected to have ten or twelve people but, to his surprise, about thirty have signed for the course. He wants me to consider going out with him to help. I agreed to try it.

On August 18, the Callahans arrived in Santa Fe and I got myself ready to go to Berkeley with them. I hoped to learn something about handling workshops as it was something I had been thinking of for Santa Fe. I felt that with his long experience teaching in Chicago and Providence, Harry would be able to give me many pointers. Working with him was a privilege and a pleasure. I did learn about things to do and

not to do. Half of our people were professional workshop attenders, I think. Eight had just finished a Minor White workshop, and I gathered from the conversation, had been most impressed by the preclass yoga meditation session. But Harry's matter-of-fact, understated approach had an effect on the class, and I believed they would get something out of the course.

8/25/66: I guess I am lucky to be in Berkeley at this time. Undergraduate folklore is being created. The protests have taken the most blatant form, long hair, dirty bare feet, anti-this and anti-that. I walked on the campus today and at first was appalled by the appearance of the mob. Long-haired boys with flying beards, dog-eared girls in filthy jeans, also with dirty bare feet, all with contrived sloppiness. It is puzzling. Maybe these are the top kids of this generation. Perhaps some of them are, and some are hangers-on. If it is healthy, I don't know. Undeniably it is alive and jumping. Under the circumstances, I might be one of them if I were in their age group. Our group is making progress. We have no avant-garde far-out types and no one has caught fire yet.

The seminar wound down and certainly was a big success for me since I learned so much about running a workshop.

I find it hard to explain the three-year gap in my journal. After I finished the Texas Architectural Survey in 1966, I had a lean period as far as photographing was concerned. I tried a lot of things, but none of them seemed to work. It was not until I had my first photographic workshop in 1969 that things began to improve.

Lucille had a nice experience in October of 1967. A woman came into her shop and wandered around looking at the books in a number of categories. She stopped at the desk on her way out and said, "I see you have Eudora Welty books." Lucille replied , "All book stores should have Eudora Welty books." That night we had been invited to dinner at Dick Wormser's house, and the guest of honor was the woman who had been to the shop—Eudora Welty. Ten years later some of Eudora Welty's photographs were shown in Portland, Maine, and she was there and remembered Lucille warmly.

I had a note from the Philadelphia Museum telling me that one of my photographs, White Sands, *had been stolen from the*

Hat market, Oaxaca, Mexico, 1969.

Basket market, Oaxaca, Mexico, 1970.

Guggenheim Fellows show and asking me to replace it. It was insured for fifty dollars. I must say I was a little flattered. When Pete Pollack's show "Ideas and Images" was traveling, one of my photographs was stolen, not once but three times.

7/19/69: My first workshop began on Tuesday and has gone very well. We made photograms the first day, and all were delighted to have something to take home with them. Had the first field trip on Thursday and that, too, was a success. We have worked out a schedule of a field trip one day and a darkroom day the next. The days are long and I am tired by quitting time. Then I usually have prints to dry and preparations for the next day. Several of the people will be quite competent by the end of the course.

7/26/69: We had an historic event today. We paid off the last of the mortgage on our house and now we own it stem to stern. Also, the men arrived back from the moon.

A camera shop in Albuquerque asked to hang a show of the results from the workshop and all of the students agreed. The first workshop was such a success that there was demand for another.

10/27/69: My second workshop finished on Saturday—a great success. Everyone was happy and all are excited about having the show.

There was a big turnout, and a number of working people asked about a weekend workshop. I had a job at the Indian School to make color slides of the Honor Collection of student art work. It is a contract job so I had to limit my weekend workshop to eight students. It began January 7, was a good one, and everyone enjoyed it and did well.

We made our annual Mexico trip as soon as the workshop was over. We traveled on the central route through El Paso and Chihuahua to Mexico City where we expected to stay a week. But the city was so crowded and construction work on the new subway made some of the streets impassable, so after a couple of days we went on to Oaxaca where we arrived just in time for the total eclipse of the sun which occurred about noon. The absolute zero was only twenty-five kilometers away so scientists and onlookers from all over the world converged on

*the town. We were at the big Friday market in almost total
darkness. It was an eerie sight, the light that remained was an
odd greenish color. The usually colorful and volatile market
was subdued and breathlessly quiet. At evening when the
visitors began to look for accommodations, they found our
trailer park full to the last space, so many slept on the ground
and luckily the weather was fine and warm.*

*The last days of our vacation were a nightmare. Just before we
reached Guadalajara our motor burned out and we had to
wait several days for its repair. We drove on for two days and
when we were near Wilcox, Arizona, we again had a signal
that there was no oil in the transmission. Did the Mexicans
forget to fill the crankcase? We will never know but we did
have to get a new motor. We made it home and except for the
last ten days it was a great holiday.*

*We are beginning to talk about ending our days in Santa Fe and
dream of living some years in Europe to round out our old age.*

5/27/70: Our thoughts are of going to France to live for a
couple of years, maybe longer if it can be arranged. Next
month I apply for Social Security and Medicare. I will be sixty-
five in September. We had a letter from Mary Callery who
thought she could find us a house in Cadaquez on the Costa
Brava in Spain where she now has a house. Also a letter from
the Morels telling how good it would be to live in St. Restitut,
the Provence village where we spent part of our honeymoon.
In October Lucille put her shop up for sale. One person is very
interested; if it is sold we will put our house on the market.

10/23/70: History is being made. Lucille sold her shop to the
Santa Fe man who has been dickering for it. He takes over
November 1, and Lucille will stay on to help him get started.
The house goes on sale next week and we may be on our way
to Europe by year's end.

12/1/70: Emily Barnes called from New York twice. She
wants to buy our house. She was here for dinner one night
last summer and loved the house. She can wait until March to
occupy it and that will be good for us. I told her the price, not
quite double what we paid for it ten years ago and she
thought that was fine. She is sending us a check for $1,000;
earnest money, they call it.

Our house, St. Restitut, 1973.

St. Paul Trois Chateaux, Provence, 1971.

Just at the same time we had a letter from our future landlords in St. Restitut telling us about a house they were restoring and which we could rent if we were going to stay three years. We got in touch with the French Consul in Los Angeles for permission to live permanently in France and made arrangements to buy a French car to be delivered at dockside in Le Havre. We found a freighter line from New Orleans that would allow us to take our dog and cat. We got busy throwing things away. I threw out hundreds of prints and negatives. The people from the museum came to get prints for their collection. We decided to leave most of our household possessions, negatives, and prints in Santa Fe storage.

On February 27 we were aboard ship, the S.S. Christopher Lykes, *and sailed that evening. When we awoke in the morning, the ship was still. We were anchored in the Mississippi River near the Gulf of Mexico in the thickest fog I have ever seen. We stayed right in that spot until March 2, when a cold front came to our rescue. When the fog lifted, we saw a dozen ships within hailing distance. The foggy days on the river set the tone for the whole trip. As we neared Le Havre, where we were supposed to debark, the captain had word that there might be a strike of dock workers, so he made his first stop in Bremen, Germany. From there we went on to Hamburg, Antwerp, and Rotterdam. We were sure the next stop would be for us, but instead we went to Southampton, and at long last Le Havre. So it was March 27 when we landed in France. Because our arrival was two weeks behind schedule, our car for which we had already paid was sold, and we had to rent one to get to Paris. We spent two days in Paris getting the car business straightened out. The animals were as sick of the delays as we were. Finally we got away on our 700-km route to St. Restitut with puss screaming every inch of the way.*

*I was invited to Arles for their film festival as one of the judges to pick the best photographic book of 1970. Lucien Clergue is the entrepreneur, and he seems like a nice guy. Bruce Davidson's book (*East 100th Street*) was the winner of the first prize.*

7/31/71: We have been in St. Restitut for four months, which passed very quickly. We spent a lot of time waiting for something or other, but now that we are happily installed in our really wonderful house, it all seems worthwhile. My darkroom is a going concern. Pierre managed to bring the

things I ordered from Paris with him; most important, the polycontrast filters.

8/14/71: Had a successful opening last night at the Maison de la Tour. A good many of the townspeople turned out as well as some from the surrounding country. I was surprised when a few prints were purchased. We made a trip to Carpentras today, only thirty minutes away but like another world. We went through Suze la Rousse, St. Cecile, Gigondas, Vaqueras, Aubignan, and several others, some of them charming villages. Carpentras is one of the best market towns and we often go there to shop. In Vaqueras we bought six bottles of 1969 Côte du Rhône wine for five francs a bottle, about eighty cents.

Road near St. Cecile, Provence, 1971.

9/3/71: Someone up there miscounted. We had a mistral that blew hell bent for four days and then quit this morning. They say the mistral blows in a series of three, six, or nine days with nothing in between. It wasn't bad, though incessant and a bit irritating. At this season, with the weather warm, it is not uncomfortable. But, what must a winter mistral be like?

9/30/71: Another rip-roaring night of mistral and today the sun is shining brightly and if one closes his ears and looks out the window, it's a beautiful day. We are going to test a local story. It is said there is no mistral in Nyons, a town thirty kilometers from here.

Mission accomplished, theory proved. Nyons was beautiful and warm enough to sit on a terrace for our morning coffee. When we got back home it was still blowing and cold. The Vendange is now in full swing and the roads are crowded with all kinds of vehicles carrying loads of grapes to the caves.

Early in October we drove to Barcelona to meet Grace Mayer who was on her annual vacation. We had a successful reunion with Grace and Barcelona. On November 1 David Donoho came to see us. He had just been to Greece and from what he told us, it sounded like a place for us to go. We got out our maps and found that we could drive to Greece. We packed and early on the morning of November 4, we were off with our dog Folly. Nine hours and six hundred kilometers later we were in Lonato, Italy, near Verona, in the smog-laden industrial area of northern Italy. We thought of going to Venice but the smog discouraged us. The heavy hanging mist makes the sun only a

*weak, orange ball hanging in a dull gray sky. The restaurant,
however, did treat us to the best piece of beef we had tasted for a
long time. The charcoal-broiled chateaubriand for two was a
meal to be remembered. The next day we passed through Trieste
into Yugoslavia to the road along the Adriatic, twisting and
turning with dramatic views of the sea. Out of the tourist season
we had difficulty finding a place to stay but finally, just at dark,
came upon a small hotel whose name I can neither spell nor
pronounce. Our trip to Athens took us through Split,
Dubrovnik, Kotor, and Skopje. After three days in Athens
walking our legs off and seeing the sights, we moved to Napflion
where we stayed at the Hotel Agamemnon and had a room with
a view over the Argosian Gulf. When we had had our fill of
Greece we booked passage from Piraeus to Brindisi, Italy, on the
S.S. Aphrodite. We had an easy drive through Italy and the
south of France, arriving home on November 22 with four
handmade Flokati rugs which look fine on our white floors.*

*Although 1971 was an exciting year in many ways, it was not
productive for me photographically. I think the moving and
the frustrations of settling in may have put me off. And, as
often happens when I am in a slump, I tried to recover by
making a project. I didn't understand then what was
happening but I do now. Not being able to see or feel is the
problem, so I picked on a rather obvious way of replacing
seeing and feeling. Many of the doors in France, and in most
European countries, have ornamental knockers. Some of the
old ones are remarkable and well worth a photograph. But I
got carried away and now I can hardly look at a door knocker.
I must have hundreds of them never printed.*

*In July 1972 we had a letter from Lee Owens offering us the
use of his apartment on Place Furstenburg in Paris while he
vacationed in Menton. It would be wonderful for us to stay on
that beautiful square which I discovered on my first trip to
Paris in 1948. I will take a print I made then to leave for Lee.
We did enjoy our week in Paris though we were appalled at the
changes since we had lived there twenty years earlier. In 1952
there were still very few cars and parking was no problem. In
1972 it was a major triumph to find a parking space. I did
find one on rue Jacob around the corner from Furstenburg
and I was proud of that. They have odd and even parking in
Paris, so by getting up early I could wait in my car until
someone across the street drove to work and then move into*

that spot. Of course we had no car to use during the day but with the metro and the buses still running on time that was no problem. We went to our old neighborhood around Alesia and sat at our favorite Cafe Zeyer, but the noise and pollution caused by the many cars made it not nearly as attractive as in 1952 and earlier. With so many cars parked along the curb, it is impossible for the street sweepers to keep the gutters clean, and the city seemed much dirtier than we remembered. Still, Paris was wonderful and we enjoyed visiting the museums and seeing old friends.

We were happy to return to peaceful St. Restitut even though we were met by a roaring mistral. As the summer wore on we began to make our plans for the fall. St. Restitut is a strange place. It is mostly rustic and quiet but it can also be a jumping place. In mid-August they had a concours hippique, *a horse show with all kinds of jumps. Horses are brought from all over the country and, of course, the village is jammed with visitors for a few days. The roads outside the village are lined with cars and horse boxes and it is very festive. When it is over, the village goes back to its sleepy existence. But not for long. The* Fête de St. Restitut *began at the end of August and was greeted by a full-scale mistral that almost blew it off the map.*

We were disappointed when we heard that Nixon had defeated McGovern. We had hoped for a miracle. The war in Vietnam lingers on in spite of the promises four years ago to end it.

The dollar has been slipping all year. We have gone as low as four and a half francs for a dollar. With the mistral and the slipping dollar we wonder how long we can stay in Provence. January 1973 turned out to be "the mistral month." We had one after another and the house was freezing most of the time. Our landlord came to tell us that he was going to install central heating, so next winter we should be more comfortable. Our little fourteen-year-old poodle, Folly, became so blind and deaf that we had to take her to the vet. He thought she had gone about as far as she could go so he piqued her and we had the sad task of burying her. It took us many months to get over the loss.

2/5/73: We are now packing for a trip to Spain, trying to keep busy and not think too much. The tears come at the most unexpected moments. Maybe I should understand. After all,

Plaza de los Luceros, Alicante, Spain, 1973.

Corner of our living room, St. Restitut, France, 1973.

for twelve years Folly was my constant companion. She stayed with me in the darkroom when I had printing to do. I doubt that I missed a day taking her for a walk in the morning and the evening and often in between.

The Spanish trip was full of surprises. The first week was fine with mild weather and good hotel stops. In Alicante we discovered a money crisis when we went to cash a travelers check to pay our hotel bill. The bank would only cash a check for twenty dollars, and the smallest we had were for fifty. After shopping at several banks we found one that would accept a fifty-dollar check. The next shock was in Albacete, a mountain town where we stopped at La Mancha, one of our favorite paradors. *When we awoke the next morning the ground was covered with snow and the roads were closed. It was bitter cold. We made our way back to the coast but it was too cold for comfort. We had a few good days in Barcelona, enjoying the museums and the sights of that fine city. But we were happy to go home to St. Restitut, even with its mistrals. The value of the dollar continued to deteriorate.*

3/30/73: We are getting four francs for a dollar and in the first ninety days of 1973 we've had seventy-two days of mistral. Maybe we should buy some gold, it just reached ninety dollars an ounce. We are having reservations about spending our golden years in Provence. There is one plus— central heating. The men are here to work on it now.

Late in April we had a letter from Lucille's friend Naomi. She was going to the States and wanted us to stay in her apartment in London for the month of May. We left on April 26 and the men were to install the heat while we were gone. While we were in London the Watergate scandal broke, and we were happy to see the news on Naomi's TV. The London papers made a headline story of it every day. We had a wonderful time being able to stay a month in London, living in a rather elegant apartment in a nice location like Hampstead.

We were glad to be back to our tranquil St. Restitut with all the goodies we brought with us from Sainsbury's and other fancy food stores. Among them were items not available in France. I have a weakness for peanut butter so I brought back a dozen jars, some for our French friends who had become addicted from sampling mine.

Boy with bread, Provence, France, 1973.

Festival parade, St. Restitut, France, 1973.

Boule champions, St. Restitut, France, 1973.

To make up for the wretched winter, spring and summer of 1973 were the best of our Provence experience. The weather was fine and the fruits and vegetables were wonderful and abundant. We were entertained in a shameful way with news of the Watergate disclosures. We did our usual routine of making pickles and chutney and always seemed to be busy on some project or other. We had many communications from friends in the States, some reporting the deaths of other old friends. Steichen and Imogene Cunningham died. Picasso died at the same time as Steichen so we saw nothing in the French papers and Picasso got the headlines.

When, on July 4 we went to cash a travelers check, the franc was 3.90 for a dollar, the lowest yet. Our fixed-economy living was looking disastrous, particularly with inflation booming. Aside from our money problems, our life during the summer of 1973 was almost idyllic, with day trips to interesting places and enough social life to be satisfying. I was in a dull period as far as photography was concerned. I was not making good prints and I was not seeing well. I think the Watergate scandal upset us more than we realized at the time. It is uncomfortable to have to apologize for your country when you are abroad. A lot of questions we found hard to answer. We had enough friends so that we had a full social life in this tiny village.

At the end of October our central heating was installed and before our five hundred-litre tank was filled the oil shortage was upon us and the price skyrocketed. And about the same time, with Agnew forced to retire, Nixon made Gerald Ford vice-president. A nice man, I think, but not too bright.

12/29/73: The year has only a couple of days left. For us, in spite of Watergate and the dollar skidding to unheard-of lows and now the energy crisis, inflation, and getting a year older, it has been a good year. We have enjoyed our handsome house in Provence and have given ourselves the exciting prospect of moving to Bath, England, in 1974. We have kept well and had three fine trips, two to Spain and a month in London. I think it must be the dreams that become plans and then realities that keep us young. I haven't photographed as much or as well as I would have liked in 1973. The move to England may generate some new enthusiasm.

St. Restitut, France, 1974.

1/8/74: We have had almost three years of fine, peaceful, and quiet life here. Maybe too quiet for our temperaments and experience. People have been as warm and kind as could be. Except for our forays to foreign lands, we haven't had much to entertain us. Now that we know we are going to England, we speak of the shortcomngs of life in France, the isolation of village life. Lucille has more trouble than I do about this while I have my photography and darkroom to sustain me. I try to think where it could be any better. At home in the States we would probably be miserable and frustrated, glued to the TV watching our beloved country fall apart. And locking our doors and not going out at night for fear of being mugged. Maybe Bath will be better. We will have some entertainment and it will be a pleasure to live in a more urban atmosphere for a change. Life may be a little richer for us there.

Compared to the previous winter, this one was benign, very little mistral, mild weather, and lots of soft rain. We were greatly involved with our move to Bath and many of our activities focused on it. I did have a resurgence in photographing and we made trips through Provence where I made some of my best work in a couple of years. In February I had a letter from Phyllis Wilson, Roy Stryker's daughter, telling us about Roy's illness. His mind appears to be affected, and he barely recognizes anyone. Very sad news. On March 1 we had our first snow in St. Restitut and I made a picture out of our bedroom window.

On April 4 we had to take our cat to the vet to be piqued and we buried her beside Folly. Losing her was not as traumatic as losing Folly. M. Pompidou, the French president, died on the same day and we had several days of mourning, meaning no mail or newspapers.

6/28/74: I was dressing in the bathroom when a hoopoe flew to the window and peered in. I sat perfectly still and made the hoopoe sounds I had learned to make when walking in the forest. He was curious and after a few minutes answered each sound I made. A great way to start the day. They are such shy birds, seldom seen. He stayed several minutes and it was thrilling to see the way he puffed himself up each time he hooped back at me.

We were at last ready for our move to England. On July 6, the

village gave us a remarkable farewell party. It was festive, with lots of food and wine. I ran the gauntlet and was kissed on both cheeks by all the women and about thirty bearded elders of the village. It was a truly warming sendoff.

7/9/74: Our final day in St. Restitut. We are tired from saying all the good-byes. The mistral stopped during the night, leaving the air fresh and cool. We sat at the Cafe St. Paul Trois Chateaux for a coffee, and the nice young *patronne* asked Lucille if she could kiss me good-bye.

We had an easy trip to Bath and were there in the afternoon of the second day. The flat was fine, a good kitchen and every important utensil. We had a letter from O'Keeffe informing us of the Newhall accident on the Snake River on June 29 and that Nancy had died of her injuries on July 7. It was sorrowful news, and I feel for Beaumont who, Georgia thought, had also been hurt but not gravely.

The TV was good for us. The BBC carried news on Watergate every morning and evening. In Bristol we found a good transistor radio that we could afford so we could be newsed to death. Lucille began to work as a volunteer guide at the American Museum and she loved it. They had a New Mexico room where she enjoyed working. It was fitting after ten years in Santa Fe.

On August 9 we heard that Nixon would make an important speech and the BBC would broadcast it live. The ten o'clock speech was three in the morning here, so we set our clocks and heard Nixon make his resignation speech. The English papers gave him a bad time and it did nothing to make us feel proud. Later, we saw Ford sworn in and that made us feel better, but not much.

We were very happy in Bath though the weather was not as fine as Provence. We had a number of rainy days and it didn't get very warm. During one spell of fine weather the thermometer rose to the seventies. The weatherman from the TV station in Bristol spoke about the heat wave and announced that it was seventy-two degrees with no relief in sight.

We had many diversions that were lacking in St. Restitut. We were within walking distance of shopping, elegant streets,

historic monuments, and quiet walks on footpaths. In a half hour by car there were a dozen towns and villages of interest and we were on the edge of the Cotswold Hills. The BBC radio was the best I had heard in years. They still did plays and documentary productions as our U.S. radio had done in the 1930s. The BBC and independent TV were as good as or better than we had in the States and infinitely superior to what we had in France. We had the excellent Bath Public Library where we could draw all the books we could read.

Our house became more comfortable and nice looking. It was light and airy with handsome views from every window. From the kitchen we looked up the roadway of elegant Bathwick Hill and above on a high ridge of meadow and woods we could see a herd of black-and-white cows grazing. From the living room the view was out over the city and in the changing light it was always interesting. When the lights came on in the evening it was spectacular. Mary, our landlady, fixed up a shed I could use for a darkroom and I bought an enlarger, trays, and whatever else I needed. It was makeshift and only useful in the warm weather, but at least I could make some prints.

It was fun preparing for our first Christmas in Bath. We ordered our turkey from the butcher at the bottom of Bathwick Hill on December 10 so it could hang for two weeks to be properly aged. Every morning when I walked to get the paper I could say hello to our bird as all the turkeys were hanging in the window.

1/2/75: The big news in the paper this morning was the verdict of the Watergate jury, convictions on all counts for Mitchell, Haldeman, and Erhlichman. Judge Sirica will sentence them later this month. I can't help but feel sorry for them, but they did harm many people.

1/6/75: I've been looking through the proofs of some of my French photographs and they look better than I had remembered. I wonder how many of the thousands of negatives a good photographer makes in a lifetime are really meaningful and worthy. My guess is that the maximum would be 500. I think I would be happy if I could make 250 to 300 fine prints of my best negatives. I have often been saddened by shows of inferior pictures by old-time photographers. When an important man dies he becomes almost sacred and

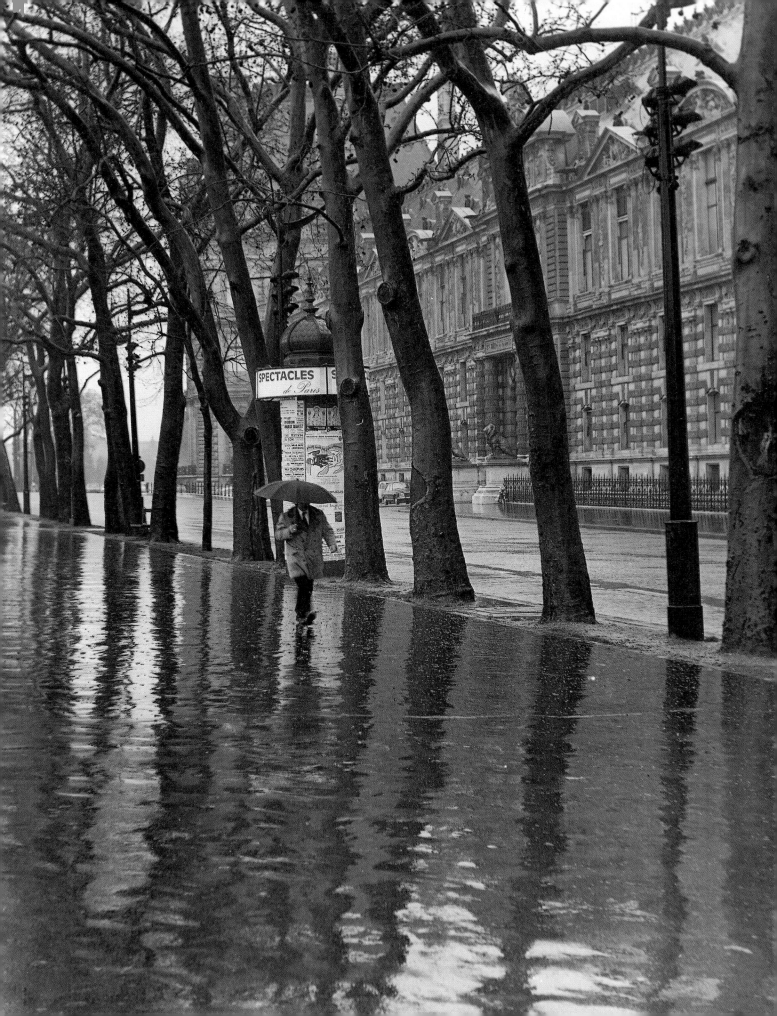

Pub near Nailsworth, England, 1976.

even his poor things and obvious misses are acclaimed. O'Keeffe knew what she was doing when she scratched many of Stieglitz's glass negatives. When I printed the old negatives for her, I noticed that the ones that were significant were not scratched, only the obvious misses. I hope I have the time and sense to destroy the negatives that I know are misses.

We made day trips from Bath, many because of the odd names of the towns. Early in January we went south and passed through Puddletown, Piddlehinton, Piddletrenthide, Shaftsbury, and Warminster. The towns were not as interesting as their names and it was too cold to walk around. One that was interesting was Milton Abbas, said to be the first planned town in England. The Duke of Abbas didn't like having his help living close to his manor so he moved them to a new planned location and built new homes for all of them. It is very neat, with a wide avenue and a row of identical houses on each side. I can't vouch for the story. It was told to us by a woman in Blandford when we asked directions to it. She volunteered that Puddletown was the place where trade unionism began. I photographed mostly pub signs. That last sentence reminds me that I was not on fire photographically when we were living in England that year. I didn't know it then but have since realized that when I find some gimmick and concentrate on it, I am not seeing well. In France I was hooked on the door knockers and in England on the pub signs.

Spring seemed to come early in England. The paper said this had been the warmest winter in fifty years and the wettest. We had no snow but lots of fog. On April 14 the sad news came to us that Walker Evans had died on April 11. I think he was my favorite photographer and I had looked forward to seeing him when we were home.

5/4/75: It was such a fine sunny morning that I took my camera with me when I walked to buy the paper. The early light is so different. Maybe it was just that there was sunlight. I think the English are not used to it. A woman stopped while I was making a photograph, waited until I was finished, and then said, "Isn't it too bright for snaps?"

The weather was so fine that we decided to go off to Devon and Cornwall. We left early the next morning and the weather was

great. We found the landscape of Devon handsome in a rural way—rolling green hills with black-and-white cattle grazing. By the time we reached Cornwall it had turned cool and the wind blew almost like the mistral in Provence. The towns along the east coast were colorful. East Looe, West Looe, and Polperro, all ancient fishing villages, were a treat to see, but the weather was too cool and windy for comfortable walking. The scenery on the west coast was dominated by high cliffs looking down on the stormy shore. The footpaths along the top of the cliffs gave access to some sensational views. We had a memorable trip, but the bad weather made us happy to be back in cozy Bath.

On May 8 we went to London to stay in Naomi's apartment while she was off to Malta.

5/13/75: Had a shocking night. Lucille began to bleed internally. No pain. She must have strained herself. We called Dr. Atkinson in Bath, and he said to keep her in bed for a couple of days and then drive to Bath.

One of the things we had done earlier was to take nine prints to Sotheby's for the fall sale. They were pictures we had had on the walls and were not in the best condition. The girl Lucille had talked to said they only handled the work of dead artists, but she liked the pictures and said she would like her colleague to see them if we would leave them for a couple of days. So while Lucille rested I called Sotheby's; they wanted to keep the pictures for the October sale. Back in Bath we saw Dr. Atkinson who made an appointment for Lucille to see Mr. Pollard, one of Bath's prominent surgeons. We heard from Mr. Pollard that Lucille had cancer and would need an operation very soon.

We were feeling the urge to return home to the States, and some friends from New York who had retired to Portland, Maine, encouraged us to try it. We did want to be on the east coast, and Maine sounded like the right place for us. It was, and we still like it.

Our remaining time in England was taken up with packing and sending things to the States. We sold our car in Paris and made arrangements with the moving company to ship our things to Portland, Maine, when we had an address. Mr.

Pollard made it possible for Lucille to enter Lansdowne Hospital on June 29, just a month before we were to fly to Boston.

6/30/75: If all goes well, a month from today we will be on our way to a new life in Portland, Maine. I have lots of hope. It is now half past one and I assume Lucille has already been operated on. I have walked around town all morning and I am worried.

I walked to the hospital late in the afternoon and the nurse told me Lucille had come through the operation fine and I could see her. She was sleeping and I thought she looked pretty sick with a tube in her nose. The nurse assured me again that she had come through the operation very well but had been given an injection a half hour before I arrived to relieve pain and would sleep for a few hours. The next day Lucille looked better and even managed a smile but was not her usual talkative self. When I came the following morning she was watching a tennis match and was disappointed when Billie Jean King defeated Chris Evert. She felt like talking and was more her old self and my hopes were revived about going home on July 30. I was getting a lot of walking, going to the hospital twice a day. It was a four-mile round trip. On the third day we were able to watch Arthur Ashe beat Jimmy Connors in the men's final at Wimbledon.

The care and attention at Lansdowne Hospital was remarkable. Better care could not have been had if one were a multimillionaire. Lucille arrived at Bathwick Hill in an ambulance. Her progress from then on was remarkable. Mr. Pollard had his nurse, Sue Woodard, make daily visits and after a few days had me taking Lucille for daily walks on the hill. Starting ten days before our departure, the nurse took us out for a daily ride in her car as conditioning for the trip to Maine. We lunched at some of our favorite pubs around Bath. They really worked at getting Lucille ready for the trip.

8/11/75: Lucille began her radiation treatment to clear away any vestiges of cancer that might be left. She will have five treatments a week for four or five weeks.

She did have some side effects but was able to complete the

course of treatments. Her doctor, Hugh Phelps, believed she had made a complete recovery and we were happy. Our things arrived from Santa Fe on September 9 and we moved into our Portland house.

9/30/75: I spent most of the day opening boxes of prints and negatives that have been stored in Santa Fe for the past five years. What a lot of prints I have. Many of them were not very fine but there were enough good ones to please me. I wonder how the things I have made in the last five years will fit in. Will they measure up? I know that now, at seventy, I am losing some of my so-called magic.

I have hundreds of prints and thousands of negatives. I do believe that three or four hundred prints should be enough to represent a man's life work. The question is, which should be selected? I suppose the editing is the responsibility of the artist. But how can that be done without picking many old favorites that you like for very personal reasons? It may be that you need an outside person to counsel you when you pick your best three or four hundred prints.

Roy Stryker at the Amon Carter Museum, Fort Worth, Texas, 1965.

10/4/75: A letter came from Phyllis Stryker telling me that Roy died last Saturday. It is a shame that he had such a bad last two years. Phyllis doubts he knew who she was for some time. He was an important man for photography and not well enough recognized. I think he was eighty-two.

10/6/75: At last I am ready to begin printing. I got over the last hurdle when I finished the wine in the jug and could use it to mix a batch of Dektol. I have the glass of the printing frame all shined, so first thing tomorrow morning I will make some 8x10 contact prints. I read in the paper today that some racehorse retired and will earn $8 million in stud fees. Why aren't people that smart? Had a catalogue from Sotheby's in London and they have my nine prints for sale. We had a sad letter from London telling us of Naomi's death. She and Lucille, who were lifelong friends, were stricken on the same day earlier this year. We feel like survivors.

We seemed to fit in well with the life of Portland. The new house soon looked like ours as we put our things about. We explored the Maine coast and countryside and I made a few photographs. When my darkroom was workable, I made prints

from my old negatives with the idea of creating a portfolio of prints to take to New York. We made a visit to Providence to spend a weekend with the Callahans. Aaron Siskind and his wife were there, and when I heard the big figures they used when discussing their photographic business, I realized that I may have missed the renaissance that made photography an art treasure. We had a great time with Harry and Eleanor, our first time together in ten years.

Sotheby's in London sold my nine rather beat-up prints and sent me a check.

12/16/75: Spent most of the day going through Mexican negatives that have never been printed. I found quite a few I am eager to work on. Then I found a box marked "unprinted French negatives" and now I am going through them. At the moment I am taking the skin off almonds as we prepare the traditional roasted almonds we always make for Christmas. We are full of our new house. Darkroom plans are going around in my head and we are both looking forward to the extra space with real bedrooms.

I met John Szarkowski. He looked at my prints and ordered a copy of the Sixth Avenue Panel. Pete Pollack arranged for me to see Bob Schoelkopf at his gallery on Madison Avenue. The Van Deren Coke show on the wall left me quite turned off. The gallery didn't look like the place for me so I didn't waste much time there. I wanted to see Lee Witkin, with whom I had corresponded for several years. He was very nice and interested and said he would like to come to Portland to see my collection and we left it at that.

We had our first Christmas in Maine, accompanied by a fifteen-inch snowfall and five-degree temperatures.

3/3/76: This was an exciting day; we had a phone call from MOMA asking permission to use one of the Texas architecture photographs for a brochure.

3/10/76: A good day for printing. I started on the old Paris 4x5 negatives and it was like living in 1949, seeing those old scenes come up in the tray. I am always amazed at how printing can churn up old memories. Sometimes I can remember precisely what it was like and what happened,

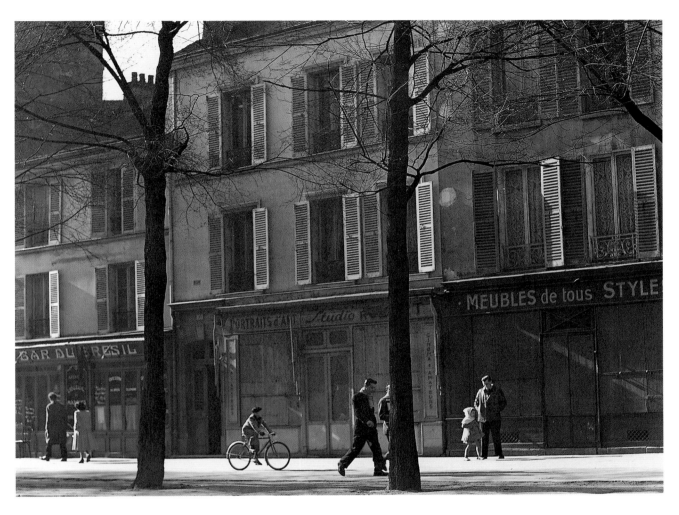

**Spring morning, Avenue du Maine,
Paris, 1951.**

even how it smelled and felt. I printed one negative of a small Paris street in the early morning of a misty spring day and I felt I was there and could smell the sour, garbagey odor that you find early in the morning and usually in poor neighborhoods.

I had a letter from Lee Witkin saying he would like to represent me exclusively and would come to Maine in early summer to pick prints for a show in 1977.

We were enjoying life in Maine and I was making prints so I would have something to show when Lee Witkin arrived. Lucille had a checkup on her cancer operation and she was fine. On April 7 we had a letter from Grace Mayer telling of the death of Paul Strand in France at age eighty-five.

Man Ray in his studio, Paris, 1951.

We read in the paper that Man Ray had died in Paris on November 18, 1976, at age eighty-five. I had enjoyed meeting him in 1971. Harry had his big show at the Museum of Modern Art on November 30 and we were there. The show was great and we saw many old friends—Helen Levitt, Lisette Model, Jake Deschin, John Morris, Marty Forscher, and many others.

We scheduled a winter trip to Santa Fe to begin on January 10, 1977, but were weathered in with a giant snowstorm. The next day we were able to get away and once out of town it was good traveling. They do a very good job in Maine of plowing the roads and keeping traffic flowing. On the second night we reached Washington, D.C., and spent the night with my brother and his wife. I had not seen them in twenty years and it was a pleasant reunion. Aside from Mobile, Alabama, and New Iberia, Louisiana, we found the South uninteresting. Texas, with the towns so far apart, we found desolate. When we reached New Mexico we stopped at White Sands, a place we had often visited when we lived in Santa Fe. It was still a superb sight with the wide spread of miles of pure white sand dunes.

It was good to return to Santa Fe. I had forgotten that at this time of year the town tends to look seedy. It improves when the foliage comes to life. Ansel Adams was having a show at the museum, and we were invited to the opening reception.

After we were caught up with the parties we went to Abiquiu to have a few days with Georgia. We met Juan Hamilton and

admired the pots he was making. While we were there,
Georgia had a phone call from New York telling of the death of
our dear and great friend Mary Callery in Paris. That was a
shock and a sad blow to all of us, including O'Keeffe, who was
always in competition with Mary, but I believe was very fond
of her.

After a busy and enjoyable month in Santa Fe we were ready
to go home. Just before we left, Georgia called to tell us that
she had a cow's skull for us and I drove up to get it and it is a
beauty. We still have it in our house.

We arrived back in Portland with a large batch of negatives to
be developed. I had forty rolls to develop so I had things to
keep me busy through the spring with a number of significant
prints to show for the trip.

We enjoyed the 1977 holiday season in Maine. This had been a
productive and pleasurable year for us—two good trips and a
hundred or more new prints for my collection. Early in
February of 1978, Harry called to tell us that Art Siegel was
dying of cancer and that was bad news.

3/21/78: The first day of spring. A light rain is falling and the
snow is melting. There was a sneaky film of ice on the front
steps from rain that froze as it fell. I took a flop that really
shook me up. My hat flew off and the umbrella I was carrying
went out almost to the street. It must have been a funny
sight. Even I laughed. Luckily I seem to have done nothing
more than bruise my upper hip. I expect to be stiff for a day
or two. I continued my walk to get the paper and have since
sanded and salted the steps. Like locking the door after the
horse is stolen.

On May 18 public TV did an interview, monitored by Edgar
Beem, about our life. A few days later we saw the film in the
studio and I don't think there will be any long lines of
producers trying to sign us up for long-term contracts. We
seemed to come through pleasantly enough and when we got to
talking it was almost all right.

On July 17 we went to Berenice Abbott's eightieth birthday
party at her lake cottage in the north Maine woods. She looked
fine and was just as tyrannical as ever. Quite a crowd

**Georgia O'Keeffe in her studio, Abiquiu,
New Mexico, 1977.**

including Lee Witkin and Ben Rayburn. She has a room in the basement to show "other people's work." I was flabbergasted to see five pictures of mine. None of them I would ever consider showing, not to mention selling. They made her things look pretty good.

In late September Senator Hathaway in Washington called to say I had been awarded a grant of ten thousand dollars from the National Endowment for the Arts. Later I learned that Harry was on the selection committee. That reaffirmed my feeling that luck, being in the right place at the right time, has a lot to do with recognition in photographic circles. In October our landlord died and his wife wanted to move into our flat, near her sisters, where she had once lived. We heard about a house in Bath, Maine, rented it, and moved in on November 27.

11/11/78: Sixty years ago I was part of a parade that was dragging an effigy of Kaiser Bill around, attached to a wagon pulled by Chauncey Hecht's two goats. That was in Detroit and the details are still clear in my mind. And even clearer, it was on this date thirty-three years ago when I was discharged from Great Lakes Naval Training Station in Chicago and went straight to New York where I really began my career as a photographer at the age of forty. Many good things have happened to me since then.

2/26/79: *Hoy hace mal tiempo.* I walked downtown to get the paper, and the icy snow was just like sand on a beach. We are eager for March 28 when we shall be on our way to Paris. We had maps and hotel books and were looking at France, Spain, and Portugal, figuring out where to go. We even delved into Ireland where we plan to go in the fall as part of our NEA project.

9/23/79: We have walked around Dublin too much as we always do in strange cities and now we are tired and prepared to relax. We went to the National Gallery where they have unimportant works by important artists. Also many religious paintings by people I had never known about. The building is handsome. I like the feel of Dublin. It is not as elegant as London or as spectacular as Paris. Except for the doors, even the architecture is quite ordinary. Lots of Georgian houses but not of the quality of the ones in Bath, England. Dublin is like a good-natured if dowdy old lady. Old-fashioned except for the

Lucille and Todd Webb, Bath, Maine, 1979.

Chair in Webbs' guest room, Bath, Maine, 1979.

Tramyard, Dalkey, Ireland, 1979.

Entrance to Trinity College, Dublin,
Ireland, 1979.

prices which are very much up-to-date. Ireland has not been a big thing for us. I think it may seem much better if you are of Irish extraction. The Callahans were here for four weeks and they didn't sound enthusiastic about it. Ten days were too much for us. A week would have been just right. Ireland and Scotland are comparable—both have rugged scenery, bleak weather, poor food, and pleasant friendly people.

I did do well in Ireland in spite of poor food and bad weather. I had a busy fall in the darkroom. In October Steve Plattner came to interview me about my connection with Roy Stryker. He was doing a book on the Standard Oil service file, Roy Stryker: USA, 1943-1950. *A few days later we were asked to Providence for a TV interview with Harry on our relationship with Steichen. The TV people were young and I believe did not know much about Steichen.*

In January we felt the oil crisis that set the world back on its heels. I paid $1.12 for a gallon of gasoline and our heating oil was $.90 a gallon. The winter was amazing. We did not have any snow until January 22, but it has been very cold.

9/16/80: I had my seventy-fifth birthday yesterday. I never did expect to reach here; if I hadn't stopped smoking twenty-one years ago, I wouldn't have. I still have the capacity to enjoy living and look forward to things with excitement and pleasure. And I shall have good things to mull over when I become less active. Right now we are in high gear in anticipation of our trip to Portugal three days hence.

10/10/80: We were off early to Gorham and the University of Southern Maine to meet with Juris Ubans about the show I am to have there. We settled most things and Juris has made a really great poster using the cow's skull and bones on the portal of the Ghost Ranch. We saw the gallery and the white walls are just what I like. We talked of 100 prints but I have 130 framed, so there will be some choice.

10/26/80: I was pleased to see all 130 prints on the wall and it was an excellent show, well received by the 300 guests who turned out for the opening.

1/5/81: I had a card from O'Keeffe today. It has been some time since I heard from her. A nice note saying how sorry she

Burro Alley, Santa Fe, New Mexico, 1981.

OLD BURRO ALLEY

is that she cannot write anymore. She recalled the time when I carried old Beau out to the White Place where we buried him under a cedar tree. She is now ninety-three, and I thought that a strange thing to remember. I am happy to hear from her. Even her signature shows some of her ninety-three years. I guess Juan writes all of her letters for her now and steers her hand for her signature. It is lucky that Georgia has Juan; it is probably good for both of them.

3/3/81: Today I finished making slides of my black-and-white prints. Now I have slides of four hundred prints, enough to put hundreds of people to sleep for hours. I have seen several photographers show too many slides, putting me to sleep along with other members of the audience.

We were making a trip to California and wrote Georgia to ask if we could stop to see her. Had a letter right back and she appeared excited about the prospect of our coming so we planned to go first to New Mexico and then fly on to California.

We arrived in New Mexico, picked up our car in Albuquerque and drove to Abiquiu. Georgia and Juan gave us a warm welcome. Georgia wondered if I would get up at six and make the breakfast coffee as I had always done when I stayed with her. So of course I was up at a quarter to six the next morning and the coffee was ready when she came from her studio right on time.

3/19/83: Steve Plattner's book of Stryker's time at Standard Oil has come out. Exxon is putting on a show at the International Center for Photography in New York, opening on May 17, and I am sure we will be invited. I can't see how it will be too impressive. I can think of very few outstanding photographs any of us made for the file. Ostensibly, anyone who did an assignment for Roy felt it must be done in the spirit of the Farm Security Administration where Roy became famous. I notice that most of the pictures in the book appear to be in the FSA tradition. I, for one, was never involved with the FSA, although I did admire a lot of the work. It was a Cause time, and the Standard Oil project was not. For the company, the goal was to improve their image and that was about it. I enjoyed working for Roy but never felt I was making a big contribution. I was delighted to be making photographs and getting paid for it. I had just put in

a whole year making pictures for love and I was pretty broke.

On May 9 I had a letter from Keith Davis of Hallmark Cards telling me he bought five of my photographs at an auction and they were on display in Kansas City. He asked if I had slides of my work so I sent him a carousel of black-and-white slides.

On May 16 we were off to New York to attend the opening of the Stryker show. We went to the press opening and lunch at ICP and it was gratifying to see people I had not seen for many years. CBS had a camera crew there filming for a Charles Kuralt show to air on May 29. The show was better than I expected, and Cornell Capa was warm and cordial. A number of the old people were there—Sol Libson, Arnold Eagle, Harold Corsini, Ed Rosskam, Sally Forbes, Esther Bubley, and others. A couple of weeks later we saw ourselves on the Charles Kuralt show and he ended by saying that three of the photographers had gone on to be famous: Gordon Parks, John Vachon, and Todd Webb.

On July 5 Keith Davis, his wife, and his mother paid us a visit. He wanted to see my photographs, was impressed, and talked about a Hallmark show and a book.

Early in 1984 I had letters from Keith Davis and Jim Enyeart. They both wanted to see my collection and talk about how I intended to dispose of my photographs. I replied and Keith came and bought one hundred prints for the Hallmark Collection on February 16. He was here for a couple of days, and we were happy to have his company.

Mary Leigh Smart of the Barn Gallery in Ogunquit wanted me to have a show there in June. I suggested "Photographs from Five Decades" and she thought that was great. It begins to look as though the O'Keeffe book [Georgia O'Keeffe: The Artist and Her Landscape] *will be published.*

4/24/84: We got word of Ansel's death of a heart attack. I always thought of him as indestructible. He really left a mark and I believe he had a satisfactory life.

6/27/84: It is a lovely day with a pleasantly warm temperature. We are going to Ogunquit this afternoon and I

will be able to wear summer clothes for a change. This is the time they are calling "Friends of Todd Webb Night" at the Barn Gallery. Lucille is going to give a background talk on why they call it that. They are showing the O'Keeffe documentary, also the Callahan interview which I have not seen.

That day ten copies of the O'Keeffe book were delivered and they made quite a hit. That was the book by Twelvetrees Press that had been in production for a year. It was a pleasant surprise, handsomely bound and the printing, done in Japan, was special. The selection of prints could have been better but on the whole, it is a book I can be proud of. Thanks for this to Jack Woody.

7/18/84: Tonight we should be winging our way across the Atlantic to London. Now, when we make these trips, I think how it was in the thirties and forties. We would have taken a train to New York, boarded a trans-Atlantic liner, and in a week landed in Southampton, having gained a few pounds from overeating. Now we go in hours as far as we went in days. The time span has shrunk and a few hours' delay seems a disaster.

7/19/84: We had an "old age" crisis at the airport when we went to pick up the car Martha, our travel agent, had rented for us. They said I was too old for their insurance policy. So we went to Avis and rented a car with no problem.

10/5/84: We met Terry Pitts, from the Center for Creative Photography, at the jetport in Portland. He is a nice man and was enthusiastic about my photographs. He described the Center to us and it sounds like the place where I would like to have my work. They will get everything that has any connection with my career as a photographer: prints, negatives, correspondence, books, manuscripts, etc. We will receive some money when they buy some of the two hundred master prints he selected for purchase.

We were invited to the International Center for Photography in New York for a book signing. We flew to New York on November 9 and that afternoon I went to Rizzoli's and signed ninety-two copies of the O'Keeffe books. Next we were at ICP where numerous photographers were signing books. Roman

Vishniac appeared to be the most prolific signer and I guess I was next. I sat next to Ray Metzker, a student of Harry's. If I had seen his book without any name I would have thought it was Harry's. He seemed like a nice guy. Sonja Bullaty sat on the other side—she and her husband had done a book on Central Park. Yvonne Halsman was signing a book of portraits by Philip. Ruth Orkin was there and many others. Capa asked if I would take part in a master photographer's seminar that ICP would offer in the spring. I said I would try it. That will mean another trip to New York. Once in a while is fine, but we were finding that the big city took some coping.

2/7/85: We spent part of the morning looking through the portfolios I assembled which will well represent my life production. Each portfolio consists of five prints from each decade, 1940s to 1980s, twenty-five prints in each portfolio. There are only a few duplications and as of now I have forty-nine portfolios ready. When I complete the selection I shall probably have sixty. That would mean I have fifteen hundred pictures that are showable. I sound like Reagan giving his State of the Union speech. Always dreaming, guessing, and hoping. If you hope enough you are considered an optimist and if you are an optimist you are supposed to exude confidence.

2/26/85: For the first time in months I didn't do any work that concerned photography. I always gave myself some chore—prints to make, prints to sort, slides to edit, prints to mount, flatten, or frame. I will be back at work tomorrow readying my black-and-white slides for my talk at ICP.

3/21/85: We've flown to New York for the seminar at ICP. It sounds as though we will be looking at slides for three hours. Hope I can stay awake.

Twenty-five people came and the slide showing worked well. Capa, as monitor, was a big help. I seemed to talk easily and my memory was good. The time went quickly and I could have continued for another hour. We had a half-time intermission and the young people wanted to look at the prints I brought with me. They seemed to enjoy that and the meeting was satisfactory.

12/11/85: I have noticed a funny thing since my left eye was fixed. (I had a cataract removed and a lens implanted.) When

I start my walk in the morning, I feel I am about six inches taller than I used to be. I suppose having binocular vision has something to do with depth perception and the ground looks six inches further away. At least I now have an idea of how it would feel to be a basketball player.

12/15/85: Just before Christmas the Hallmark book, *New York and Paris* by Todd Webb, was published and Keith sent us copies which will make good presents for close friends. We are very pleased with the book. It has been a good year and the best thing for me was to have my sight fully restored.

1/26/86: While I was signing books at the Hallmark show in Kansas City, a man introduced himself as Mr. Webb. He said he had seen some of my photographs in New York twenty-five years ago and was impressed and said to himself that if he ever had a son he would call him Todd. He has and he did. His birthday is tomorrow and his father bought a book and asked me to sign it "Todd Webb."

3/6/86: I had a call from the *Albuquerque Journal* asking to use one of my photographs of O'Keeffe. I asked why they wanted it and they said they had an unconfirmed report that she was dead. They called back and confirmed the death. And on the evening news Dan Rather reported it. I am sad but I am sure these last three years were very bad for Georgia. When she moved from Abiquiu to Santa Fe I thought she must be in trouble. Santa Fe will be devastated. She was their most legitimate claim to fame. I have no desire to be at the funeral, if there is such a thing. I didn't go when Stieglitz died. Laurie Lisle's biography (*Portrait of an Artist*) will have a timely birth.

6/28/86: It has turned very hot and New York City is steaming. We are attending the opening of the Hallmark show at the International Center for Photography, but I rather wish we were returning to Maine today. Yesterday I was interviewed for a TV exposure which I am sure we will never see. There were a lot of other publicity things we had to do. I am beginning to think New York should just be a happy memory for us. It has become too chaotic for us to cope with.

7/6/86: Had a check from Miller today, the first royalties on the O'Keeffe book. He said we would be getting another check for about $3,000 [never received].

As a matter of fact we did not receive another royalty check until February 1989 and that check was returned for insufficient funds.

My right eye, from which a cataract was removed three years ago, was becoming slightly cloudy and Dr. Holt decided to use the Var Laser to cut away the film causing the cloudiness. It was without pain or any sensation and in seconds my eye was clear again.

10/27/86: A woman from Connecticut near Hartford called at noon. She just saw me on TV, an educational program, she said. Her name is Webb and they have a son named Todd. She is interested in photography and would like to work the way I do. She said I have touched their lives and she was grateful to have seen the program. It is nice to hear things like that, and it is the second time I have heard of a new Todd Webb this year.

1/13/87: This is the season when nothing seems to be happening. People stay home and wait for better weather. We speak of Tuesday as a "red letter day" because we get the garbage ready to put out for the next morning's collection. I admit it is not much to celebrate but then this is winter in Maine. Now our fingers are crossed in the hope that the weather will permit us to drive to Worcester for the opening of the Hallmark show.

On February 6 I began my artist-in-residence stint at the University of Southern Maine in Gorham. They had a room for us on the campus in case of bad weather but not once were we unable to commute, driving the hundred-mile trip each time. I worked three days a week with a morning and afternoon class. My function was inspirational more than just teaching. I helped to improve the prints in both classes and helped them to think about where to stand when making a photograph. Lucille came with me every day and she was an important part of the work. She could listen to the students and tell them about being the wife of a photographer and say things about me that I could not tell.

6/9/87: Faith Reyher will be here about eleven o'clock and we wonder how she will be. We will have much to talk about, we know, from the fine letters she writes. But you always wonder when you are to see an old friend for the first time in many

years. We had the same feeling when we saw the Backers after thirty-five years. When I see people now whom I considered friends before the war, it just doesn't work. Living in New York and around the world changed my viewpoint and values so much that when I meet friends who have stayed put, we find even making conversation difficult. There seems nothing to discuss but adolescent experiences.

Faith was no problem. She has had her share of getting around. She brought me up to date on her father, Ferd, who was such a good friend in New York in 1946. He was born in 1890 and died in 1966. Faith was a witness to Ferd's experiment at being a farmer in Maine. She was there as a little girl watching her father crank his Model T Ford. The farm was in Robinhood, about ten miles from our home. Faith was a great talker, like her father, and we enjoyed her and hoped to see her again.

We had a letter from Juan Hamilton telling us of the big O'Keeffe exhibit at the National Gallery in Washington, D.C., and that the catalogue for the show would contain two of the letters O'Keeffe had sent us.

9/1/87: Juan Hamilton sent us a catalogue of his sculpture at the Miller Art Gallery in New York. His work is handsome. He enclosed an article from the Santa Fe paper telling about the settlement of the O'Keeffe estate and that was a good thing. It seems to have put all the unpleasant aspects of the so-called scandal behind and Juan comes off very well. I always said he was the best thing that happened to O'Keeffe and it has turned out that O'Keeffe was the best thing to happen to him. I believe his care and concern added ten years to her life. As we saw them together, I think they were really devoted to each other. The fact that he is now a wealthy young man does not lessen his value to her while she needed him.

9/26/87: Mary Benjamin and her movie-star friend, Jane Alexander, are coming for lunch. She is making a movie of O'Keeffe and wants first-hand information on what O'Keeffe was like as a person. We had a good time with Jane Alexander and liked her very much. I think we were able to tell her what O'Keeffe was like privately. A German actor is coming to play the part of Stieglitz. The story is about them in

their early days, much of it before my time and about which I don't know a great deal.

We were invited to the dinner and preview of the O'Keeffe show at the National Gallery in Washington. Turned out to be a black-tie affair and I had to rent a tuxedo from Bud Shepard, our local men's clothier. We drove to Washington and stayed comfortably with Faith Jackson in her new apartment. In the afternoon at the gallery we saw an Edouard Manet and Berthe Morisot show and they warmed us for the evening festivities.

10/30/87: The dinner and preview of the O'Keeffe show were gala events. The evening began in the gallery where people could have a drink as they wandered around looking at the paintings. I was surprised and pleased to find a huge ten-by-seven-foot print of my photograph of O'Keeffe in Juan Hamilton's studio. It was a very good print, which is what surprised me. After dinner the guests were presented with the O'Keeffe book printed in conjunction with the show.

11/24/87: After we were in bed last night watching TV we had a phone call from Tokyo. It was 9:10 P.M.. here but 11:10 A.M. the next day in Tokyo. The young woman, Reiko Ikeda, spoke excellent English. She had the Hallmark book and there were two photographs she wanted to buy. We agreed on the price and she said payment would be made in thirty days.

We sent the photographs by Federal Express and a couple of days later had a call saying that they had arrived. It was the beginning of a good relationship. The year of 1987 wound down and for us it had been good. We were both well and happy and looking forward to a trip the next year, this time to Alsace, the one part of France that we did not know.

The new year began with very cold weather and lots of snow. We had a letter from Keith Davis informing us that the Hallmark show was going to travel in England, opening in Bath and moving on to Cardiff and various places in the Midlands.

One night we heard a woman on TV giving a tribute to Georgia O'Keeffe and I thought she did very well speaking of Georgia as a woman and a painter. She was at the National Gallery, walking around and talking about the paintings. The

last shot was of the gallery entrance and there was the huge enlargement of my picture of Georgia in Juan's studio.

On April 15 we went to the preview of the Eliot Porter show at Bowdoin College. They had the usual lavish feed for Friends of Bowdoin. There was a film about Eliot's life that we enjoyed more than the show. He looked fine and said a lot of things with which I agreed. Marnie Sandweiss talked about the photographs. She was nice but I must say I am not interested in having anyone explain to me what I am looking at. I did enjoy hearing about her experiences while working with Eliot. She was a nice girl and I liked her when we talked after the lecture.

6/8/88: I have my color photographs back from our [England] trip and they look good. Dennis Griggs has let me use his color printer so I am able to make some prints myself. I believe not being able to control making my prints was the factor that kept my interest in color lukewarm.

Early in August we had a letter from Dana Asbury, an editor at the University of New Mexico Press. She was going to be in Maine and wanted to talk to me about my memoirs. And on August 17, Dana and her husband Richard came and had lunch with us. They vacation every year in Maine at Biddeford Pool. She is interested in seeing my book when it gets further along.

9/8/88: We made a trip to downtown Santa Fe to look at the city we once called home. What a change! It doesn't seem wonderful anymore as a city in which to live. It is now a resort where tourists can indulge in buying questionable art treasures at outlandish prices. The city has outgrown itself and we had a hard time finding our way. We had an expensive lunch in a modern establishment serving mediocre food.

Later we saw friends. I called Eliot Porter and Aline answered the phone and thought Eliot too ill to have visitors. We saw Beaumont Newhall and other old friends. One of the things we enjoyed was driving to Abiquiu. We went to O'Keeffe's house in Abiquiu and, as the gate was open, I drove in. The only sculpture Georgia had made [and which Juan had enlarged] stood at the end of the yard overlooking the Chama valley. I made a photograph of it and as I was doing so a young man

came out to say that pictures were not allowed. We talked and when he found I had known his grandfather, Steven, O'Keeffe's gardener for years, he became friendly.

11/4/88: We drove to Massachusetts for Harry's show at the Worcester Museum. The museum had invited us and it turned out to be quite an affair. The Callahans, Aaron Siskind, Keith and his parents, as well as others we knew were there. About three hundred people came to enjoy Harry's great color prints.

We were home by November 7 so we could vote in the election. The next week we had a visit from Reiko Ikeda from Tokyo and it was a pleasure to have her here. She picked seventy-eight prints for a show in Tokyo next year. She speaks English very well as we already knew from our telephone conversations. I believe she had a good time with us and plans to come next year and, we hope, to stay longer.

Toward the end of the year I was spending so much time writing this tome that I neglected my current journal.

We did go to a Minor White show at the Payson Gallery in Portland. I had never seen many of Minor's photographs and I must say I was disappointed. One of Minor's ex-students gave a lecture which I wish I had missed. We went through Minor's "getting in the mood" sequence, in which people are asked to take the yoga position for some minutes of meditation accompanied by a recording of weird music. It was the old guru approach to Art and I found it a bore. So did many others. Such a bore that we left in the middle of the talk.

We have been lucky with the weather. As the year was winding down I heard that in November and December we had had only three inches of snow, some kind of a record for Maine. We had a bountiful Christmas with many unexpected presents from unexpected sources. Reiko sent us calendars using three of my photographs and three of Andreas Feininger's. It was all in Japanese.

Conclusion

Finishing this story of my life to age eighty-four gives me a feeling of accomplishment. Putting it down bit by bit has made me realize what a period of history I have experienced. I remember vividly being a youngster in a gentle and kind Detroit; most of the street traffic consisted of horse-drawn vehicles. The telephone directory had about twenty-five pages. Homes were lit by gas or kerosene lamps. When I was about ten, Thomas Edison became a great hero to us when our house was wired for electricity. Our gas chandeliers sprouted Edison electric bulbs, and five years later our hand-wound Gramophone was replaced by an electrically operated Edison machine.

At about that time, Henry Ford announced that the minimum wage for workers in his Model T auto factory would be five dollars a day. Until then, the daily pay for labor had been one dollar a day. With the influx of workers from all over the country and from the ghettos of Europe, Detroit became a racial melting pot and soon stopped being a kind and gentle city.

In 1914 World War I exploits of the armies locked in deadly combat on the western front became the main topic of news stories and conversations. The demand for news fostered advances in communication. A telephone line was laid under the Atlantic, soon followed by reports of battles and disasters tapped out by wireless operators. Airplanes were found to be suited for warfare and the fighter pilot became the cream of the hero crop. The armistice on November 11, 1918, ended the war but the communication advances continued.

In 1921 voice radio was welcomed by the news-hungry world. The crystal sets available to the public were squeaky but, with careful adjustment and the right weather, we were able to hear things happening. Not long after, planes began to carry the mail. Horse-drawn vehicles disappeared as the automobile became affordable and dependable. I was lucky to have a few luxurious Atlantic crossings by steamship before they were supplanted by huge passenger aircraft. The progress continued through television and supersonic air flights from one continent to another. It was hardly a surprise when men landed and walked on the moon in 1969 and later.

When these miracles happen in your lifetime you tend to take them in stride since the happening is gradual. It wasn't until World War II that I thought of the history being made in my lifetime. And that is when I began my career in photography. With some feeling that I was living history, I decided to keep a journal to put down my thoughts as things were happening. I began to write daily in February of 1946, just after I came to New York to live. So much was happening to me that I was certain I would forget many of the details.

As I write this I know that my journal enabled me to bring my career into focus. I realize that I never approached the medium as a way to make a living. I was really in love with photography as a means to express myself. I had my first commercial job with *Fortune* magazine, and when they asked me what my rates were, I was embarrassed. I had no idea what to ask. Until then I had been willing to work at some other job to support my photography. I never did get over this feeling and have always kept the work I did to earn a living separate from the photographs I made for pure joy. Of the hundreds of photographs in my collection, few are the result of an assignment. I never saved negatives of my commercial activity. Often, when working, I took a day off to make some images for myself.

I suffered an early cure for landscape photography when I tried to emulate Ansel Adams after his 1941 workshop in Detroit. Pure nature was not for me. I found that my interest was more in what man does to nature. I enjoyed most making photographs in cities and towns and I still do. I love to walk the streets of a city with my camera. When I go out to photograph it is almost always with an open mind. I have no plans. I just walk and look. When something moves me I make a negative, usually only one. If it has been an exciting day, I can hardly wait to get home to develop my film and make prints of the most memorable discoveries. Often I go out and see nothing that moves me and come home with no film to develop.

I am writing this on Veterans' Day (1989) and I realize that I don't give much thought to being a veteran. I was too old for the draft and didn't have to go into the service. I was thirteen years old when World War I ended, but I was an old thirteen and had a lot of friends, as I grew up, who had been in the

war. I envied them their experiences, so when the next war came and I was too old I felt that I was missing something so I volunteered to the navy as a photographer. It turned out to be not as harrowing and dangerous an experience as I had envisioned. I was one of the lucky ones, doing something that meant a lot to me. Although I was classified as a combat photographer, I was exposed to very little action that would result in trauma. Most of my thirty months of duty in the South Pacific, with the exception of the Philippine Invasion, were spent far behind the fighting front. The war did not supply me with the vivid and heroic memories I expected but it did get me out of Detroit where I had found myself in a deep rut. When I was discharged on November 11, 1945, I went straight to New York instead of returning to Detroit and have never been back there even for a visit.

About three years ago I made color negatives with a 35mm camera. I had found that long hours in the darkroom making black-and-white prints were too much for my old legs. I made a few color rolls but it was unsatisfactory not to have any control of the prints. My friend Dennis Griggs, who is a fine commercial photographer and has a big machine for making color prints, showed me how to use the filters and allows me to make my own prints. It is much more satisfying. Still, I cannot find the joy in color that I have enjoyed with black and white. It seems almost too easy and certainly less creative. I haven't had any desire to show my color prints.

I have been lucky to have had encouragement and help from many important people and I am thankful to them. I believe all of them are included in this book.

Lucille and I have now been living in Maine for more than sixteen years, and we feel very much at home. For our time of life it is just right. People often ask where, of all the places we have lived, we liked best. Invariably we say "here." As I think back that was always the answer. When we lived in Paris that seemed to be the only place to live. We felt the same about New York and Santa Fe. We would like the winters to be a bit shorter in Maine, and Lucille just mentioned that she would be happy to live in Bath, England. I could go along with that. But English weather can be monotonously dreary. Like Maine winter.

Plates

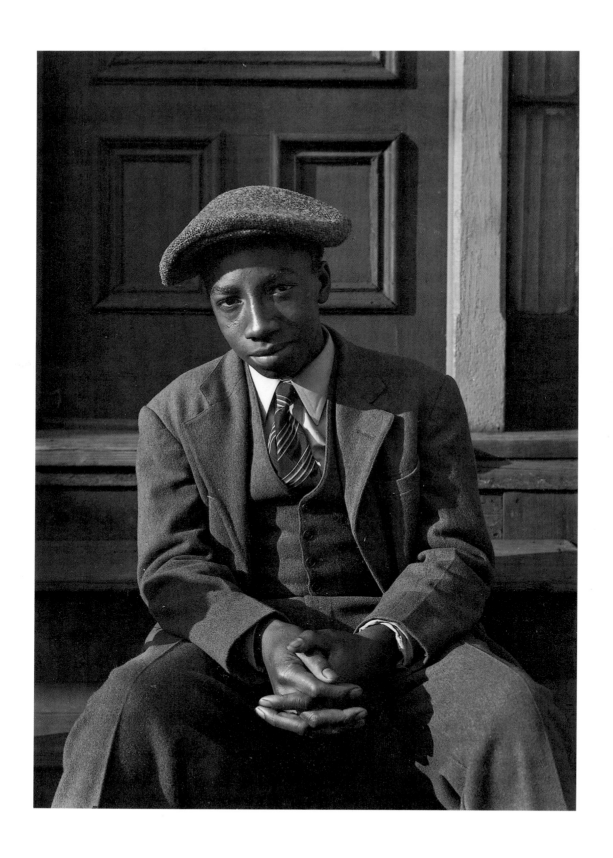

Boy on steps with cap, Detroit, 1942.

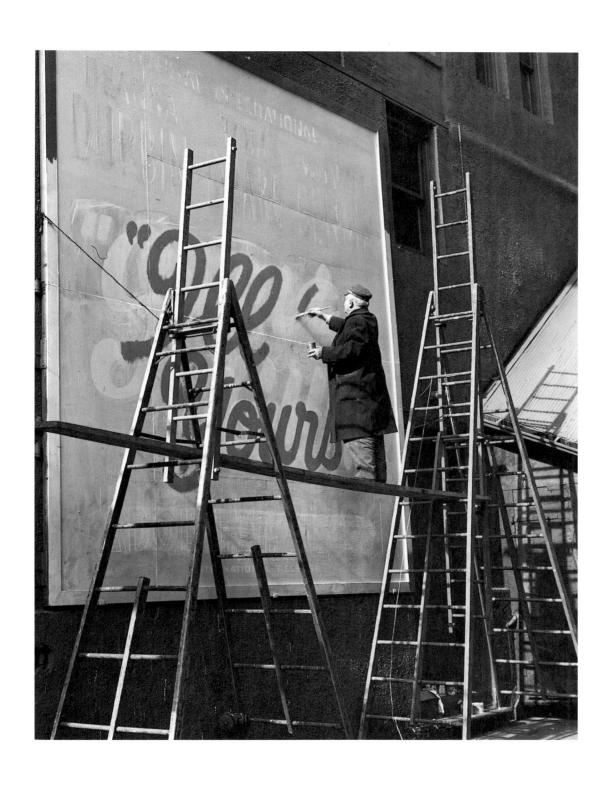

Times Square, New York, 1946.

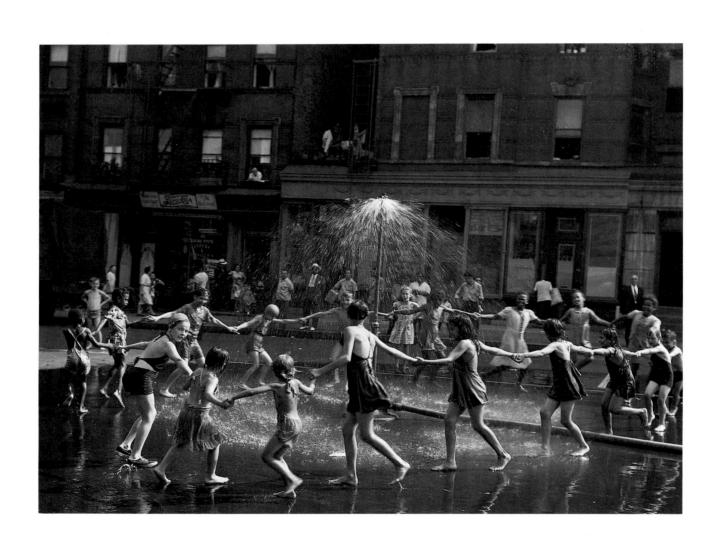

Children in circle, LaSalle Street, New York, 1946.

Roosevelt poster, 106th Street, New York, 1946.

Fisherman's store, Fulton Street, New York, 1948.

242

Bourbon Street, New Orleans, 1948.

59th Street El station, Third Avenue, New York, 1948.

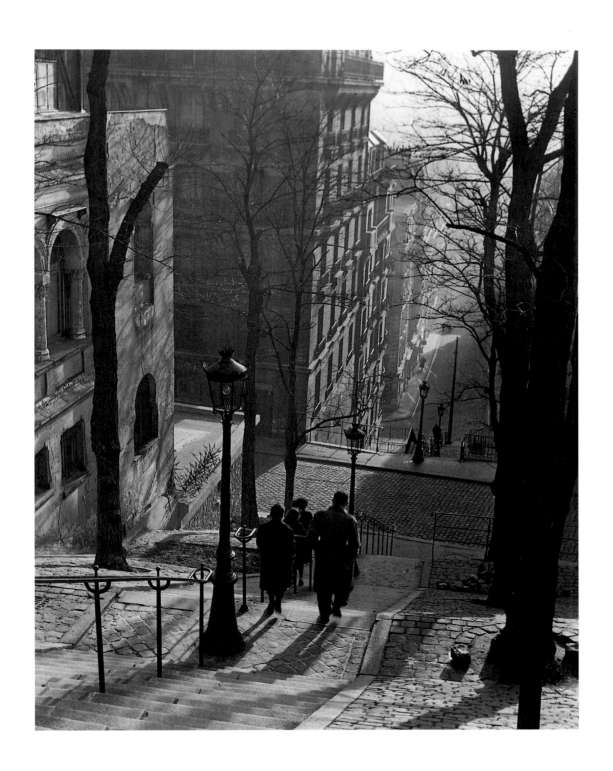

Stairway from Montmartre #1, Paris, 1949.

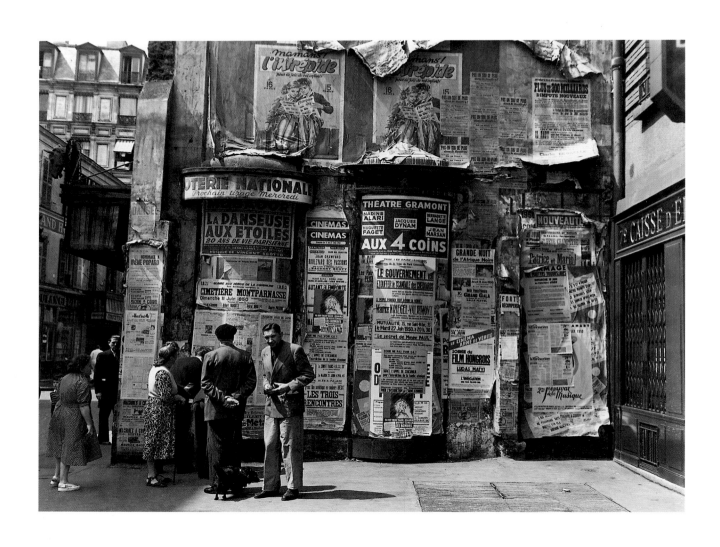

Place Pervety, Paris, 1950.

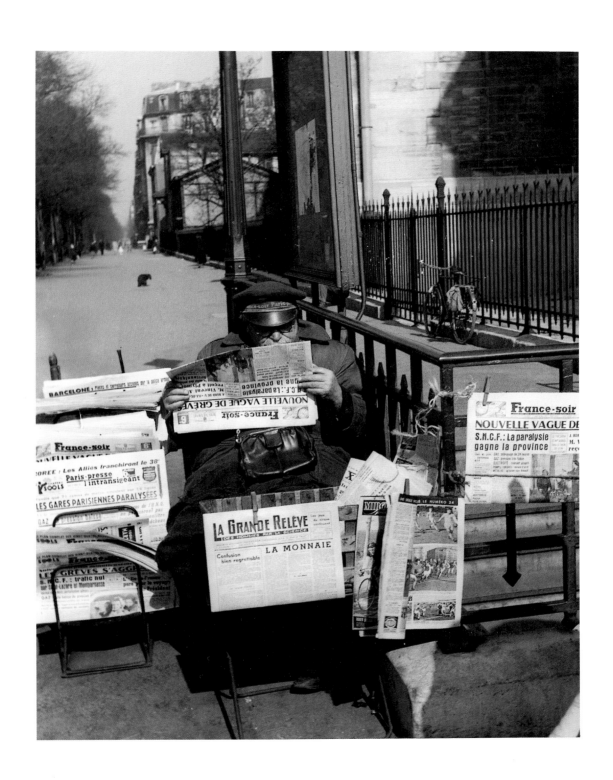

Newspaper vendor at Metro Alésia, Paris, 1950.

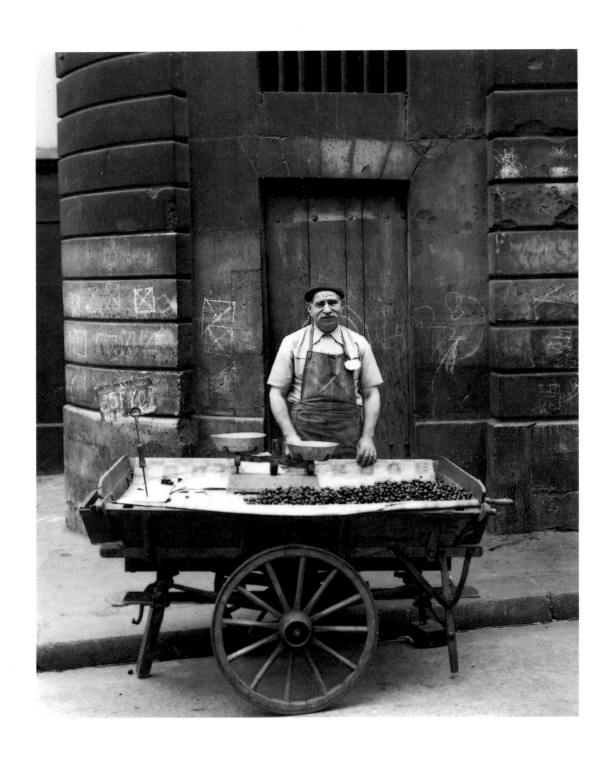

Cherry man, rue Mouffetard, Paris, 1950.

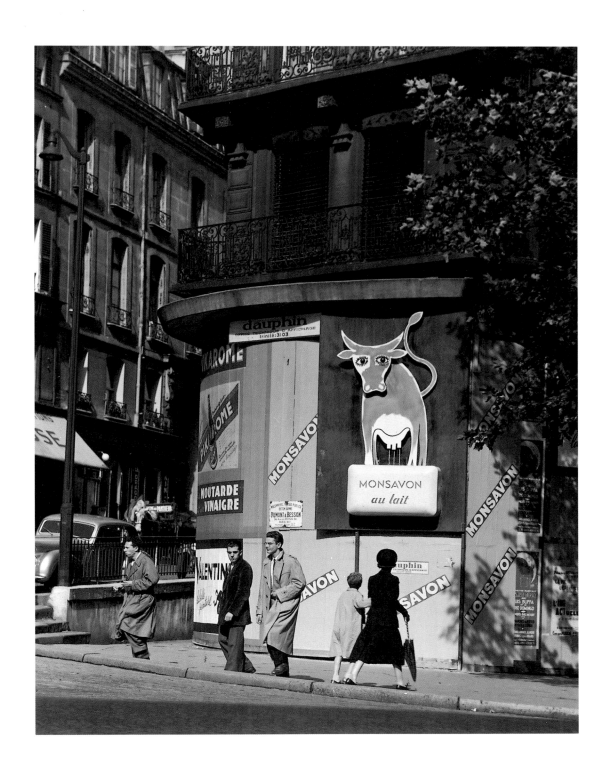

Place St. Michel, Paris, 1950.

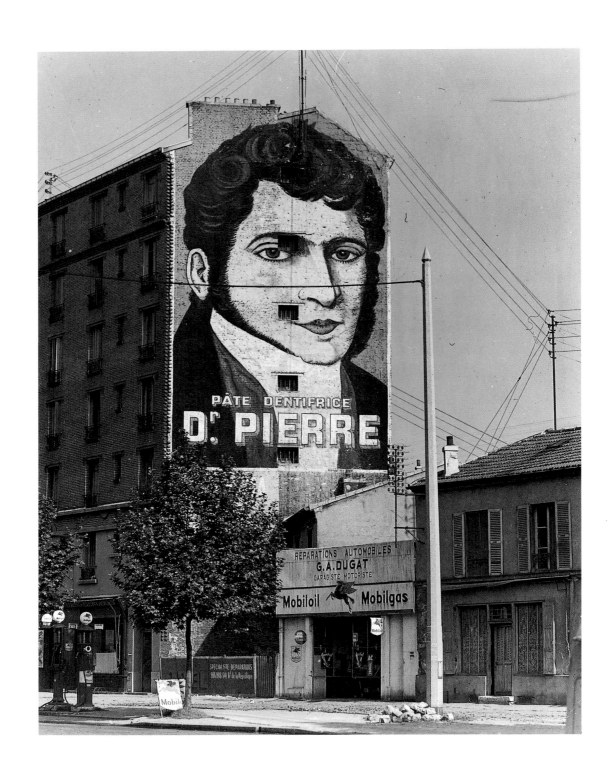

Toothpaste ad, Paris, 1950.

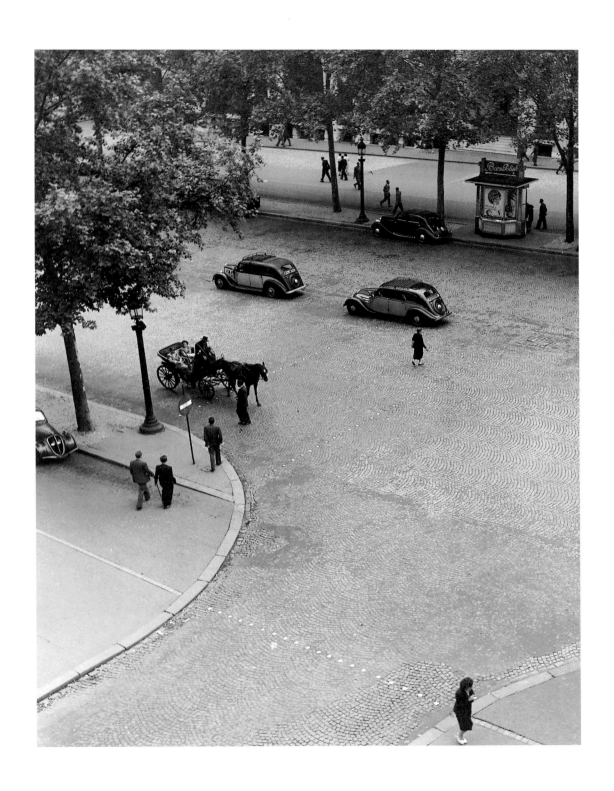

Champs Elysées, Paris, 1950.

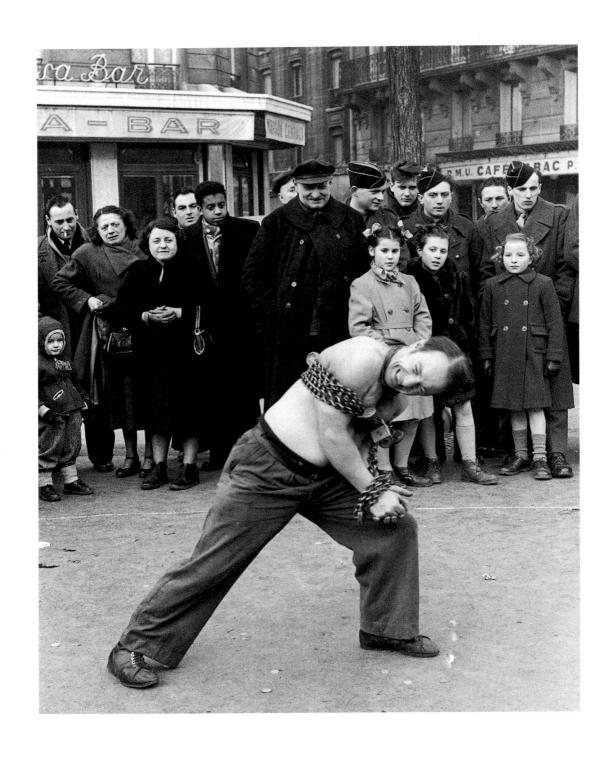

Strong-man act, Paris, 1951.

79th Street, New York, 1952.

Sixteenth-century door, Ile St. Louis, Paris, 1953.

Lower Broadway, New York, 1956.

Steamboat gothic house, Piermont, New York, 1954.

St. Luke's Place, New York, 1959.

The Flatiron Building, New York, 1959.

At Georgia O'Keeffe's Ghost Ranch house, New Mexico, 1959.

O'Keeffe's studio, New Mexico, 1963.

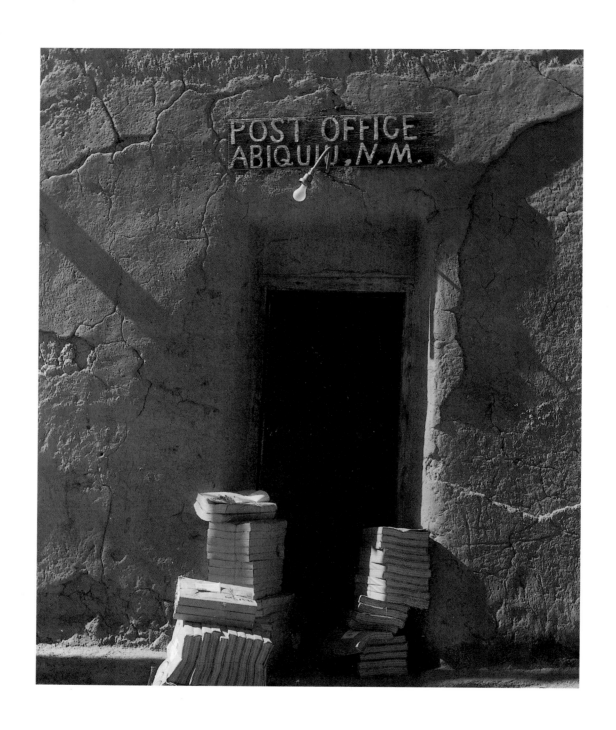

Abiquiu Post office the day the Montgomery Ward catalogs arrived, New Mexico, 1962.

Plaza Real, Patzcuaro, Mexico, 1965.

263

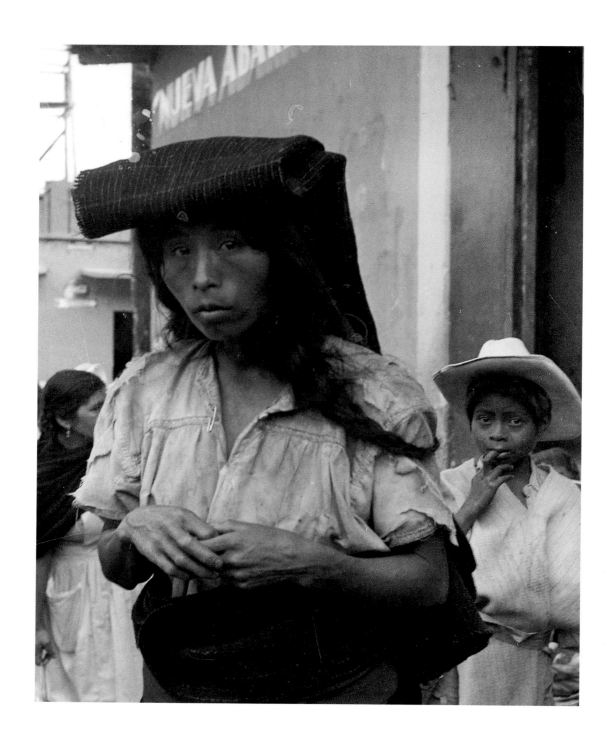

Indian woman and boy, San Cristobal de las Casas, Chiapas, Mexico, 1969.

Church, Mazatlan, Mexico, 1970.

Entrance to Hadrian's Temple, Ephesus Ruins, Turkey, 1972.

Lobby, Hostel San Marco, Leon, Spain, 1972.

267

Santiago de Compostela, Spain, 1972.

Door knocker, Cordova, Spain, 1972.

Street cleaning, Segovia, Spain, 1973.

Dog watching a woman reading, Provence, France, 1973.

From North Parade Bridge, Bath, England, 1976.

Cathedral, York, England, 1976.

Church interior, Dingle, Ireland, 1979.

Sardine griller, Nazaré, Portugal, 1980.

Man loading grain from a cart, Lagos, Portugal, 1982

White horse of Westbury, Wilshire, England, 1982.

Village of Laycock, England, 1984.

Siena, Italy, 1984.

Venice, Italy, 1984.

Venice, Italy, 1984.

Designed by Mary Shapiro
Set in Century Schoolbook and Helvetica Black Condensed
Printed and bound by Dai Nippon Printing Company
Printed in Japan